THE
TUDORS

Acknowledgements

Siobhan Clarke: To Kate Anders, James Campbell and Sarah Mason-Campbell with love. Hoping Isla and the new arrivals of 2019 will enjoy the Tudors as much as your aunt.

Linda Collins: To Zachary, Imogen, Eva, Lucie and Isabella Collins, with love.

THIS IS AN ANDRE DEUTSCH BOOK

Text © Siobhan Clarke and Linda Collins 2019
Design © Andre Deutsch 2019

This edition published in 2019 by Andre Deutsch
A division of the Carlton Publishing Group
20 Mortimer Street
London
W1T 3JW

Printed in Dubai
All rights reserved
A CIP catalogue for this book is available from the British Library

ISBN: 978-0-233-00596-6

THE TUDORS

THE CROWN, THE DYNASTY,
THE GOLDEN AGE

Siobhan Clarke and Linda Collins

ANDRE
DEUTSCH

THE HOUSE OF TUDOR

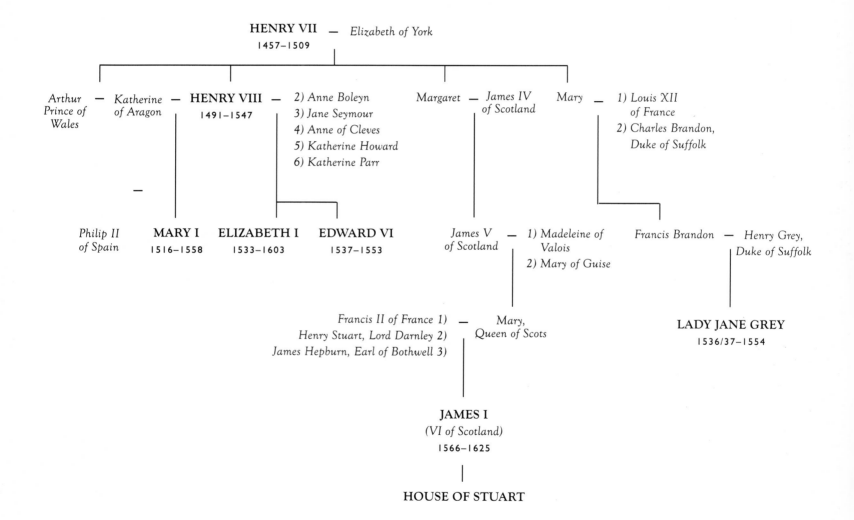

HENRY VII — *Elizabeth of York*
1457–1509

Arthur
Prince of
Wales
— *Katherine*
of Aragon
— **HENRY VIII** — 2) *Anne Boleyn*
1491–1547 3) *Jane Seymour*
4) *Anne of Cleves*
5) *Katherine Howard*
6) *Katherine Parr*

Margaret — *James IV*
of Scotland

Mary — 1) *Louis XII*
of France
2) *Charles Brandon,*
Duke of Suffolk

Philip II
of Spain
MARY I
1516–1558
ELIZABETH I
1533–1603
EDWARD VI
1537–1553

James V
of Scotland
— 1) *Madeleine of*
Valois
2) *Mary of Guise*

Francis Brandon — *Henry Grey,*
Duke of Suffolk

Francis II of France 1)
Henry Stuart, Lord Darnley 2)
James Hepburn, Earl of Bothwell 3)
— *Mary,*
Queen of Scots

LADY JANE GREY
1536/37–1554

JAMES I
(*VI of Scotland*)
1566–1625

HOUSE OF STUART

CONTENTS

6 INTRODUCTION

8

RICHARD III
THE BATTLE OF BOSWORTH

30

HENRY TUDOR
RED AND WHITE ROSES
AND THE FOUNDING OF A DYNASTY

52

HENRY VIII
DISSOLUTION, MAGNIFICENCE
AND THE EARLY TUDOR COURT

74

EDWARD VI &
LADY JANE GREY
PROTESTANTISM AND SUCCESSION

96

MARY TUDOR
ENGLAND'S FIRST QUEEN

116

ELIZABETH I
GLORIANA AND HER GOLDEN AGE

140

THE END OF THE TUDORS
THE UNION OF THE CROWNS

158 INDEX | 160 CREDITS

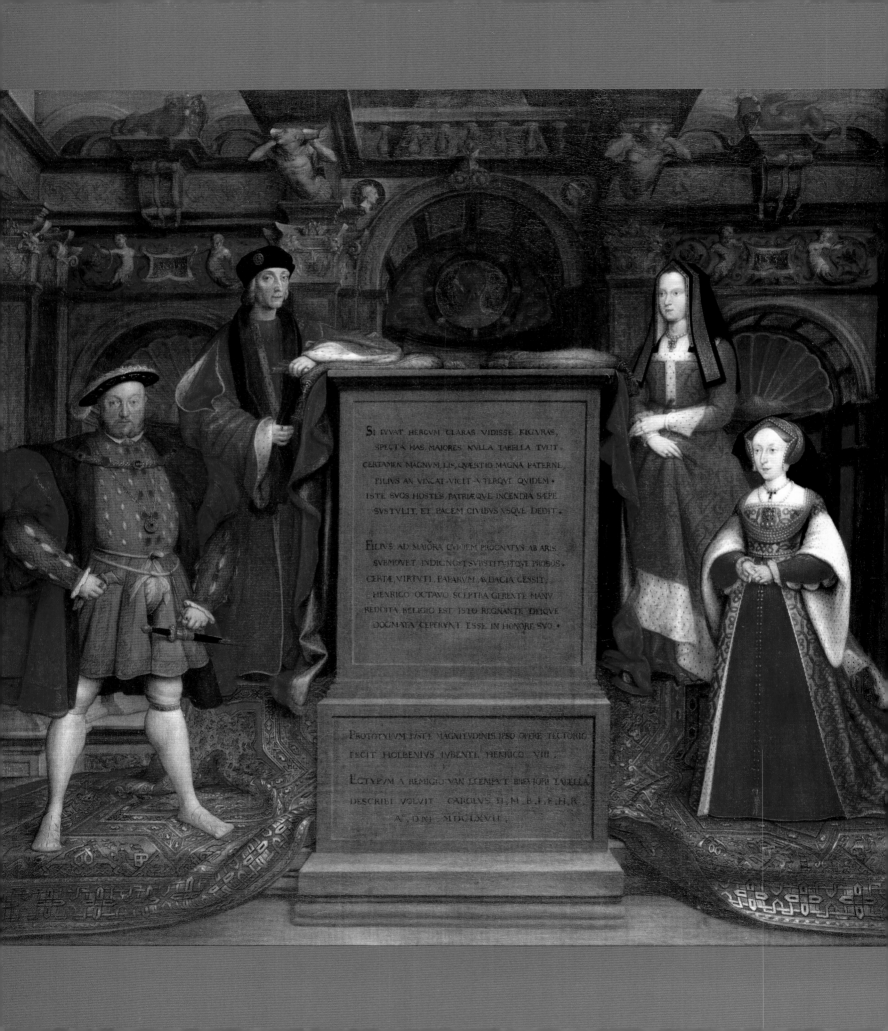

INTRODUCTION

The story of the Tudor monarchy began on a bloody battlefield, at Bosworth in 1485, when Henry Tudor seized the crown of England from his distant relative, Richard III. Henry VII proved to be a shrewd and prudent king, who laid the foundations of a strong dynasty and healed his war-torn kingdom. Often seen as a cold, miserly figure, by the time of his death he had curtailed the power of a fractious nobility, leaving his son a peaceful realm and a full treasury.

The teenaged Henry VIII came to the throne as a golden Renaissance prince and ended his life as a bloated tyrant. No English king is as well known to us, as instantly recognisable, as rich or as powerful. He is famous for his six marriages, for breaking with the Pope, dissolving the monasteries and creating the Church of England; and for his ruthless elimination of those who stood in his way. But he was also an enthusiastic patron of the arts, who established the most magnificent court ever seen in England. As founder of the Royal Collection, as well as the Royal Navy, each of his commissions told some aspect of one central story: self-glorification.

During the reign of Henry's long-awaited son Edward VI, the boy king's regents struggled to contain the social and political discontent that engulfed the country. The Church of England became more explicitly Protestant – Edward himself was fiercely so. Such was his fervour for the Protestant religion that he excluded his sisters from the succession, in favour of Lady Jane Grey, and set in place a tragic series of events that would lead his young cousin, Jane, to the scaffold.

The reign of Henry's elder daughter, Mary Tudor, England's first queen, is best known for her attempt to reverse the English Reformation, and the burnings that led to her denunciation as "Bloody Mary". Her personal life was scarred by her parents' divorce, her unpopular marriage to Philip of Spain and her inability to produce an heir. But she was also a courageous and determined woman, who fought all her life for her religion. Ultimately, she had the courage to fight for the throne and she won.

Elizabeth I – also known to us as "Gloriana", "Good Queen Bess" and "the Virgin Queen" – reigned like a goddess over a golden age, in which England defied the power of Spain and embarked upon exploration to "new worlds". Elizabethan England enjoyed a period of unrivalled brilliance in literature and music and, despite the many Catholic conspiracies that threatened her life, the Queen's long reign provided stability and helped forge a sense of national identity.

The end of the Tudors coincided with the dawn of a new century and in some respects a new country, for Elizabeth was succeeded by James I – the son of her cousin and enemy, Mary, Queen of Scots. The Union of the Crowns joined Scotland and England under one monarch and laid the foundations for what would become Great Britain.

In this book, Linda Collins explains the Wars of the Roses, the founding of the Tudor dynasty and the lives of its first monarchs: Henry VII and Henry VIII. Siobhan Clarke explores the reigns of the children of Henry VIII – Edward, Mary and Elizabeth – the end of the Tudors and the Union of the Crowns. Our book is structured into chronological chapters, taking in the lives of the kings and queens, as well as what was happening more widely during the period.

In an age when few could read, ordinary Tudor people were very good at understanding visual images such as emblems and heraldry. Tapestries and other works of art told picture stories and the brightly painted palaces of the Tudor monarchs proclaimed their wealth. We have therefore used paintings, artefacts and documents from the period, as well as contemporary photographs of key places and relics, to help us illustrate the captivating aspects of the Tudor age.

LEFT: The Whitehall Mural by Remigius van Leemput, 1667. A copy of the original mural by Hans Holbein, 1537. A celebration of the Tudor dynasty and an iconic image of Henry VIII.

RICHARD III

THE BATTLE OF BOSWORTH

Richard III was crowned the last Plantagenet King
of England in 1483. He ruled for only two years
before perishing in battle against Henry Tudor on the
bloody field at Bosworth. For five hundred years he
has been depicted as a child-murdering tyrant.
Since the rediscovery of his remains in 2012,
however, historians have been re-evaluating the
story of his short reign.

THE HOUSES OF YORK AND LANCASTER

The houses of York and Lancaster were part of the Angevin dynasty, or House of Plantagenet, which ruled England for more than three hundred years from the coronation of Henry II in 1154 until the death of Richard III in 1485. (The surname Plantagenet is believed to have originated in the twelfth century as the nickname of Geoffrey, Count of Anjou (father of Henry II), who wore a sprig of broom (*planta genista*) on his helmet or his jacket.) It was the bitter rivalry between the heirs of these two houses that led to the Wars of the Roses.

In 1485, at Bosworth, Henry Tudor, the Lancastrian claimant, triumphed over the last Yorkist king, Richard III, and established himself as Henry VII, the first Tudor king. Both factions in the Wars of the Roses were descended from Edward III (1312–77), who reigned as King of England for fifty years. He and his Queen, Philippa of Hainault, were parents to thirteen children, among them Lionel of Antwerp, John of Gaunt and Edmund of Langley. The House of Lancaster descended from John of Gaunt and the House of York from Lionel of Antwerp and Edmund of Langley.

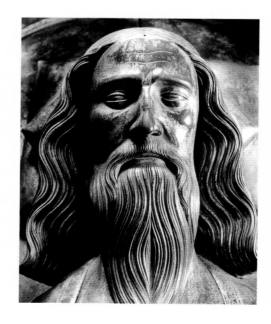 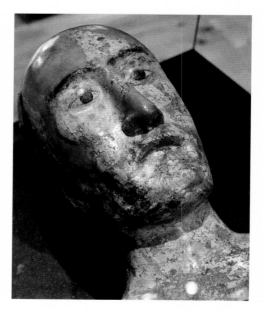

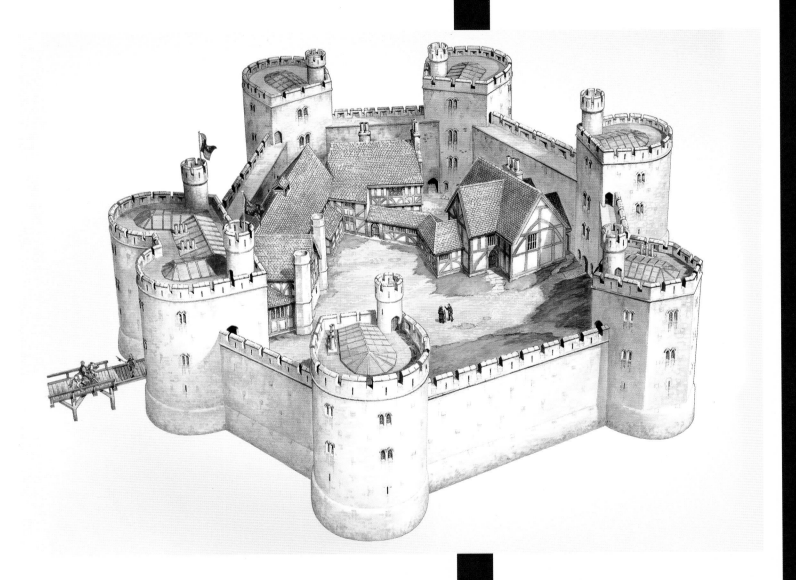

HOUSE OF LANCASTER

John of Gaunt was the third surviving son of Edward III; his name derived from the anglicized version Ghent, his birthplace. He was born in 1340, and in 1359, he married fourteen-year-old Blanche of Lancaster. Blanche was described as beautiful and graceful.

Shortly after their marriage, her father, Henry of Grosmont, Duke of Lancaster, and her sister Maud died, leaving her the sole heiress to the duchy. In her right, John of Gaunt became Duke of Lancaster, and one of the greatest landowners in England.

John and Blanche's son, Henry of Bolingbroke, was born at Bolingbroke Castle, Lincolnshire, in 1367. At ten, he played a part in the coronation of his cousin, King Richard II, son of Edward the Black Prince.

In 1398, while still a teenager, Bolingbroke quarrelled with Thomas Mowbray, Duke of Norfolk, which culminated in a duel. To prevent this trial by combat, the King intervened and exiled them both – Bolingbroke for ten years, initially, then for life.

ABOVE: Bolingbroke Castle, the birthplace of Henry IV. A computer-generated reconstruction of how the castle is believed to have looked in the fourteenth century.

OPPOSITE LEFT: The tomb of Edward III, possibly by John Orchard, lies in Westminster Abbey, London. The inscription reads, "Here is the glory of the English, the paragon of past kings, the model of future kings, a merciful king, the peace of the people".

OPPOSITE RIGHT: A full-length wooden effigy of Edward III was carried at his funeral. The face is a plaster cast believed to have been taken from a death mask of the King.

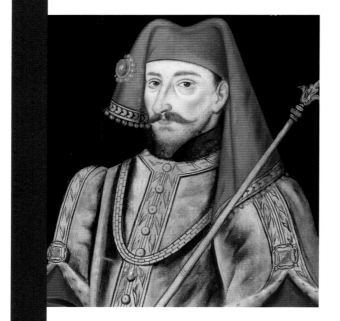

RIGHT: Henry V. At the battle of Shrewsbury in 1403, Henry was shot in the face by an arrow. Using specially designed tools, the metal arrowhead was removed and Henry survived.

TOP: King Henry IV. It had been prophesied that Henry would die in Jerusalem. Planning to go to the Holy Land, he was praying in Westminster Abbey when he became ill. He was taken to the Abbot's house and laid by the fire. On asking where he was, he was told that he was in "Jerusalem" – the name assigned to that particular chamber.

ABOVE: The code of chivalry dictated that a knight should be a warrior, but also kind and courteous.

When John of Gaunt died at Leicester Castle in 1399, Richard II confiscated the Lancastrian estates. Set on revenge, Bolingbroke returned to England and forced Richard's abdication. Richard surrendered without resistance and Bolingbroke was crowned Henry IV at Westminster Abbey, the first King of the House of Lancaster. He imprisoned Richard II in Pontefract Castle, where he died in 1400, perhaps of starvation.

Henry had married Mary de Bohun around 1380–81 and they had seven children. Their eldest surviving son, also named Henry, was born in 1386 or 1387. When his father died in 1413 at Westminster Abbey, he was crowned Henry V, and later became famous for his victory at Agincourt in 1415. Five years after Agincourt, as agreed in the Treaty of Troyes, Henry V married Katherine of Valois, daughter of King Charles VI of France, at Troyes Cathedral. It was a short-lived marriage because Henry died unexpectedly in 1422 while on campaign in France, possibly of dysentery, leaving an infant child of less than a year old to succeed him. When Charles VI died a month later, the infant Henry VI became King of France also, under the terms of the Treaty of Troyes.

In 1429, Henry was crowned King of England in Westminster Abbey, and in 1431 he was crowned King of France in Paris. A regency council ran England until he was almost sixteen and considered old enough to rule alone. He was twenty-three when he married Margaret of Anjou at Titchfield Abbey in Hampshire, and they had one son, Edward of Westminster, who was born in 1453.

After Blanche of Lancaster died in 1368, John of Gaunt fathered four illegitimate offspring by his mistress Katherine Swynford, whom he married in 1396. They were given the surname Beaufort, after a French lordship John of Gaunt once held. After John and Katherine's marriage, Richard II legitimized the Beaufort children. Henry IV confirmed their legitimacy by Letters Patent, although he added the words "excepting the royal dignity" to exclude them from succeeding to the throne. The clause, however, did not receive the authority of Parliament and was deemed invalid.

John of Gaunt's great-granddaughter, Margaret Beaufort, became the mother of Henry Tudor, who was born on 28 January 1457 at Pembroke Castle in Wales. His father, Edmund Tudor, Earl of Richmond, had died three months earlier. Margaret Beaufort was only thirteen when she gave birth to Henry and he was to be her only child. Through her, he became the most senior claimant of the House of Lancaster after the death of Henry VI.

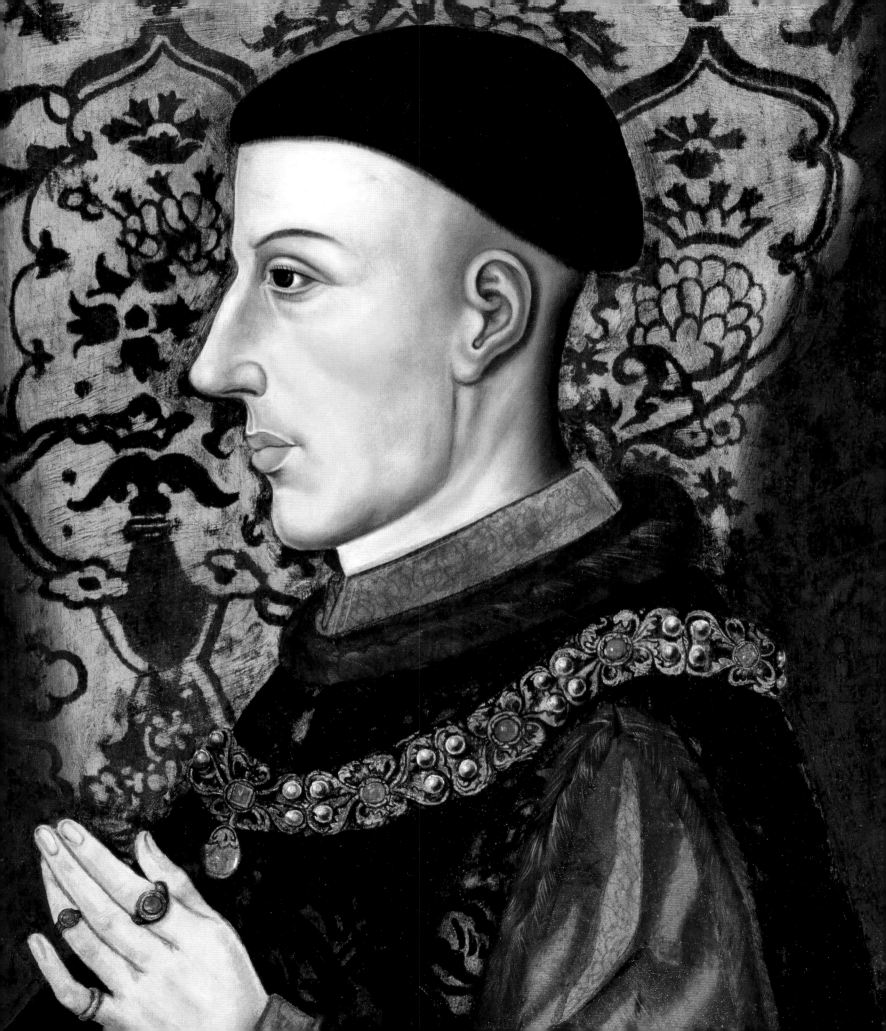

HOUSE OF YORK

The House of York descended from Edward III's third son, Lionel of Antwerp (1338–1368), in the female line, and his fifth son, Edmund of Langley (1341–1402), in the male line. Edmund married Isabella of Castile in 1372 and they had three children. Their second son, Richard of Conisburgh, Earl of Cambridge, married Anne Mortimer, the great-granddaughter of Lionel of Antwerp. Their son, Richard, was born in 1411 and created Duke of York in 1426. Two years earlier, he had married Cecily Neville, known as the Rose of Raby, who bore him twelve, possibly fourteen, children, among them the future kings Edward IV, born 1442, and Richard III, born in 1452.

Cecily died at the age of eighty at Berkhamsted Castle in Hertfordshire, and is buried at the Church of St Mary and All Saints at Fotheringhay, Northamptonshire.

Two years after his coronation, the authority of King Richard III of York was challenged by Henry Tudor, the chief claimant of the House of Lancaster. In 1485, these two men from different houses faced one another across Bosworth Field in a battle for the crown of England.

LEFT: Edmund of Langley, 1st Duke of York.

RIGHT: An artist's impression of Conisburgh Castle, which is today largely a ruin.

THE WARS OF THE ROSES

The Wars of the Roses began in 1455 and continued for more than thirty years. They were the consequence of political and social unrest, the loss of all England's French territory except Calais, and Henry VI's political incapacity and his inability to control the factions that dominated his court.

In 1453, Henry VI suffered a severe mental breakdown that rendered him unfit to rule. Richard, Duke of York was named protector and restored firm government. Two years later, Henry recovered and challenged York's authority.

This conflict between the houses of York and Lancaster, and good and bad government, led to the Wars of the Roses. In this conflict, Margaret of Anjou played a proactive role on behalf of her husband the King and their son, Edward of Westminster.

The two sides first confronted one another at St Albans on 22 May 1455, where the Yorkists defeated the King's Lancastrian army.

There followed four years of uneasy peace, which lasted until September 1459, when the two armies met once again, at Blore Heath in Shropshire, where York achieved a decisive victory.

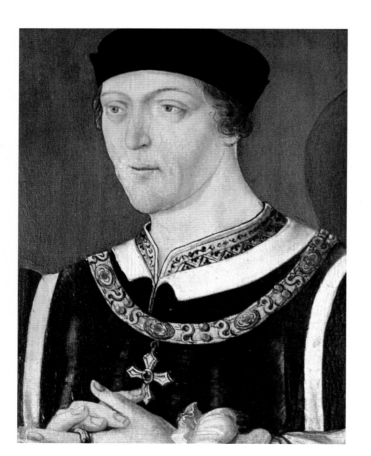

LEFT: Henry VI. In 1910, George V gave permission to exhume the body of Henry VI. Bones were found of a strong man measuring 5ft 9 to 5ft 10, with light brown hair.

Less than three weeks later, on 12 October 1459, the opposing forces faced each other at Ludford Bridge near Ludlow. It was soon York's forces that were obliged to retreat and a largely bloodless victory was won by Queen Margaret and the Lancastrians.

At Northampton in 1460, the Yorkists triumphed and Henry VI was captured. It was at this point that York claimed the throne and the conflict became dynastic. Refusing to see her son disinherited, Queen Margaret continued raising men to fight for the Lancastrian cause. On 30 December, York attacked the Lancastrians at Wakefield, Yorkshire, but was soundly defeated and killed.

When he learned of the death of his father and the crushing Yorkist defeat at Wakefield, Richard of York's son, Edward, Earl of March, planned to march to London and join forces with Richard Neville, Earl of Warwick, who is known to history as "Warwick the Kingmaker". But, on hearing news that an army was being raised in Wales, he changed direction.

BELOW: On the morning of the Battle of Mortimer's Cross, three suns appeared in the sky. To calm and encourage his troops, Edward of York explained them as a sign of good fortune, showing God was on their side. The three suns were an optical phenomenon known as a parhelion, caused by the refraction of ice crystals in the atmosphere.

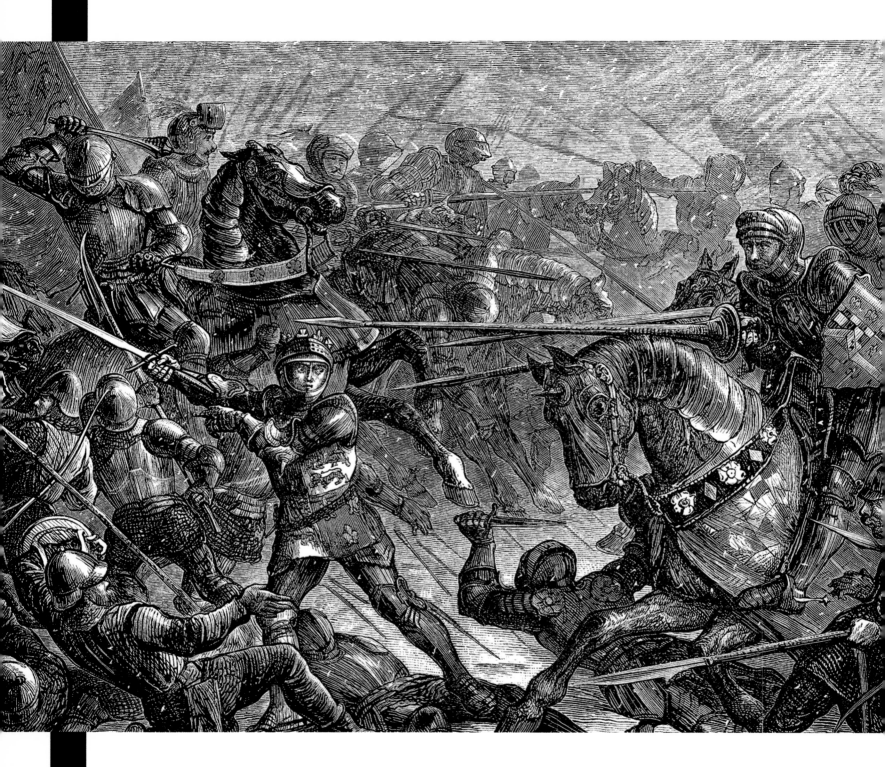

At the Battle of Mortimer's Cross, Herefordshire, on 2 February 1461, he inflicted a severe defeat on the Lancastrian army before continuing his journey to join Warwick in London.

Warwick was waiting at St Albans as Edward and his army arrived, but on 17 February 1461 they were taken by surprise at the Second Battle of St Albans, which finished in a victory for the Lancastrians under the command of Margaret of Anjou. But London closed its gates to Margaret and her army of feared northerners. Edward rode into the city and was proclaimed King of England, as Edward IV, and Henry VI was deposed.

Margaret had retreated north and raised a huge army, and the new King rode north to defeat it.

The Battle of Towton in Yorkshire, in March 1461, has been described as the biggest battle ever fought on English soil. It was a bloody fight that took place in a freezing snowstorm; and after many hours, it ended in a resounding defeat for the Lancastrians. Henry VI, his Queen and their son fled to Scotland.

The way was now clear for Edward IV to be crowned the first Yorkist King of England. What remained of the Lancastrian forces was virtually destroyed three years later at the Battle of Hexham, Northumberland. From now on, the fighting would not be between the houses of York and Lancaster, but against the internal policies of the House of York.

Edward IV began to resent the increasing power of Richard Neville, Earl of Warwick. In 1464, he angered Warwick by marrying a Lancastrian widow, Elizabeth Wydeville, and advancing her relations, who were looked upon as upstarts by the nobility. Edward and Elizabeth had ten children, including Edward, the heir to the throne, who was born in 1470, and Richard, Duke of York, born in 1473. In retaliation, Warwick raised an army to fight the King.

In July 1469, at the Battle of Edgecote, Northamptonshire, Warwick was victorious against the King, who was taken prisoner. By 1470 Edward had regained control. He forced Warwick to seek refuge in France with his ally, George, Duke of Clarence – Edward's own brother –and there they came to terms with Margaret of Anjou. Returning to England, they deposed Edward IV and restored Henry VI to the throne. Edward IV fled to the Netherlands but returned to England in 1471 to meet Warwick at the Battle of Barnet in Hertfordshire.

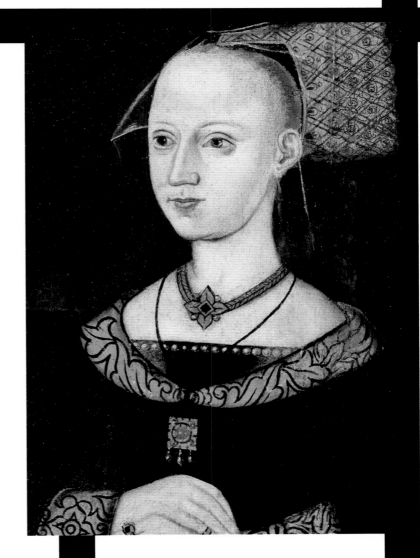

ABOVE: Elizabeth Wydeville was known as "The White Queen". A "red" Lancastrian by birth, she became part of the "white" Yorkist family by marriage – and Queen of England. Elizabeth was a co-founder of Queens' College, Cambridge, where her portrait now hangs.

OPPOSITE: The Battle of Towton was perhaps the largest and bloodiest battle ever fought on English soil.

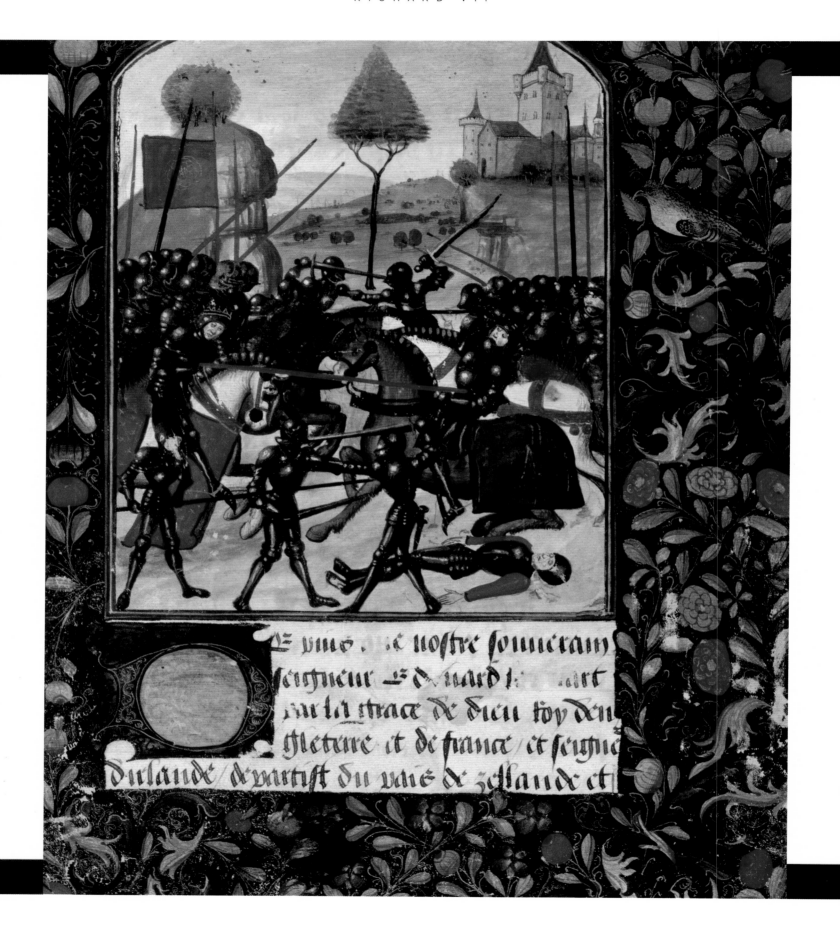

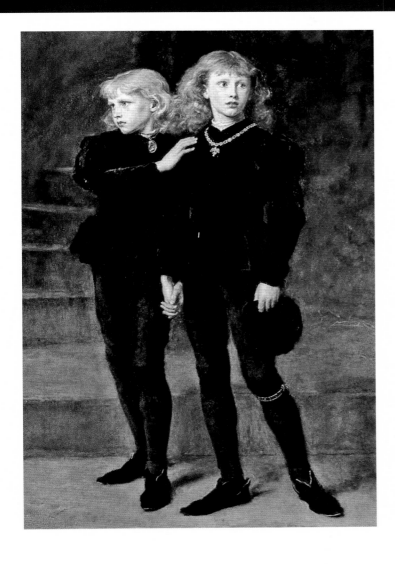

Clarence had already deserted Warwick and made his peace with his brother, King Edward, fighting for him at Barnet, where Warwick "the Kingmaker" was defeated and killed.

Margaret of Anjou soon arrived from France and, in May 1471, her forces met Edward's at the Battle of Tewkesbury, Gloucestershire, which was a decisive victory for the King. Her only son, Edward of Westminster, for whose rights she had fought so enduringly, was killed, and she herself was captured. On the evening of the day on which Edward IV marched victorious into London, Henry VI was murdered in the Tower of London.

Margaret was ransomed by Louis XI and returned to France, where she died in 1482. Edward IV reigned as King of England until his early death in April 1483, whereupon his eldest son, twelve-year-old Edward V, succeeded to the throne. He and his younger brother Richard were lodged in the Tower of London, as monarchs customarily did before being crowned, but, in June, Edward V was declared illegitimate and deposed the same day. Instead, his uncle, Richard, Duke of Gloucester, was crowned Richard III.

"The Princes in the Tower" were presumed to have been murdered, and it has long been debated whether or not Richard III was responsible for their deaths. Their disappearance led to increased Yorkist support for Henry Tudor, the Lancastrian claimant.

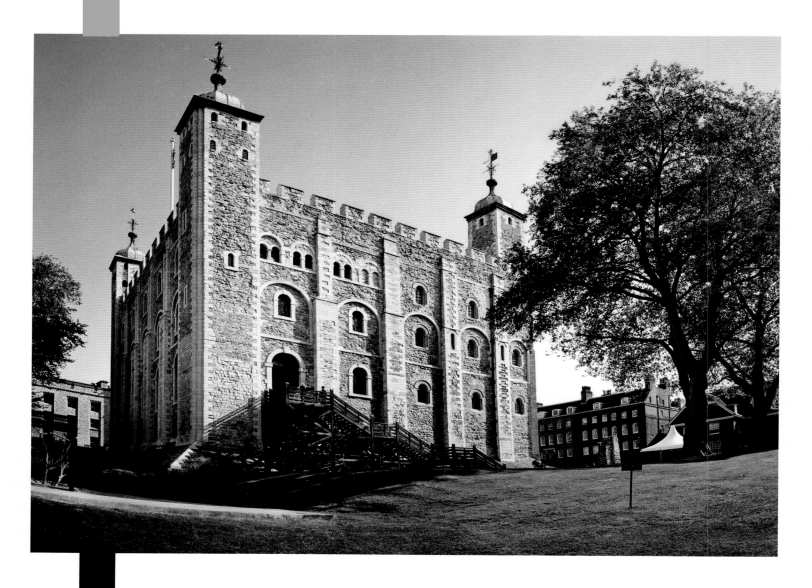

In 1483, Henry Tudor, then an exile in Brittany, vowed to marry the prince's sister, Elizabeth of York, and claim the crown of England.

In January 1484, Richard III's only Parliament issued a statute, *Titulus Regius*, confirming Richard's title to the crown and declaring that the marriage of Edward IV and Elizabeth Wydeville was invalid and their children illegitimate and incapable of inheriting the throne.

ABOVE: Construction of the Tower of London was begun by William the Conqueror in the 1070s. It is considered the most secure castle in the land, looked on with fear and awe – and yet, for five hundred years, monarchs used the Tower as a luxurious palace.

RIGHT: Henry VII. An inscription on the portrait records that it was painted on 29 October 1505, possibly as part of an unsuccessful marriage proposal to Margaret of Savoy.

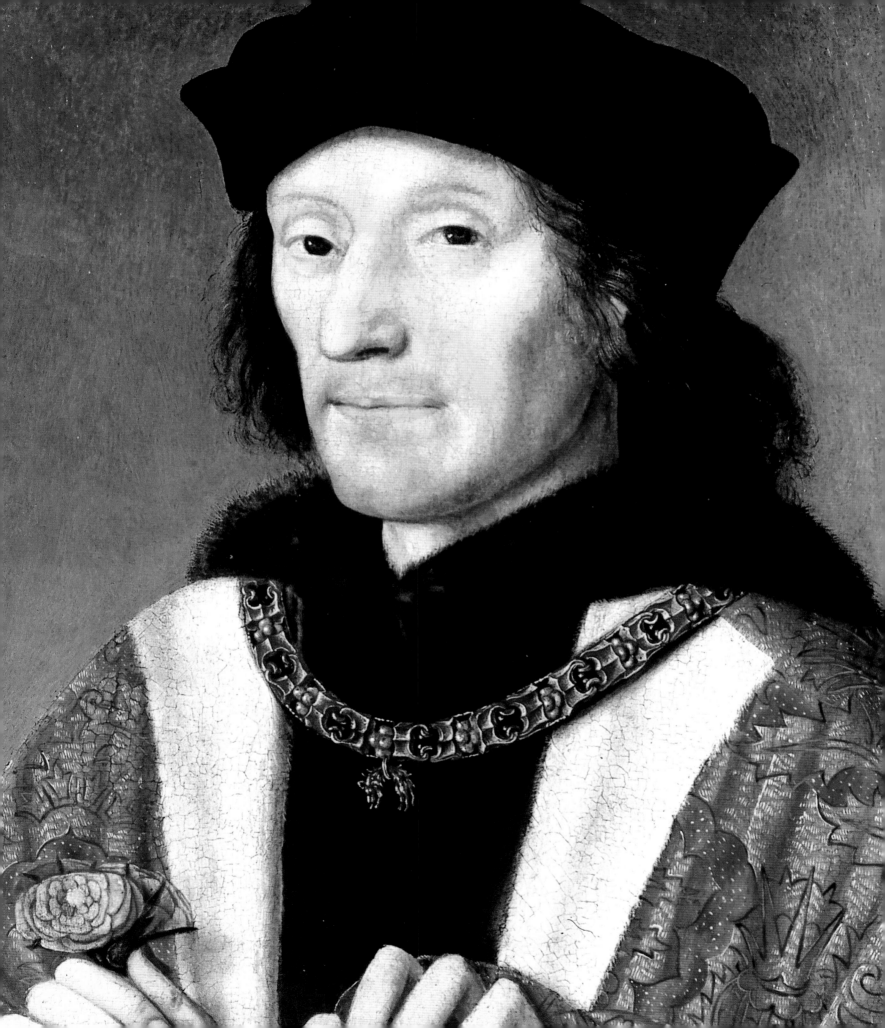

BOSWORTH: THE FINAL BATTLE

I n 1485, Henry Tudor sailed from Harfleur in Normandy and landed at Milford Haven, Wales, on 7 August. His army consisted of around two thousand men, of which five hundred were loyal supporters and the remainder French mercenaries.

Marching through Wales into England, they gained further support, and by the time Henry faced Richard III at Bosworth Field, his troops are likely to have numbered around four and a half to five thousand men.

Relatively inexperienced in battle, Henry relied on his field commander, the practised veteran John de Vere, 13th Earl of Oxford, to lead his troops.

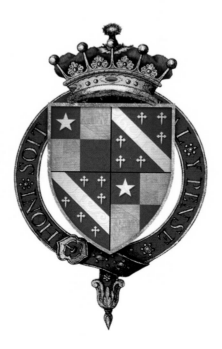

LEFT: The quartered arms of John de Vere, 13th Earl of Oxford, principal commander of Henry Tudor's troops at the Battle of Bosworth.

OPPOSITE: The Battle of Bosworth was the last significant clash of the Wars of the Roses. It was fought 12 miles west of Leicester and 3 miles south of the town of Market Bosworth.

OVERLEAF: The Battle of Bosworth Field (a nineteenth-century reimagining).

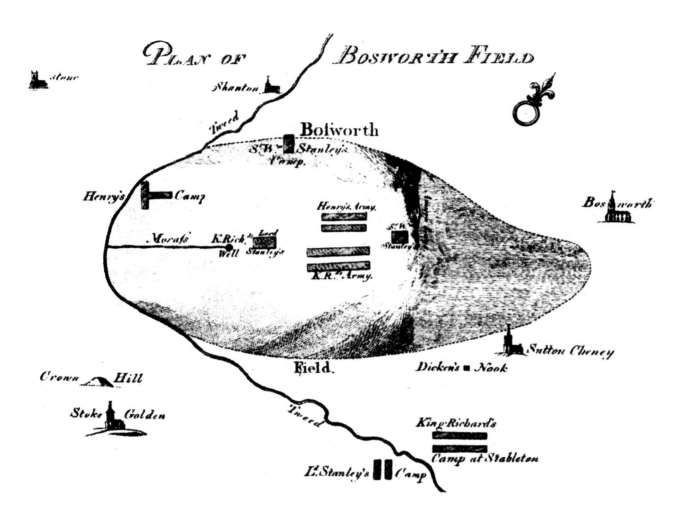

PLAN OF BOSWORTH FIELD

Stone

Shanton

Tweed

Bofworth

S·B· Stanley's Camp.

Henry's Camp

Bosworth

Henry's Army.

Morafs

K·Rich.'s Lord Stanley's

Well

S·W· Stanley's

K·R.'s Army.

Crown Hill

Field.

Dicken's Nook

Sutton Cheney

Stoke Golden

Tweed

King Richard's

Camp at Stableton

L·Stanley's Camp

Richard III mustered his army of between ten and twelve thousand men at Leicester. The Stanley brothers, Thomas, Lord Stanley and Sir William Stanley, stood by with an additional three thousand to four thousand men. They had pledged support for the King, but he considered their loyalty to be questionable. Henry Percy, Earl of Northumberland, commanded a rearguard of the King's army with as many as seven thousand men, but, for unexplained reasons, they did not take part in the battle, severely reducing the power of the King's forces. John Howard, the ageing Duke of Norfolk, commanded the King's vanguard, which was principally composed of archers. He was slain during the battle.

Richard was superior in manpower, but Henry's French mercenaries were experienced and equipped with up-to-date weapons. The skill of the longbow men recruited in Wales and the inaction of the Earl of Northumberland went some way toward levelling the balance between the two armies. On 22 August 1485, the battle began, on a marshy moor not far from Ambion Hill, south of the town of Market Bosworth in Leicestershire. Originally known as the Battle of Redemore, it was more than twenty-five years before it was known as Bosworth Field.

Henry Tudor's standard-bearer, Sir William Brandon, was killed by Richard's own hand and Sir John Cheyney, at 6ft 8in the tallest soldier of the day, was knocked down.

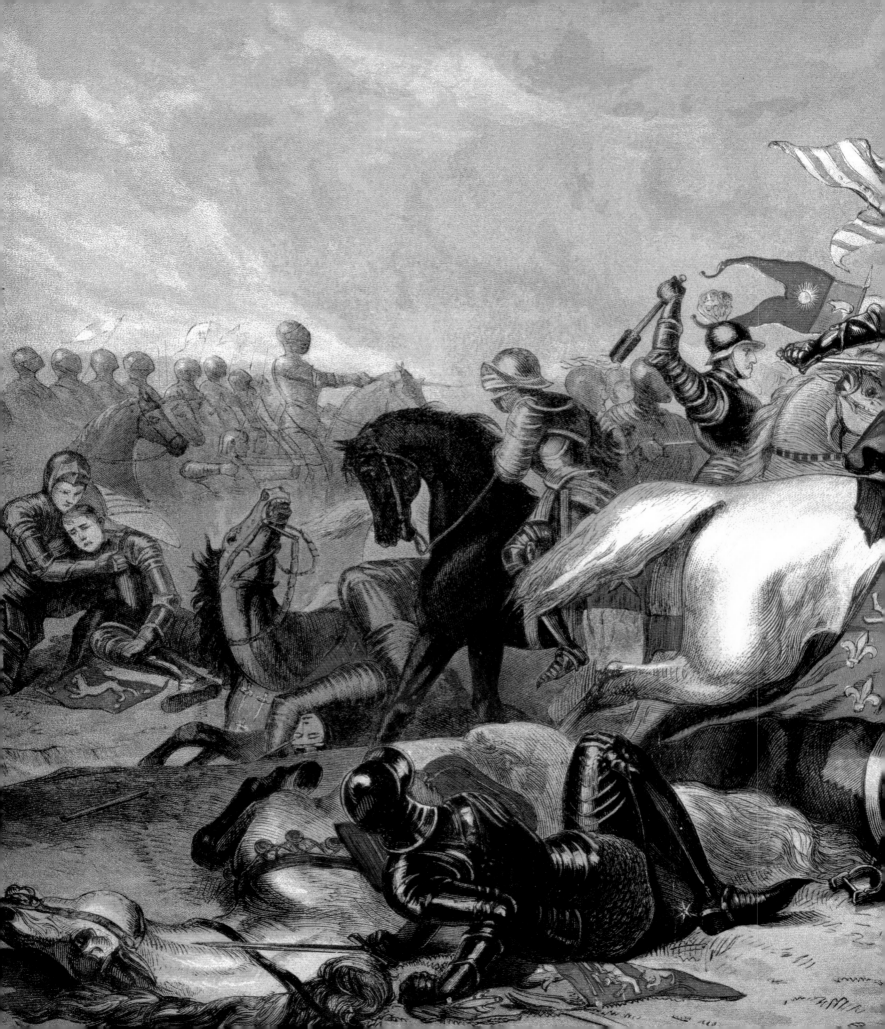

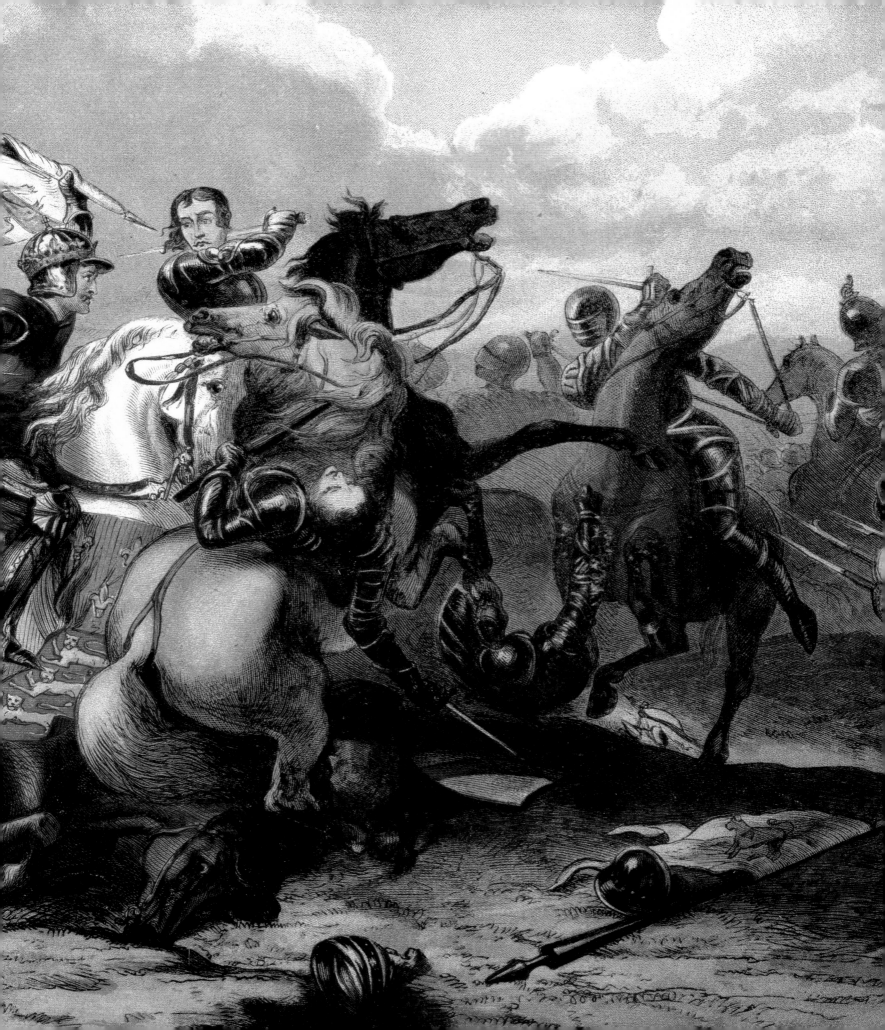

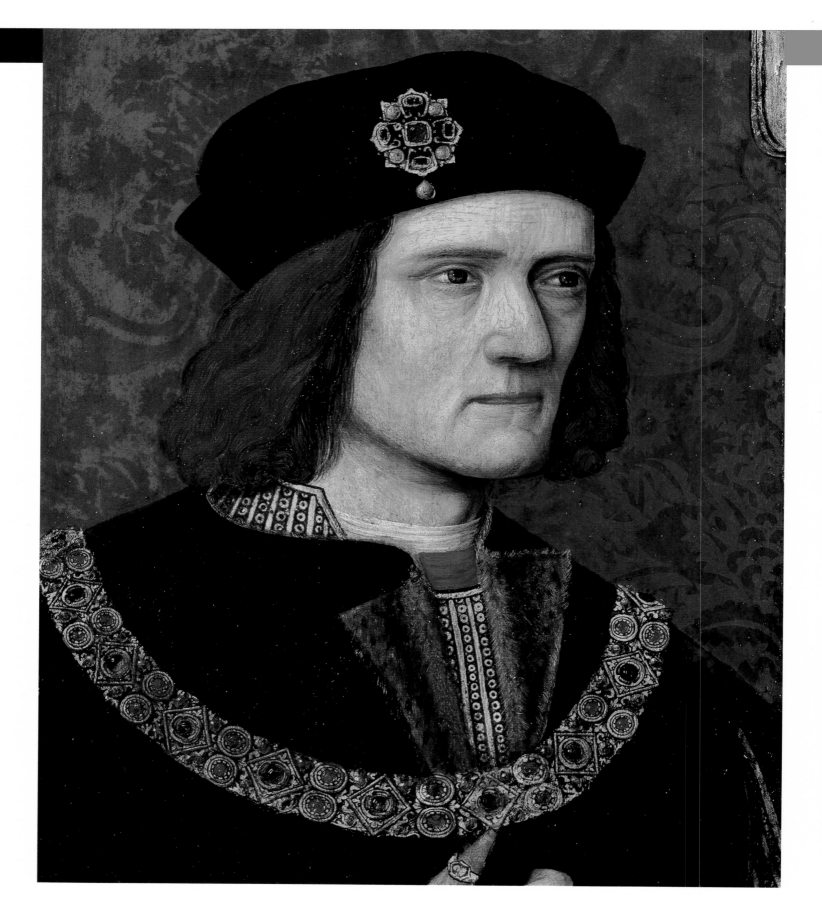

Sir Percival Thribald, the standard-bearer of Richard III, lost his legs in the battle but remained steadfastly clutching the Yorkist standard until he died. Richard was hard-pressed when he sighted Henry Tudor and his standard across the battlefield. Wearing his crown over his helmet, he charged toward him and came within sword contact, but, before he was able to act, he was attacked and killed by the Stanleys' men.

Thomas and William Stanley had waited to see which way the battle was going and turned against the King, with fatal consequences for Richard, who, according to evidence taken from his remains, sustained wounds to the front of his skull, while the back of his head was probably removed by a blow from a halberd – a type of two-handed poleaxe – and a sword was run into his brain through the base of his skull.

The battle, which had begun in the early morning, was probably over soon after noon.

Richard's body was stripped and trussed, tied to a horse and removed to Leicester. It was placed on public display there for two days prior to being interred in the church of the Grey Friars. Richard was the last English king to die in battle. His death ended 331 years of Plantagenet rule and paved the way for the Tudor dynasty.

Henry VII was proclaimed king near the village of Stoke Golding, close to the battlefield, and Richard's coronet was placed on his head by Lord Stanley. According to legend, Richard's crown was been found in a hawthorn bush; contemporary hawthorn emblems in the Henry VII chapel at Westminster Abbey suggest that this may be true.

After Bosworth, Parliament enacted that Richard had unlawfully usurped the throne and Edward IV's children were restored as the legitimate heirs. Elizabeth of York was recognized as heiress to the House of York and Lord Stanley was appointed Earl of Derby.

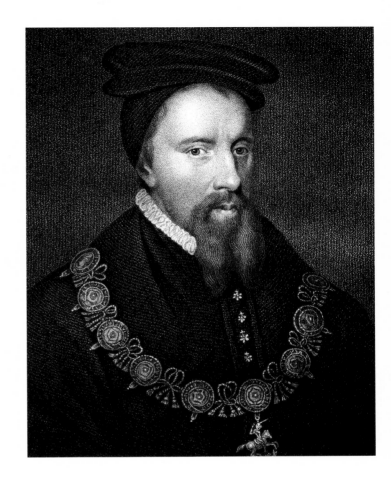

OPPOSITE: Richard III.
Sir Thomas More's *History of King Richard III*, written in 1513, describes the King as "crook backed" and "hard favoured of visage". It was this view that Shakespeare continued in his play *Richard III* of c.1591. Historians today are aiming to unravel the propaganda that has historically formed opinions of Richard III.

ABOVE RIGHT: A nineteenth-century engraving of Thomas Stanley, Earl of Derby. Polydore Vergil writes that after the victory of Henry Tudor at Bosworth Field, it was Thomas Stanley who placed the coronet on the head of Henry VII.

HENRY TUDOR

RED AND WHITE ROSES
AND THE FOUNDING OF A DYNASTY

Henry VII, the founder of the Tudor dynasty, had
claimed the throne by right of conquest, asserting that
the judgement of God at Bosworth had given him a
divine right to it.

MARRIAGE AND CHILDREN

Henry VII's coronation took place on 30 October 1485 at Westminster Abbey. The next sitting of Parliament was to be on 7 November. Being crowned before that date meant that Henry would not be reliant on Parliament to declare him the rightful king.

His future wife and Queen, Elizabeth of York, had a strong claim to the throne in her own right, as the heiress of York; it appears that Henry had himself crowned before his marriage to make it clear that he was the rightful heir and was not claiming his throne through marriage to Elizabeth.

The first task of Henry VII's Parliament was to repeal the *Titulus Regius* – and to reinstate Elizabeth's legitimacy. In January 1486, two days after a Papal dispensation was granted, the couple married at Westminster, uniting the warring houses of York and Lancaster, restoring stability to the country, and laying the foundations of the new Tudor dynasty. Shortly afterwards, Pope Innocent VIII issued a Papal bull threatening the excommunication of anyone denying Henry VII's marriage or his title to the throne.

Elizabeth of York was nine years younger than her husband. She was described as young, tall, blonde and attractive, with a kind and gentle personality. Her generosity and sweet nature were remarked upon. She would give large sums of cash to servants or to the poor, often in return for small gifts of food. Henry supplemented her income with payments from the royal treasury. Importantly for the Queen of a new dynasty, she was descended from a line of fertile women; her grandmother, Cecily, Duchess of York, had given birth to at least a dozen children and her mother had borne ten.

"How sweet a thing it is to wear a crown"

(William Shakespeare, *Henry VI*)

THE TUDOR ROSE

At the beginning of his reign, Henry VII ruled over a population estimated to number just under three million, the majority of whom were largely illiterate. It was an age when visual culture was employed to promote political ideals. Henry VII was shrewdly aware of the power of visual symbolism. Emblems on buildings, coats of arms, painted banners, guild signs and family shields were commonplace. In a symbolic gesture of reconciliation, Henry promoted the union of the royal houses by entwining his own and Elizabeth's emblems: the red rose of Lancaster with the white rose of York.

It was common for couples to unite their individual heraldic devices on marriage, and the message of the Tudor rose was one of unity and peace after a terrible and bloody civil war. It was also a reminder that Henry's children with Elizabeth of York would have both Yorkist and Lancastrian blood flowing in their veins.

Long before the Tudor reign, red and white roses had been associated with the Virgin Mary. They represented her sacrifice and her purity. The colour red is strong and evocative of danger. It is the colour of blood, whereas the white rose represents peace and harmony. The spread of the cult of the Virgin Mary throughout Europe in the twelfth century, and the increasing circulation of Marian images, meant that the religious symbolism of the two Tudor roses and their association with God and the Virgin Mary would have been recognizable to all.

Although members of the House of York were using a rose as a badge from 1436, and Edward IV employed a white rose from 1461, the red rose was only used from time to time before the coronation of Henry VII. Before the Battle of Bosworth, Henry Tudor was more firmly associated with the white greyhound of Richmond and the mythical King Cadwallader's red dragon of Wales. Henry used the latter as his emblem at Bosworth.

It is testament to his ingenuity that the Tudor rose has remained a powerful and enduring device to the present day.

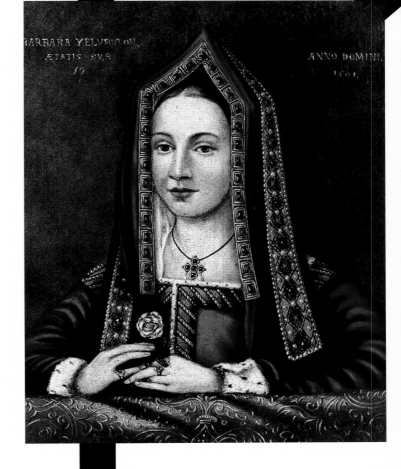

ABOVE: Elizabeth of York was the daughter of Edward IV by Elizabeth Wydeville. She has been described as beautiful, devout, fertile and kind.

LEFT: Tudor roses. When literacy levels were low, visual symbols were important. The Tudor rose combines the white rose of York with the red rose of Lancaster.

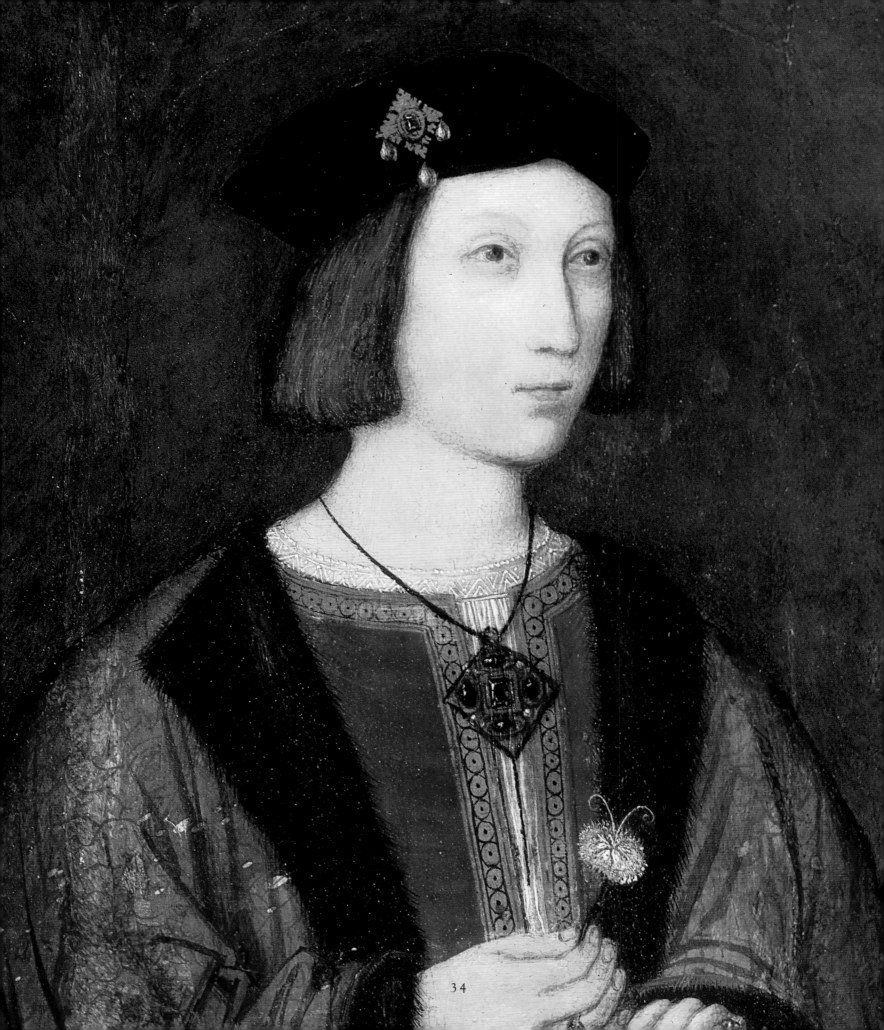

34

Eight months after Henry and Elizabeth married, their first son was born at St Swithun's Priory at Winchester. He was named after Arthur, King of the ancient Britons, to associate the new dynasty with the great historical past. John Skelton, who was appointed court poet to Henry VII in 1488, commented: "The rose both white and red, in one rose now doth grow."

Henry and Elizabeth would have a further six offspring, of whom three survived to adulthood: Margaret (born 1489), Henry (born 1491) and Mary (born 1496). Their fourth child, Elizabeth (born 1492), died at three years old, Edmund (born 1499) at just a year and Katherine in the first month of life.

PRETENDERS AND REBELLIONS

Henry VII claimed the Crown of England in a decisive victory on the battlefield at Bosworth Field in August 1485. Shortly afterward Pope Innocent VIII issued a Papal bull threatening the excommunication of anyone denying Henry VII's marriage or monarchy.

There were challenges over the course of his reign – some stronger than others – but Henry died with the crown resting firmly on his head.

THE LOVELL AND STAFFORD REBELLION

In April 1486, Henry VII's rule was challenged by a rebellion led by Francis, Lord Lovell, and Humphrey and Thomas Stafford, supporters of Richard III who wished to see the Crown returned to the Yorkists. Lovell centred his efforts around Middleham Castle in Yorkshire, one of Richard III's chief seats, while the Stafford brothers attempted to raise troops in Worcestershire. But Henry's intelligence was good and his reactions quick. His informers followed the Staffords to Culham Church in Oxfordshire, where they had sought sanctuary, and the brothers were removed and arrested. Protests were made to Pope Innocent VIII about the legality of breaking sanctuary, but a Papal bull issued in August limited the provisions of sanctuary in cases of treason, exonerating the King's actions.

Lovell escaped to the court of Margaret, Duchess of Burgundy, sister of Edward IV and Richard III; Humphrey was executed, but Thomas, the younger of the Stafford brothers, was spared.

The rebellion was not without danger, having taken place early in Henry's reign before he had time to become firmly established on the throne; but it failed for the principal reason that there was no strong Yorkist pretender to accept the crown had it been won. There was little support for the revolt, nor any foreign involvement in the uprising, which lasted around a month.

OPPOSITE: Henry VII was not brought up with the expectation of kingship. It was not until his early teens that his destiny was changed by a series of deaths. His claim to the throne was reasonable although not indisputable.

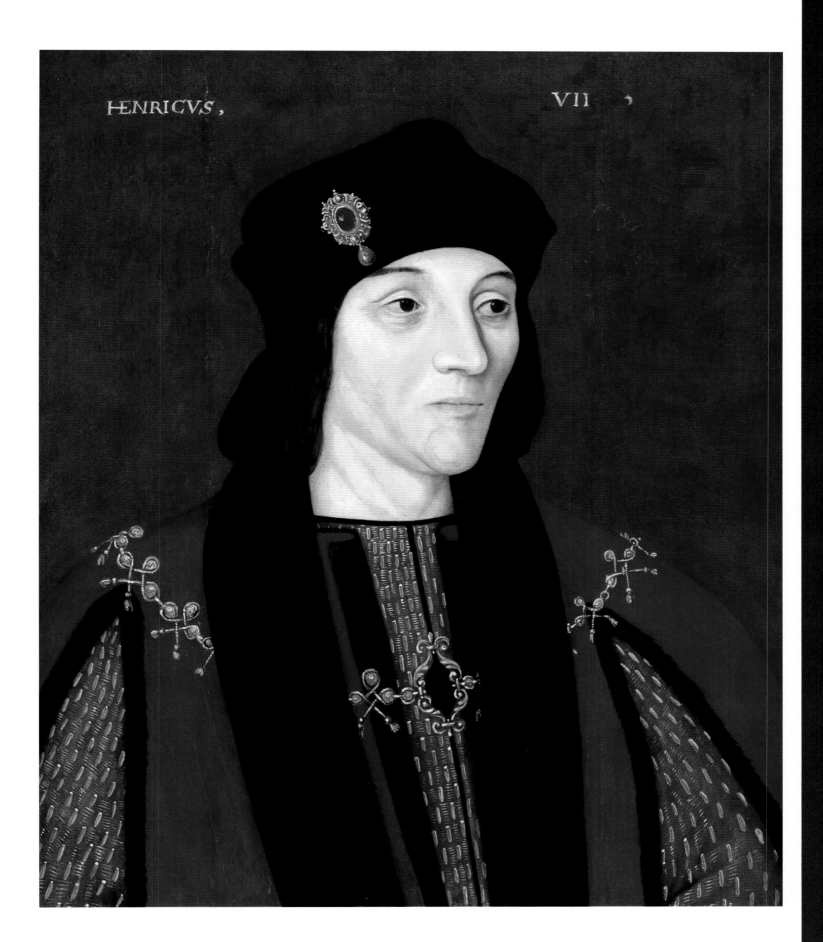

HENRICVS, VII

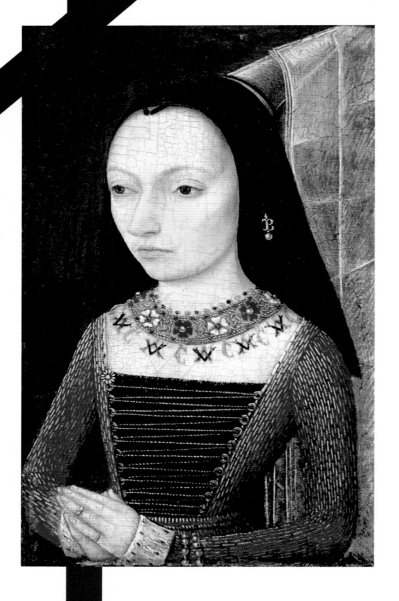

THE PRETENDER LAMBERT SIMNEL

The next challenge to Henry VII's throne came with the appearance of Lambert Simnel in 1486–87. Simnel appears to have been the son of a tradesman living in Oxford.

At about ten years old, he became the pupil of a priest called Richard Simmonds. Simmonds noticed the similarity of Simnel to Richard, Duke of York, the younger of "the Princes in the Tower" and claimed that Simnel was York. However, when it was rumoured that George, Duke of Clarence's son, Edward Plantagenet, Earl of Warwick (who had been imprisoned in the Tower by Henry VII, purely on account of his nearness in blood to the throne), had died, Simmonds alleged instead that Simnel was Warwick. Simnel was taken to Dublin, where he was convincing enough to be crowned King Edward VI. Henry VII paraded the real Earl of Warwick alive and well in London, but the uprising was already gaining momentum.

Richard III's nephew and intended heir, John de la Pole, Earl of Lincoln, was probably the brains behind the rising and may have intended to seize the throne himself. Foreign support came from his aunt, Richard's sister, Margaret, Duchess of Burgundy, who provided two thousand German and Swiss mercenaries.

On 4 June 1487, Lincoln and his army landed at Furness, then in Lancashire, and marched south. Local support was weak because the people were fearful of another civil war.

On 16 June 1487, a battle took place at East Stoke, near Newark, between the rebel Yorkists, led by the Earl of Lincoln and Francis, Lord Lovell, and the King's forces, led by John de Vere, Earl of Oxford. The struggle reportedly lasted about three hours. More than half of Lincoln's eight thousand men were killed compared with possibly a hundred of the well-equipped royalist forces. Lincoln died in the fighting. Richard Simmonds was captured and imprisoned for life, but Henry understood that the eleven-year-old Simnel was no more than a pawn in the plot against him and sent him to work in the royal kitchens. The youth rose from spit turner to falconer and died around 1530.

Delayed through pregnancy and the rebellion, Elizabeth of York's coronation did not take place until 25 November 1487. The ceremony in Westminster Abbey was a particularly splendid one.

LEFT: Margaret of Burgundy has not been described as beautiful but she was tall, slim and fair with a warm smile and wry sense of humour.

OPPOSITE: Lambert Simnel was not punished by Henry VII but put to work in his kitchens.

THE YORKSHIRE REBELLION

The Yorkshire rebellion of 1489 was a protest over a proposed rise in taxes, not a rebellion intent on overthrowing the King. A poor harvest in 1488 led to increasing poverty in the north. Henry VII feared that French control of Brittany would mean a threat to England. He raised taxes to fund an army should the Breton Crisis become a reality, but the people of Yorkshire believed that Brittany should not be their concern and rose in protest.

The Earl of Northumberland took a petition to the King on behalf of the rebels but returned empty-handed. At Cock Lodge in North Yorkshire, he was confronted by Robert Chamber, a yeoman of York, and a group of protesters. A scuffle ensued and Northumberland was assassinated. Chamber was tried and hanged for the crime and Sir John Egremont, an illegitimate member of the Percy family, became the new leader of the dissidents.

A large army led by Thomas Howard, Earl of Surrey, was despatched by the King to suppress the revolt and, at news of its advance, the dissidents dispersed.

The rebellion in Yorkshire had lasted around a month. There was no march south and the threat to the King was minimal.

The rising achieved its aims when collection of the Breton tax was abandoned and the rebels received a full pardon.

THE PRETENDER PERKIN WARBECK

A more serious threat became apparent when Perkin Warbeck first came to notice in 1491 in Cork, Ireland. Just seventeen years old, he was acclaimed first as the Earl of Warwick, but then it was announced that he was Richard, Duke of York, the younger of "the Princes in the Tower". Henry VII believed that Margaret of Burgundy, his mortal enemy, had encouraged him in his claim.

Despite the sensation he had created in Cork, Warbeck failed to win much support in Ireland. In 1492, he went to France, where Charles VIII – ever ready to discountenance Henry VII – warmly acknowledged him as "Richard IV". But, later that year, after the signing of the Treaty of Étaples by Henry VII and Charles VIII, Warbeck was expelled from France and fled to the Netherlands under the protection of Margaret of Burgundy. She coached him in the manners of a Yorkist prince and acknowledged him as her nephew. In 1493, Warbeck was recognized by the Holy Roman Emperor Maximillian I as Richard IV of England. All three foreign rulers had an interest in destabilizing Henry VII.

Warbeck landed in Kent in 1495 but was repelled. He made another failed attempt at an invasion at Waterford in Ireland before he landed in Scotland and was welcomed by James IV, who offered him the hand of his kinswoman, Lady Catherine Gordon, in marriage.

When, in 1497, Henry VII threatened war with Scotland if the pretender remained there, Warbeck left for Cornwall. His aim was to raise support amongst an already agitated Cornish population.

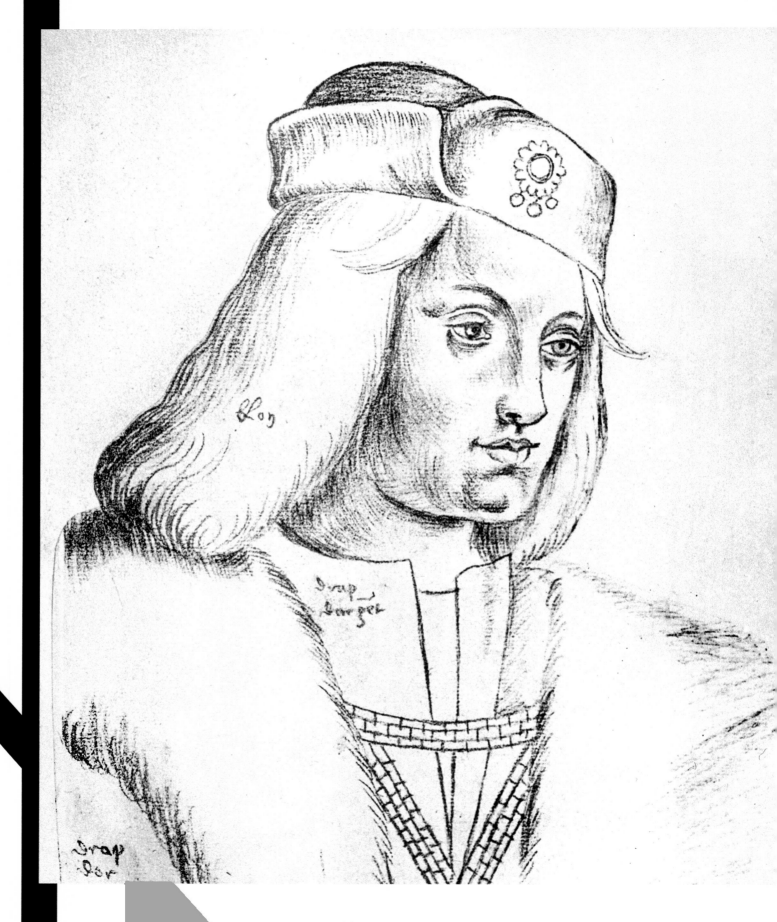

THE CORNISH REBELLION

The Cornish people had refused to contribute taxes toward a war against the Scots. They rose in protest, planning to march to London to present a petition to the King. Lord Audley joined them in Somerset and they marched toward London, setting up camp at Blackheath to the south-east of the city. Giles, Lord Daubeney, was sent to Blackheath by the King to contain the rebels.

The Cornishmen were not trained soldiers and they had no cavalry or artillery with which to face a professional army, but contemporary observers were in no doubt that they fought bravely. More than a thousand men were slain; Lord Audley was taken prisoner and later beheaded on Tower Hill. The rebel leaders, Thomas Flamank, a Cornish lawyer, and Michael Joseph (also known as Michael An Gof, from the Cornish for his occupation of blacksmith), were hanged, drawn and quartered at Tyburn. The King offered a full pardon to the other rebels.

Meanwhile, Warbeck, having heard that the King was raising an army to deal with the rebels, abandoned his dwindling following and took sanctuary in Beaulieu Abbey, Hampshire.

Realising his cause was hopeless, he surrendered to the King. After making a public confession that he was an imposter, he was allowed to live under guard as a courtier for almost a year. Henry VII wanted to demonstrate that he did not consider Warbeck a threat. However, when Warbeck escaped, he had him imprisoned in a dark cell in the Tower.

Warbeck had posed a serious threat to Henry because of the foreign support he had gained, but few major nobles in England supported his claim. Henry VII's intelligence service was once again rapid and efficient: Warbeck was found to be from Tournai; he had been working for a Breton silk merchant named Pregent Meno, who sold silk in Cork, Ireland. The young man modelled expensive and elegant clothes and displayed noble manners, but it was the support of several European leaders seeking revenge against Henry VII that helped promote the deception.

LEFT: Perkin Warbeck was leniently treated by the King but after he was implicated in a plot to overthrow him, Henry ordered that Warbeck be drawn on a hurdle from the Tower to Tyburn, where he was hanged on 23 November 1499.

TAMING
THE NOBILITY

Given his tenuous claim to the throne, Henry VII needed a positive relationship with the nobility in order to remain safely on it. They represented his interests around the country and were required to keep control on his behalf in local government. They were also, however, potential rebels with the resources to fight against him. Throughout his reign, Henry distrusted them.

Referring to Henry's methods of taming the nobility, the scholar-diplomat Polydore Vergil claimed that the King wished to keep all Englishmen obedient through fear.

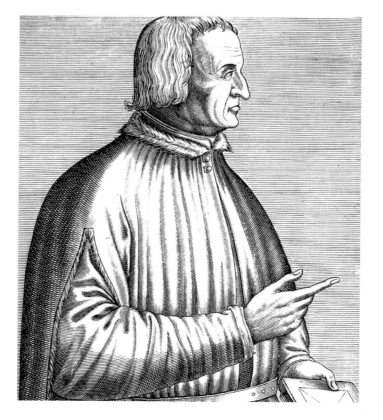

LEFT: Polydore Vergil was born near Urbino, Italy, but spent most of his life in England. He first travelled to England in 1502 and was welcomed by Henry VII. He began work on *Anglica Historia*, a history of England, as early as 1505 and was naturalized in 1510.

OPPOSITE ABOVE: Thomas Howard, 2nd Duke of Norfolk, was a nobleman, politician and statesman who served four monarchs.

OPPOSITE BELOW: George Bergavenny by Hans Holbein the Younger. Bergavenny was a nobleman and Lord Warden of the Cinque Ports.

ACTS OF ATTAINDER

Those nobles who had shown loyalty to him at Bosworth were rewarded with lands and a title, whereas those who had fought against him had their estates and titles declared forfeit by Act of Attainder, a sentence passed by Parliament, without trial, for treason or disobedience to the Crown. The highest penalty for those attainted was death, but the confiscation of property and lands and the revoking of titles were more commonly imposed.

Henry took great advantage of attainders to limit the power of the nobles and at the same time to increase the value of Crown land. In the Parliament of 1504, fifty-one attainders were issued compared with twenty-seven by Edward IV over twenty years. An Act of Attainder could impoverish and destroy noble families. Conversely, it could be reversed by the King as a reward for loyalty and good behaviour. During Henry's reign, 138 acts of attainder were passed and 46 repealed.

Henry had dated his reign from the day before Bosworth, making traitors of those who had fought for Richard III. Thomas Howard, Duke of Norfolk, was one who lost his title and estates and was imprisoned in the Tower of London, but Henry released him and restored one of his lesser titles, the earldom of Surrey.

As a reward for not supporting the pretender Lambert Simnel, Howard was returned a proportion of his lands – but not all of them. He was thus encouraged to hope that, through loyalty and gratitude to the King, the remainder of his estate might at some time be restored.

ILLEGAL RETAINING

Following the Battle of Bosworth, many nobles still possessed private armies of liveried retainers who received "good lordship" in the form of favour or payment. Members of the nobility traditionally employed a retinue of servants to support them in their duty of asserting local authority on the King's behalf.

However, in 1504, Henry passed a law declaring that only the King could keep retainers. He was aware that, if the number of retainers was permitted to increase unchecked, a force more powerful than the Crown would be available to be used against him. A limit was therefore set on the number of retainers a noble could employ and fines and punishments were imposed on those who exceeded the proposed numbers. George Neville, Lord Bergavenny, was fined the crippling sum of £70,000.

BONDS AND RECOGNISANCES

The King could place a bond on anyone he saw fit, without the right of appeal. A bond was a written agreement with the King that the person concerned would perform a specific task. If the conditions of the bond were not satisfied, then a heavy fine was enforced. This had been legal before Henry's reign, but it had never been applied with such zeal.

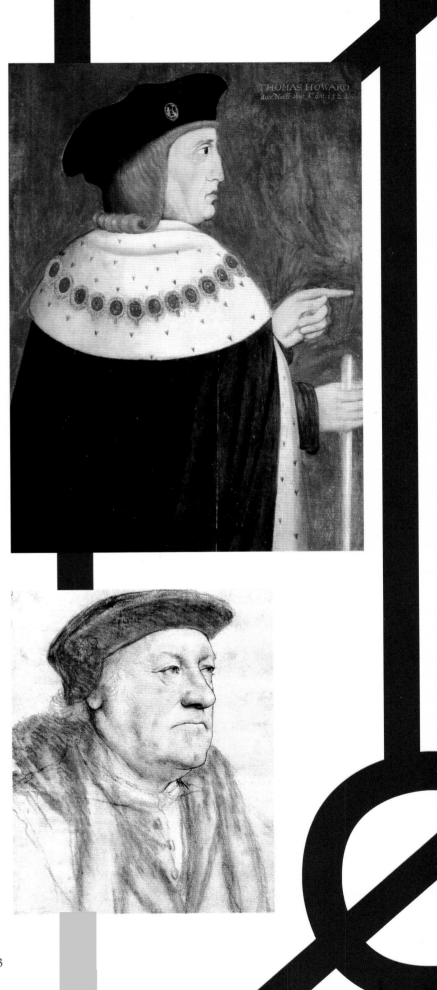

Henry VII issued financial bonds on forty-six peers, placing more than seventy per cent of his nobility under obligation, and in debt, to the Crown. A recognisance was a written obligation to pay a debt or rectify a misdemeanour. Should further misdemeanours be committed, a considerable penalty was to be paid to the King.

PATRONAGE

Henry rigorously enforced all these measures to maintain the nobility under his direct control and to ensure their loyalty. He was sparing in his creation of peers. Creating new titles entailed increasing the nobility that he was attempting to limit. It also involved the bestowing of royal land in the form of estates, with the accompanying loss of income to the Crown. At the start of Henry's reign in 1485 there were fifty-five peers, but by 1509 there were forty-two. Henry created only one earl and five barons. He rewarded nobles instead by dubbing them Knights of the Garter. It was an honour, but no hereditary title was involved, nor any Crown land.

MARRIAGE AND THE NOBILITY

A highly effective intelligence system was employed by Henry to monitor the nobility. It ensured that marriage alliances amongst the noble families were not permitted in situations where a united power base might rival that of the Crown.

POSITIONS OF TRUST

Henry appointed men to office on merit. He reduced the power of the nobles by advancing men of lesser status to significant offices. These lower-born "new men" were more dependent on royal favour than the nobility, and more inclined to be loyal to the King through gratitude.

By the time Henry VII died, he had succeeded in reducing the power of the nobility. Aristocratic families were considerably less wealthy – and less threatening to the King than they had been at the start of his reign.

RIGHT: In 1501, Henry VII restored the palace of Shene. It was named Richmond Palace for the earldom Henry had borne before becoming king.

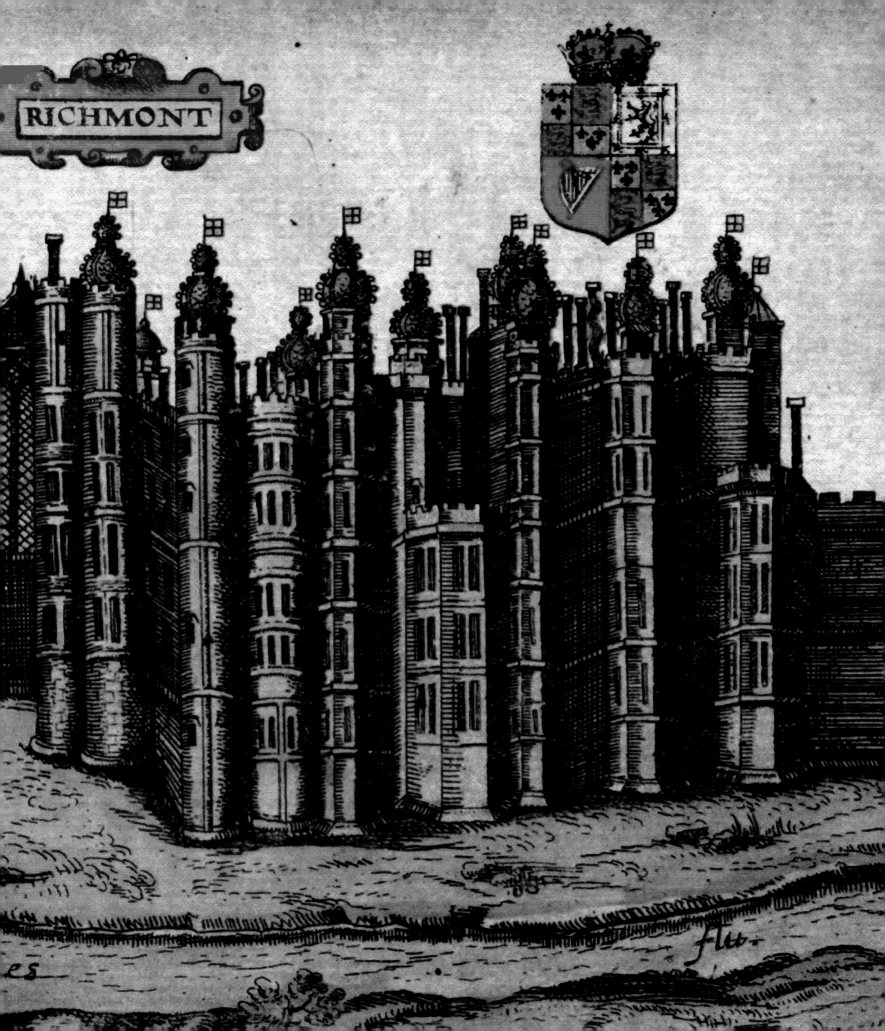

RICHMONT

FILLING THE ROYAL COFFERS

Henry VII had had little training in financial management. He did not inherit wealth but he required it to subdue rebellions, deal with pretenders, maintain the support of the nobles and purchase their loyalty. He was not innovative in devising new sources of income, but over the course of his reign, he proved extremely capable in exploiting the system that was already in place.

In 1485, Acts of Attainder were brought against all the Yorkist supporters of Richard III, causing their lands and possessions to be forfeited to the King. The following year, Henry's Parliament passed the Act of Resumption, which laid down that all offices, revenues and lands that had been given away by the Crown since 1455 were to be returned.

This income from royal domain further increased in 1495, when Henry inherited the estate of his uncle, Jasper Tudor, Duke of Bedford, and again in 1502, when his son Arthur died and he received an additional £6,000 yearly from the prince's assets. By the time of Henry's death in 1509, the royal estates were more extensive than they had ever been.

Henry gleaned funds from his nobility with a system called "wardships" and "reliefs". If a wealthy noble died leaving a son and heir who had not yet reached the age of majority, the King took control of the land and oversaw it. When the heir came of age, the property would then only be transferred on payment of a large sum of money known as a "livery".

Trade and industry also provided a profitable source of income for the Crown finances, through an import and export tax known as tonnage and poundage. This tax was imposed on goods coming in or out of the country. English woollen cloth was the best in Europe and it was by far the largest export. Wool, cloth, wine and leather were the most lucrative, although not even the King was able to recoup the income lost through smuggling.

As head of the legal system, the King also received court penalties and fines. A standard taxation during the reign of Henry VII was the "fifteenth and tenth", based on an amount of one tenth of the value of moveable goods of lay persons for cities and one fifteenth for rural inhabitants. It had been calculated in the 1330s and had hardly increased; by Henry VII's reign, it was a relatively small sum. Problems arose when the fifteenth and tenth needed to be supplemented by a subsidy, to which Henry's subjects objected.

OPPOSITE: In 1504, the Spanish visitor da Ayala commented that Henry VII was wise and attentive, with nothing escaping his attention.

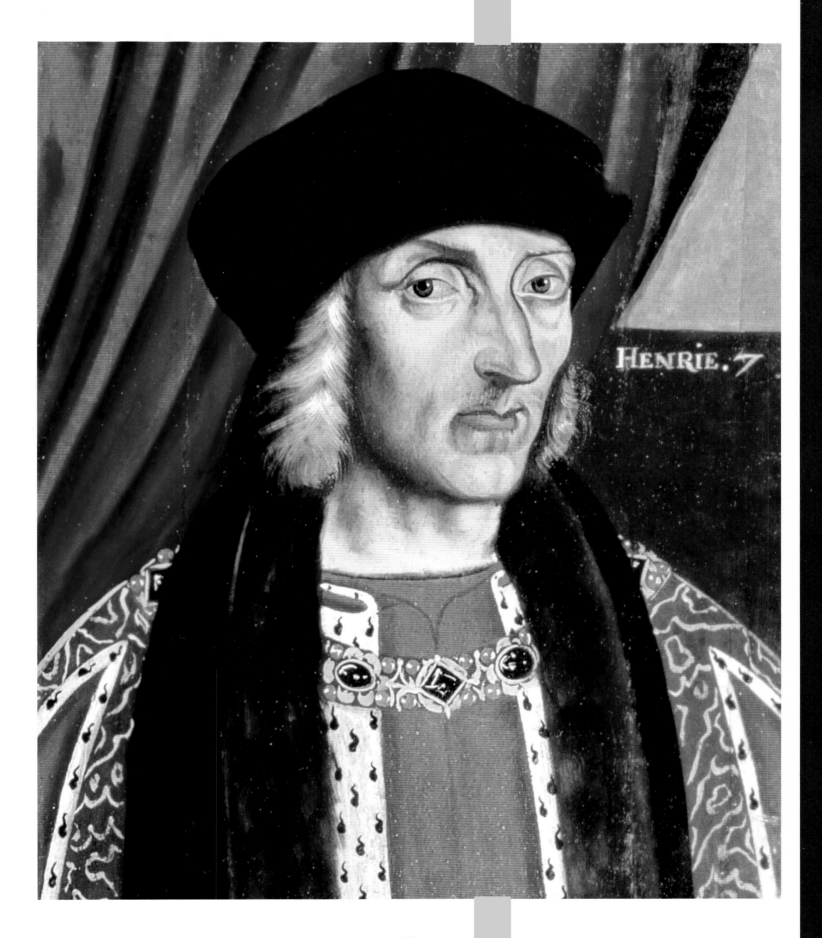

HENRIE. 7

ABOVE: Charles VIII of France
agreed by the Treaty of Étaples
of 1492 to pay Henry VII
heavy compensation for the
abandonment of English interest
in Brittany.

RIGHT: During the reign of Henry
VII, the wool trade was especially
lucrative. Fine woollen cloth had
a good market both in England
and on the Continent.

The greatest expense to the King during peace time was the maintenance of his family and his court. It was expected that this would be settled from feudal dues, customs duties and Crown lands. However, in extraordinary situations such as war, uprisings or rebellions, extra income needed to be found, usually in the form of direct taxes. A grant would be issued by Parliament to tax the people, and the nobility charged with its collection, a move that proved unpopular with both parties.

In August 1508 a new post was created to ensure that no dues were overlooked. Edward Belknap was appointed Surveyor of the King's Prerogative. The role entailed searching for areas in which the royal right might have been infringed and, if that was the case, imposing fees or fines. There was much complaining and grumbling from the people because many of the sums gathered were legitimately due but had been left uncollected for years.

Under the terms of the Treaty of Étaples of 1492, Henry received an initial indemnity of £159,000 from Charles VIII of France, in addition to a pension of around 50,000 crowns yearly. In return, he agreed to acknowledge French rule in the hitherto independent duchy of Brittany, and Charles VIII consented to expel the pretender Perkin Warbeck.

In times of emergency Henry could ask his wealthier nobles for loans. Such loans were usually small and were repaid quickly; the King knew he was in no position to manage a resentful nobility. But he did demand benevolences, which had been introduced by Edward IV in 1475 to fund a war with France. They differed from loans because they were considered a patriotic donation to the King and they were not repaid.

Henry VII was never to be in the monetary position of Louis XII of France, who until 1509 was able to finance his wars without increasing taxation, but he left the kingdom financially healthy, with a flourishing economy to pass on to his heir. The Tudor dynasty was firmly established, and Henry VIII was able to succeed to the throne without dispute

DEATH AND LEGACY

The death of Henry's fifteen-year-old son and heir, Arthur, in 1502, was devastating. On hearing the news, Henry immediately sent for Elizabeth to break it to her personally and grieve together. Elizabeth comforted Henry, reminding him they were both young enough to have more children.

She was soon with child again and gave birth to a daughter named Katherine on 2 February 1503 in the Tower of London. Elizabeth died nine days afterwards, on her thirty-seventh birthday, probably as a result of iron-deficiency anaemia. She was followed to the grave by the infant Katherine, who died on 18 February 1503. Mother and child were buried in Westminster Abbey.

Following his wife's death, Henry is said to have retired to a room alone and given instructions that he was not to be disturbed. He ordered a lavish funeral for Elizabeth, with hundreds of Masses said for her soul. Her funeral effigy, dressed in royal robes, was carried on a hearse through the City of London, followed by eight ladies of honour on white horses.

The Tower of London was abandoned as a royal residence and Henry did not marry again. Each year, on the anniversary of Elizabeth's death, a Requiem Mass was sung and candles were burnt in her memory. The inscription on her tomb describes her as "his sweet wife ... very pretty, chaste and fruitful". It does seem that the couple had a happy marriage by the standards of the time.

In 1509 Henry became ill with what was probably tuberculosis, gout and asthma. His decline was rapid and, on 21 April, he died, aged fifty-two, at Richmond Palace, Surrey. He was buried with Elizabeth in Westminster Abbey in the magnificent tomb in the Henry VII Chapel, which he himself had founded. By the time of his death, he had restored England to a firm and prestigious footing in Europe. The marriage alliances negotiated for his children were a triumph of European diplomacy. Their eldest son Arthur had married Katherine, the daughter of Ferdinand of Aragon and Isabella of Castile of Spain. Their daughter Mary became Queen of France on her marriage to Louis XII, and her younger sister Margaret was Queen of Scots following her wedding to James IV of Scotland.

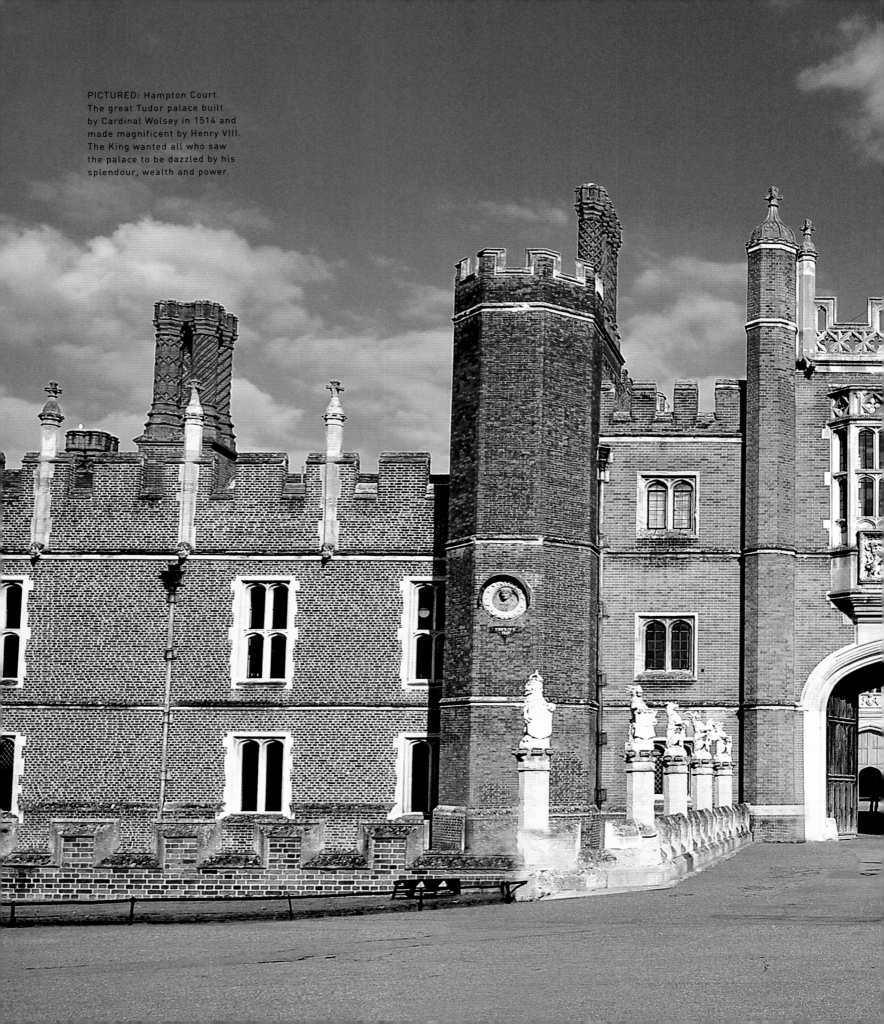

PICTURED: Hampton Court. The great Tudor palace built by Cardinal Wolsey in 1514 and made magnificent by Henry VIII. The King wanted all who saw the palace to be dazzled by his splendour, wealth and power.

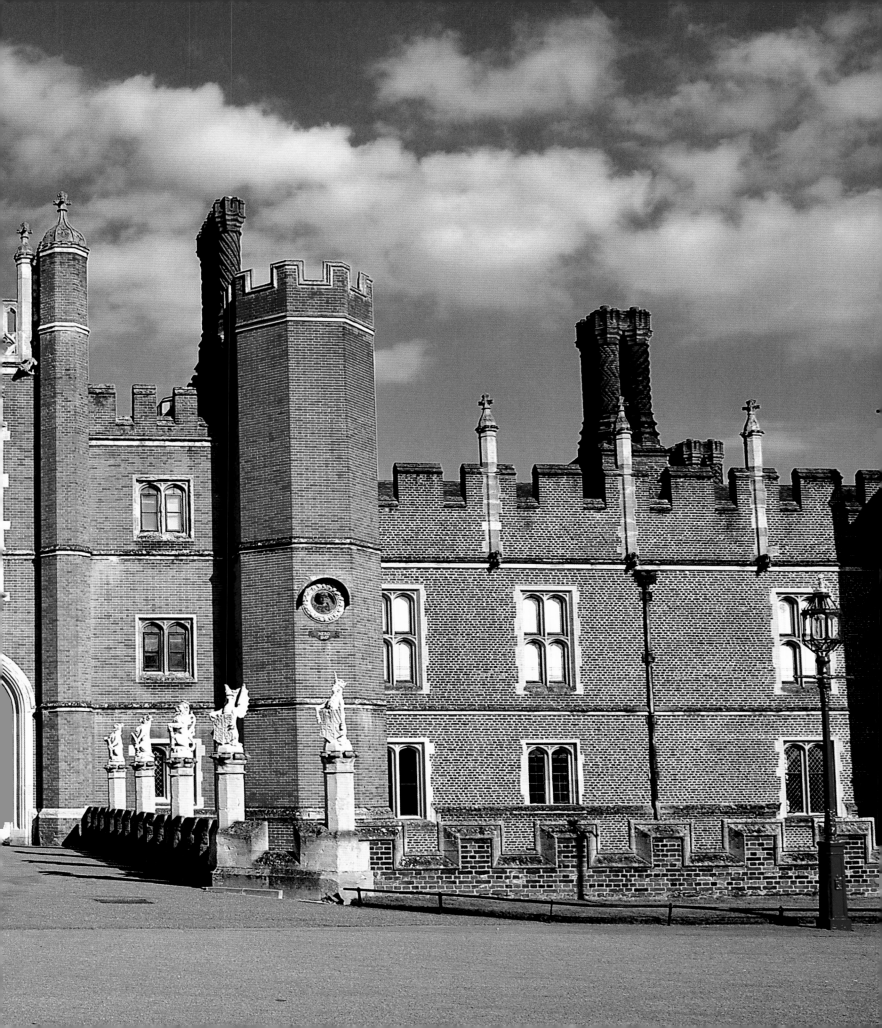

HENRY VIII

DISSOLUTION, MAGNIFICENCE
AND THE EARLY TUDOR COURT

Henry VIII is best known for his six marriages, his
break from the Church of Rome and the Dissolution of
the Monasteries. He expanded the role of Parliament,
achieved the unification of Ireland, brought Wales into
union with England and could arguably be considered
the founder of a modern England.

RENAISSANCE PRINCE

H enry was born on 28 June 1491 at Greenwich Palace, the second son of Henry VII and Elizabeth of York. His early years were spent at Eltham Palace, where he was tutored in both the rationalism of the new Humanist learning and the romance of medieval chivalry.

When his elder brother Arthur died in 1502, Henry became heir to the English throne and resided at court with his father, where he was closely monitored and protected. He was allowed outside only with bodyguards and, even within the palace, his movements were restricted.

"Heaven smiles, earth rejoices; all is milk and honey and nectar," wrote William Blount, Lord Mountjoy, to the Dutch humanist Desiderius Erasmus upon Henry VIII's accession.

On 11 June 1509 at Greenwich Palace, Henry married Katherine of Aragon, his brother's widow. She was twenty-three and he was almost eighteen. Educated, cultured and athletic, Henry was hailed as the embodiment of a Renaissance prince.

The Renaissance was a period of rediscovery in the field of the arts, architecture, literature, music, science, philosophy and religion. To be a Renaissance man or woman meant to be educated and enquiring, with a thirst for knowledge in all fields. To be a Renaissance prince required a noble and splendid court that patronised artists and musicians, founded centres of education and undertook acts of charity. Such a prince would compete in physical challenges; he would understand the principles of chivalry and courtly love, while displaying strong ambitions for self-development, both corporeal and intellectual.

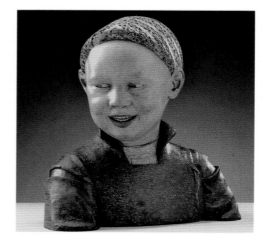

LEFT: This clay bust is attributed to Mazzoni of Modena. It has been part of the Royal Collection since its creation in c.1498. It has been variously described as a laughing girl, a German dwarf and a portrait of Henry VIII as a seven-year-old boy. The identification remains conjectural.

The English Renaissance did not arrive directly from Italy but chiefly through France. The influence of Henry VIII's contemporary and great rival, François I, was considerable and exchanges between the two kings were often on a personal level. For example, on hearing that François had rather thin legs, the Venetian ambassador related how Henry opened his doublet, placed his hand on his thigh and declared: "Look here! I have a good calf to my leg."

Henry VIII was a Renaissance prince of the highest calibre. He wrote poetry and music, enjoyed dancing and performing in court masques, and he spoke fluently in several languages, including Latin and French.

In the field of music, he was proficient on the lute, the organ, the flute and the harp. The British Library conserves a songbook dating from c.1518, which includes twenty songs and thirteen instrumental pieces ascribed to "The King H Viii". One of the songs, "Pastyme in Good Companye", speaks of the princely pleasures of hunting, dancing and singing. By the close of his reign, Henry VIII was the patron of more than fifty musicians.

In matters of science, Henry was able to discuss astronomy and mathematics with the leading minds of the age. The astronomical clock at Hampton Court Palace, installed in 1540, bears witness to the King's interest. Designed by the mathematician Nicholas Kratzer, it displays not only the hour but the phases of the moon, the astronomical signs and the time of high water at London Bridge.

The young King was accustomed to philosophical and religious debate. As a child he had dined with Desiderius Erasmus, and he was later a friend of the English humanist and scholar Thomas More.

Poetry and literature flourished in the early Tudor court. Sir Thomas Wyatt is credited with introducing the sonnet into the English language and Henry Howard, Earl of Surrey, was one of the founders of Renaissance poetry in England. Henry VIII wrote both poetry and verse, including "Alas! What shall I do for love?" in about 1518.

An active and proficient participant in wrestling matches and jousting performances, Henry's gallant image on horseback was compared by contemporaries to St George, the patron saint of England. He was declared "a beautiful sight". The affinity of the joust to actual battle ensured that Henry bonded through sport with those whose loyalty he would demand in war. Henry's patronage of the arts led to an enrichment of culture in England. His desire to be remembered as a Renaissance prince resulted in the acquisition of tapestries, paintings and manuscripts that still form part of the Royal Collection of HM Queen Elizabeth II today.

In 1517, the German theologian Martin Luther produced his *Ninety-five Theses*, an attack on the sale of indulgences by the Catholic Church. In 1521, Henry VIII published a vicious counter-attack to Luther's work, titled *Assertio Septem Sacramentorum* (Defence of the Seven Sacraments). In recognition of this support for the Church, Pope Leo X awarded Henry the title "Defender of the Faith".

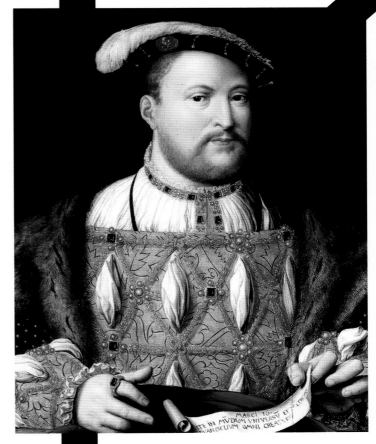

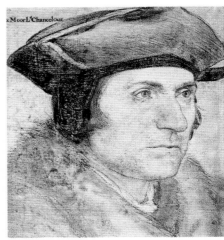

TOP: Henry VIII, after Joos van Cleve. The inscription on the scroll translates as "Go ye into all the world and preach the gospel to every creature". (Mark 16:15)

ABOVE: Thomas More was a councillor to Henry VIII, an author, a statesman and a Renaissance Humanist. In 1516 he published his book *Utopia*, on the organization of an ideal nation.

WAR AND GLORY

The young Henry VIII was vigorous and athletic, he was skilled at hunting, jousting and competitive sport, and in the early days of his reign, his reliance on Cardinal Wolsey allowed him to put pleasure before state affairs.

For the eighteen-year-old King, however, the ultimate challenge of his physical capabilities would have been warfare.

In 1511, Pope Julius II reconstituted a Holy League consisting of Henry VIII, the Emperor Maximilian and Ferdinand of Aragon. The Papal States were under subjection from France and the Pope promised Henry VIII recognition if he defeated Louis XII.

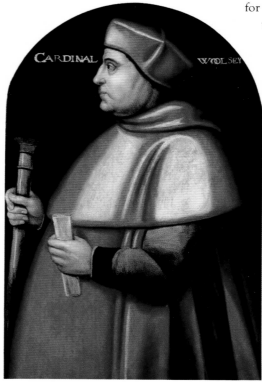

Henry VIII was twenty-one years old and prepared for conflict; he signed a pledge of mutual aid with Ferdinand of Aragon. In April 1512, Thomas, Marquess of Dorset left England with twelve thousand troops to fight with the Spanish against the French at San Sebastián on the French border. The Spanish, however, were unprepared for the English arrival and Henry's army was forced to wait. Drunkenness, disease, lack of discipline and dysentery from the insanitary conditions left the English force incapacitated. They returned home. The campaign was unsuccessful and Henry's desire to fight was not assuaged, since throughout the campaign he had remained on English soil.

The following year, in June 1513, Henry led more than ten thousand men from London to Dover, where they crossed to France. In alliance with the Emperor Maximillian the English army besieged the French town of

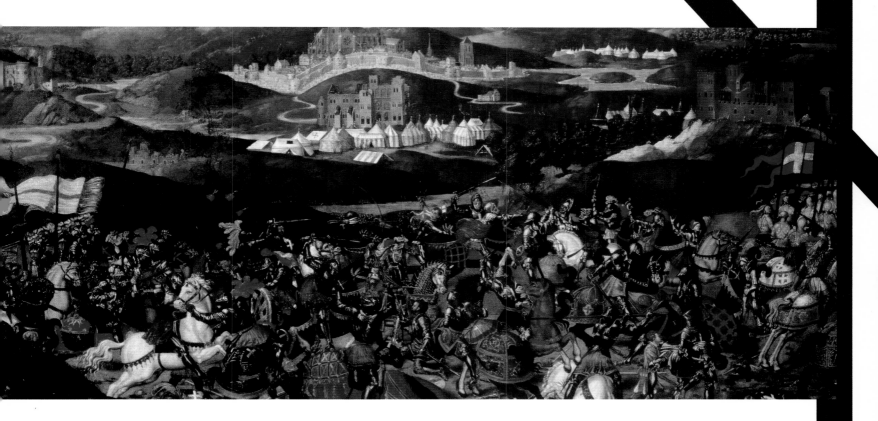

Thérouanne, near Calais, hoping to starve it into submission. Endeavouring to break the siege, a French force of about eight thousand armed soldiers arrived with supplies, but the English acted swiftly and, finding themselves vastly outnumbered, the French light cavalry rapidly retreated.

The skirmish was dubbed "the Battle of the Spurs", since the French were said to have used their spurs more than their swords. Within a few weeks of the battle, the town of Thérouanne had fallen to the English.

Henry had been present at the battle but not in the heat of the fighting. The Tudors were a dynasty in its infancy and Henry had no heir. His council therefore considered it essential that Henry was kept well away from danger.

It was during this period of 1512 to 1514 that Henry VIII recognized the administrative and diplomatic talents of Thomas Wolsey. In 1514 Wolsey was created Archbishop of York, the following year Pope Leo X made him a cardinal, and Henry VIII appointed him Lord Chancellor of England. From 1515 to 1529 Wolsey's authority was undisputed.

OPPOSITE: Cardinal Thomas Wolsey was born in Ipswich c.1473. He attended Magdalen College, Oxford, and in 1498 he was ordained a priest. Henry VII appointed him Royal Chaplain, and, in 1509, when Henry VIII became King, Wolsey's meteoric rise to fame began.

ABOVE: Battle of the Spurs, circa 1513, unknown artist. Conflicts like this were bloody and rarely glorious.

1513: THE BATTLE OF FLODDEN

With Henry VIII away fighting the French, James IV of Scotland, an ally of France, invaded England. The largest Scottish army ever to set foot on English soil crossed the River Tweed just a month after the Battle of the Spurs. Thirty-five thousand Scottish troops set about capturing castles along the coast of Northumberland.

Henry's Queen, Katherine of Aragon, was a capable regent and, on her husband's behalf, she despatched Thomas Howard, Earl of Surrey, with thirty thousand English soldiers to combat the invasion.

Thomas Howard was a seventy-year-old veteran of the Wars of the Roses and a proficient commander. The English guns were better placed and more lethal than those of the Scots. Troops approached one another in close combat and pikes, swords, axes and bill hooks caused vicious injuries to both sides. The Scots fought valiantly but the English won the day.

Ten thousand Scottish lives were lost, including that of King James IV, the last monarch to die in battle on British soil.

Sixteenth-century wars were bloody and rarely glorious. Given the weapons available to them, soldiers did not generally experience a swift death. They were maimed and would have fallen, bleeding and moaning from their horrific injuries as the battle raged around them.

By his early twenties Henry had experienced military success, but had received little in return. War was expensive; it consumed the personal fortune Henry had inherited from his father and it drove up taxes. England's coffers were now almost empty.

COURTLY MAGNIFICENCE

Henry was an enthusiastic and lavish patron of the arts, who established the most magnificent court ever seen in England. No English monarch owned as many houses or spent so lavishly on a lifestyle calculated to enhance his own prestige. Henry used his wealth to create an aura of magnificence and splendour in an era when magnificence equalled power.

In matters of fashion, Henry shone. His clothes were of gold or silver thread and sewn with jewels, his doublets slashed to reveal the fine shirts underneath. The heavily padded shoulders of his gowns increased his physical presence and provided proof of his authority.

Henry was once described as "the best dressed sovereign in the world".

He was taller than many of his courtiers, well-built and flame-haired. He cut a dashing figure on the sports field and on the royal tennis court, where a contemporary account relates how his skin glowed through the muslin of his shirt.

One of the most magnificent events in the history of Tudor diplomacy took place in June 1520, when Henry VIII met François I in northern France. The affair was a glittering occasion of sport and lavish entertainment that became known as "The Field of Cloth of Gold".

LEFT: Henry VIII by Hans Holbein the Younger. Holbein presents Henry as a powerful monarch, his bulk filling the picture frame. The King looks down at the viewer and in his hand holds a glove, portraying him as a man of action.

Henry was accompanied to France by more than five thousand nobles, courtiers and servants. An English camp was built at Guînes and the French settled at Ardres.

The dress code was extravagant and keeping up appearances was essential. Many of the accompanying men and women literally carried their estates on their backs. A description of the Field of Cloth of Gold by Edward Hall, a chronicler of the time, mentions "cloth of gold, cloth of silver, satins embroidered and crimson satins", before concluding "surely among the Englishmen lacked no riches, nor beautiful apparel or array".

Cardinal Wolsey managed the event as a celebration of peace between the two countries, but only two years later war resumed once again. As Erasmus commented: "Kings and princes will never agree."

Henry spent lavishly on his royal palaces. With its original five-storey gatehouse, Hampton Court would have towered over the humble dwellings surrounding it, leaving no one in doubt as to the wealth and power of this Tudor king. The exterior architecture of the building remained essentially Burgundian, but Henry filled the interior with Renaissance glory.

The most valuable and esteemed form of art within the early Tudor court was tapestry. Woven from wool and silk and embellished with gold and silver thread, they far outshone painting as an art form. Richer nobility might own fifty tapestries, the richest might own a hundred and Thomas Wolsey had owned six hundred. In 1547, Henry possessed more than two thousand four hundred tapestries; five hundred and twenty at Hampton Court alone.

"The Story of Abraham" tapestries were woven in Brussels and received by the Royal Wardrobe between 1543 and 1544. By this date, Henry was head of the Church of England and possibly saw himself, like Abraham, as a prophet of his people, also comparing his son Edward to Abraham's son Isaac.

At his death, Henry possessed more than fifty great houses including Whitehall Palace, Greenwich, Hampton Court, and Richmond. Edward Hall described the King as "the moste goodliest Prince that ever reigned over the Realme of Englande … it was marveilous to beholde".

BELOW: The Abraham tapestries are rich in gold and silver thread that would have made them gleam in the candlelight of the day. The colours were extremely bright and perhaps even too garish for today's tastes.

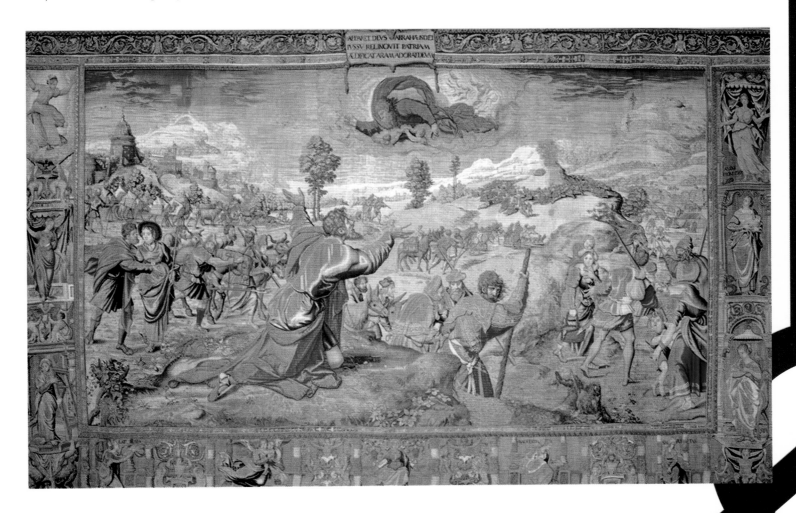

THE KING'S "GREAT MATTER"

Henry VIII's desire for an annulment of his marriage to Queen Katherine of Aragon became known as the King's "Great Matter".

By 1525, Katherine of Aragon was past childbearing age. She had failed to bear the son Henry needed to secure his dynasty. The King had lost interest in his ageing queen and was already pursuing Anne Boleyn, a maid-of-honour in Katherine's service.

Henry became convinced that his union with Katherine of Aragon contravened Divine Law. He quoted Leviticus 20:21, which forbids a man to marry his brother's widow. He applied to the Pope for an annulment in 1527 and the following year, Pope Clement VII granted Henry VIII a Papal commission to hear his case. Clement was in a politically sensitive position. The mercenary armies of Katherine's nephew Charles V had sacked Rome in 1527. Charles had effectively placed the Pope under arrest and applied intense pressure on him to resist the annulment of his aunt's marriage.

In October 1528, Cardinal Lorenzo Campeggio arrived in England, as co-legate with Cardinal

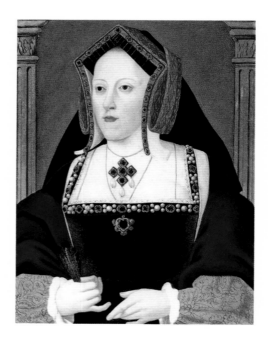 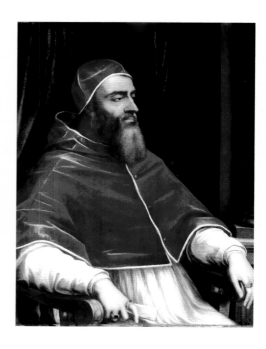

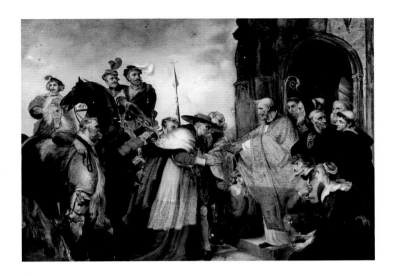

Wolsey, to hear the King's case. Campeggio was unsuccessful in his attempts to bring about a reconciliation between the King and Queen, as Clement had ordered.

In 1529, Katherine appeared at the Legatine Court in Blackfriars to proclaim her innocence to Henry's charges. She knelt to respond to his accusations and although the King tried twice to lift her up, she refused. When she finished her plea, she left the court and refused to return. After almost a year in England the Cardinal returned home to Bologna, leaving Henry VIII still married to Katherine of Aragon.

Wolsey did his best to obtain an annulment, but lost his position as Chancellor and was banished to York. He was arrested for treason and, had he not died at Leicester Abbey in 1530, he would almost certainly have been executed. On his death bed, Wolsey was reputed to have said, "If I had served my God as diligently as I have served my King, He would not have given me over in my grey hairs."

The continuing task of obtaining the annulment fell to Wolsey's successor as Chancellor, Sir Thomas More, a devout Catholic whose conscience would not allow him to sanction an annulment of the royal marriage.

By 1531, Henry had separated from Queen Katherine for good. Two years later, in January 1533, he secretly married Anne Boleyn, who was pregnant with their child. They married without Papal annulment of the King's first marriage and, on learning of this, Pope Clement VII drew up a bull of excommunication, although this was not promulgated until 1539.

The King appointed the reformist Thomas Cranmer as Archbishop of Canterbury, who then assembled a court and declared Anne to be the true queen. On 7 September 1533, at Greenwich Palace, Anne Boleyn gave birth to a healthy daughter named Elizabeth.

In 1534, the Pope declared Katherine's marriage valid. The Act of Supremacy of 1534 recognized Henry VIII as "Supreme Head of the Church of England". Everyone of note was required to swear a new Oath of Succession, recognizing Henry's marriage to Anne Boleyn and their children as legitimate heirs to the throne. Sir Thomas More refused to swear and was executed for standing by his principles.

The iconography of the new monarchy was supplied by the artist Hans Holbein. He was one of the most supremely talented painters in Europe and by 1535, Henry had appointed him to the position of King's Painter. In Holbein, the King found an artist capable of creating an image of monarchy that far surpassed those that had gone before in England.

Holbein transformed Henry's image into the epitome of a mighty and ruthless king. Henry VIII awarded Holbein the prestigious commission of painting a mural on the wall of the Privy Chamber at Whitehall Palace. Henry is painted low on the wall, the perspective cleverly making him appear much closer to the approaching viewer. The King's intimidating magnificence did not go unnoticed. In the early seventeenth century, the artist Karel van Mander noted how Henry VIII "stood there, majestic in his splendour, [he] was so lifelike that the visitor felt abashed, annihilated in his presence".

OPPOSITE LEFT: Pope Clement VII was born Giulio di Giuliano de' Medici in Florence, Italy, and ruled as head of the Catholic Church from 1523 to his death in 1534.

OPPOSITE FAR LEFT: Katherine of Aragon, depicted c.1530. Katherine always refused to accept Henry VIII's annulment of their marriage.

ABOVE LEFT: Wolsey died at Leicester Abbey on 29 November 1530. His remains were interred within the Abbey but the site of his burial is unknown.

ABOVE RIGHT: Henry VIII as Supreme Head of the Church of England from Foxe's Book of Mayrtrs, first published in English by John Day in 1563.

DISSOLUTION

Henry VIII had inherited a financially stable realm, but, after twenty years, much of this wealth had been exhausted. The King required a new source of finance to fund his magnificent lifestyle and support his wars with Scotland and France.

Henry considered that the income the Pope had previously received as Papal tithes from the monasteries of England and Wales should now flow directly to the Crown.

There were more than eight hundred religious houses in England and Wales, which owned more than a quarter of the land. In 1535, the King ordered his Principal Secretary, Thomas Cromwell, to produce a report – the *Valor Ecclesiasticus* (church valuation) – to assess the wealth of the monasteries, abbeys, nunneries and friaries, where more than ten thousand monks, nuns and friars were living.

The investigation was carried out by commissioners who were mostly local gentry, magistrates, sheriffs or mayors. They were not trained for the task and, for the most part,

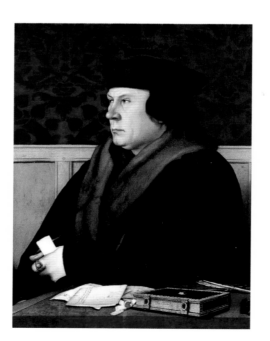

appear not to have been paid. Many of their findings still exist in the National Archives at Kew. Their concern was for the monetary value of the properties, but with it came evidence of scandal and corruption. It was claimed that monks and nuns lived in excessive luxury. It declared that monasteries had grown wealthy by using fraudulent relics to encourage visiting pilgrims, or by leasing false tokens said to have healing powers.

In 1528, the Protestant reformer Simon Fish had produced a pamphlet titled, "A Supplication for the Beggars". It claimed that monks were "ravenous wolves" who had "debauched one hundred thousand women". It called the monks "the great scab" who prevented the Bible from being published in English.

The damning reports contained in the *Valor Ecclesiasticus* led in 1536 to the first Act of Suppression, in which smaller monasteries, with an income of less than two hundred pounds a year, were closed and their possessions taken by the Crown. The following year, Cromwell launched the dissolution of the remaining religious houses and, by 1540, all the monasteries had been closed. The last to be dissolved was Waltham Abbey in March 1540.

Henry VIII gleaned the wealth of the monasteries and used it to increase the finances of the Crown. He suppressed opposition by allowing prominent families to purchase monastic lands in return for their political support. It was these families who most significantly profited from the Dissolution. As the monastic buildings crumbled through want of maintenance, the landscape of England and Wales was changed forever.

Monks and nuns were generally awarded reasonable pensions according to their status, although women received a smaller amount than their male counterparts. Many found positions within the new Church of England, but a few who resisted were executed. Domestic servants in the religious houses perhaps received the harshest treatment and were usually left without either employment or income. The Dissolution led to a critical change in the lives of the poor, who often had to resort to begging and caused social problems within towns which led to the Poor Law Acts.

In 1538, an official version of the Bible in English was prepared by Miles Coverdale. It was authorized by Henry VIII and his image appeared on the title page. Within a year it was distributed to every parish church in the land.

Henry VIII remained conservative in his religion. He continued to believe in transubstantiation (the certain belief that at consecration the eucharist elements become the body and blood of Christ), purgatory and clerical celibacy, and he maintained Latin rituals to the end of his days.

TOP: Waltham Abbey was one of the largest religious buildings in England. Once an important site of pilgrimage, today only the Lady Chapel and west wall survive from the fourteenth century.

ABOVE: After the Dissolution of the Monasteries, social problems increased as the poor had nowhere else to go for help and care.

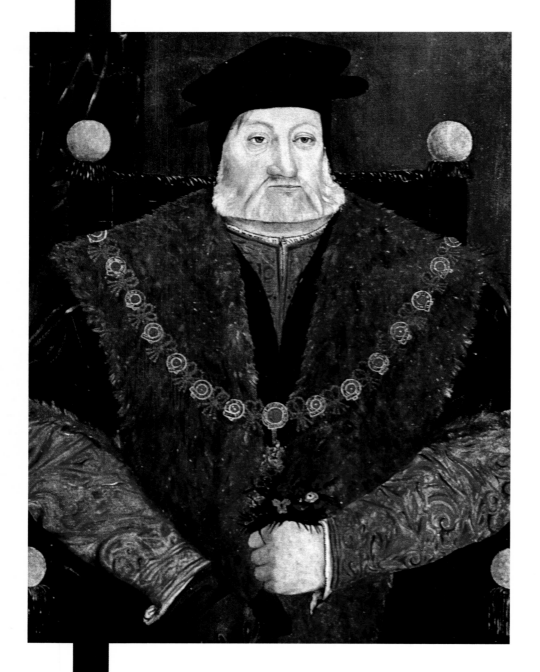

ABOVE: Charles Brandon, 1st Duke of Suffolk, was a prominent courtier and brother-in-law to Henry VIII.

OPPOSITE ABOVE: The first record of an execution at Tyburn is in 1196. Tyburn takes its name from a river that ran beneath Brooke Street called the Ty Bourne.

OPPOSITE BELOW: A stone plaque near Marble Arch, London, marks the place where the gallows once stood.

HENRY VIII: THE PILGRIMAGE OF GRACE

The most serious internal political crisis that Henry had to contend with during his reign was an uprising in the northern counties known as the "Pilgrimage of Grace". It was a direct response to Henry VIII's Reformation legislation and it began at Louth in Lincolnshire in October 1536, before spreading to Yorkshire a few weeks later.

Thomas Cromwell had been sent by the King to increase government control in the north of England but his presence was bitterly resented by the feudal magnates, who viewed it as an erosion of their traditional power.

The working classes, too, had their grievances. During the 1530s, poor harvests had led to arable land being enclosed and transformed into more profitable pasture land. As a result, rents increased, unemployment rose and poverty intensified.

Added to these resentments was the matter of religious reform. Rumours were rife and, though unlikely to be true, spread quickly – church silver was to be taken from the parishes and replacements fabricated from tin, and a tax was to be introduced on marriages and baptisms.

Destitution was more widespread in the north and closure of the monasteries possibly had a greater effect on the lives of the local population, who had relied on them for shelter, food and medical care. Essentially specific to Yorkshire, the Duke of Norfolk nevertheless referred to "All the flower of the North" being involved in the rising, since, in an unusual alliance, both nobles and commoners joined forces against the Crown.

The rebellion began in October 1536, at the church of St James in Louth, Lincolnshire. The rebels clearly stated that the uprising was not aimed personally at Henry VIII. The Lincolnshire rebellion was led by Nicholas Melton, a local cobbler. It initially involved about twenty thousand people, but increased to more than forty thousand on reaching Lincoln.

Charles Brandon, 1st Duke of Suffolk, was sent by Henry VIII to contain the uprising and, on hearing news of the King's

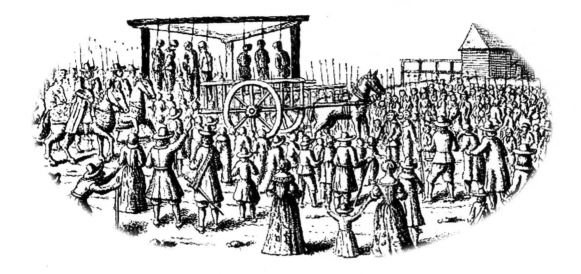

actions, the rebels disbanded. The Lincolnshire rebellion was over within two weeks.

The vicar of Louth, Nicholas Melton and two of the principal Lincolnshire leaders were arrested and were hanged at Tyburn in London for their part in the rebellion.

The revolt that had begun in Lincolnshire quickly spread to Yorkshire, where the lawyer Robert Aske became an effective leader of an army of troops against the King's policies. It was this part of the rebellion that is properly referred to as "The Pilgrimage of Grace".

A group of more than thirty thousand men marched on Doncaster. In order to contain a revolt of such proportions, Thomas Howard, 3rd Duke of Norfolk, and George Talbot, 4th Earl of Shrewsbury, were despatched by Henry to settle the situation. The numbers of rebels involved meant the threat to the throne was grave.

The Duke of Norfolk opened negotiations with Aske. Norfolk's aim was to save himself from massacre while allowing the King time to assemble and despatch an adequate fighting force. Aske and the rebels were offered a full pardon, along with a vague promise that England would return to Papal obedience and that a Parliament free from royal influence would be considered. Aske naively accepted Norfolk's promises and dispersed the rebel army.

In January and February 1537, Norfolk used a rebellion in Cumberland as justification for bringing the leaders of the Pilgrimage of Grace to London. By early May, fifteen of the main leaders were under arrest. All the accused were found guilty of treason and Aske was taken back to Yorkshire to be hanged in chains. On 25 May, Nicholas Tempest, esquire, a

priest named as Doctor Cockerell and a friar called Doctor Pickering were among those taken from the Tower of London to Tyburn where they were "hanged, bowelled and quartered". In total, more than two hundred lords, knights, churchmen, monks and commoners were executed.

The Pilgrimage of Grace did not accomplish its aims. The Dissolution of the Monasteries continued, Church land was seized by the Crown and both Catholics and Protestants were required to tread a sensitive path.

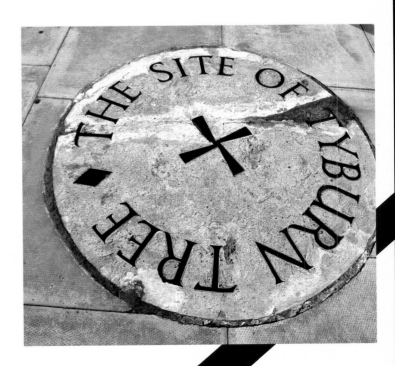

THE ROYAL NAVY

Henry VII, Henry VIII's father, had considered a navy important as a merchant fleet, for carrying goods and expanding trade. Intent on avoiding war, this first Tudor king consolidated the navy rather than greatly extending it, resulting in a force that was compact and well equipped.

Henry Tudor was, in 1496, the first monarch to build a permanent dry dock at Portsmouth. He offered financial incentives for the building of merchant ships, which in times of war could be loaded with guns and sailed into combat. Toward the end of the reign of Henry VII the carrying of large and heavy guns on warships became increasingly important and so greater ships, such as the 600-ton *Regent* and the *Sovereign*, were built in 1487–88.

When Henry VIII became king in 1509, he inherited only seven warships. This was increased during the early part of his reign to twenty-four. The dry dock at Portsmouth was expanded and royal dockyards were founded, leading Henry VIII to become known as "the father of the English Navy".

Henry VIII's foreign policy differed from that of his father. For the young King, a naval fleet was necessary for both defence and attack. In 1546, an internal structure was organized within

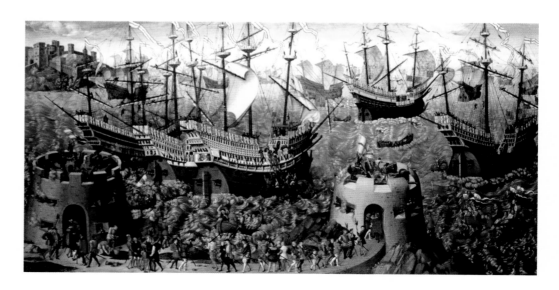

the navy that was administered and funded by tax revenue. It was known as the Navy Board and it was to remain almost unchanged for more than three hundred years.

The *Mary Rose* is perhaps the most widely known of Henry's warships. It was lost in 1545, recovered in 1982, and is at present on public view in Portsmouth. The first mention of the *Mary Rose* is in a payment record made by Henry VIII in 1510.

The *Mary Rose* took part in the 1513 war against France, under the leadership of the Lord High Admiral Sir Edward Howard, but in 1522 she was placed in reserve, probably in need of repair. By 1535 she was once again used as a weapon against the French. A successful warship, the *Mary Rose* served in Henry's fleet for almost thirty-four years.

In 1514, the *Henri Grace à Dieu* was built at Woolwich. Known as "the Great Harry", she carried fifty-two guns, displaced at least one thousand tons and carried around seven hundred men. With a forecastle four decks high and a stern six decks high, the ship was effectively a floating castle. At the time of launch, the *Henri Grace à Dieu* was the biggest warship in the world.

In 1520, it was the *Henri Grace à Dieu* that carried Henry over the Channel to meet François I at the event known as "The Field of Cloth of Gold". Heavily embroidered pennants flew from the tops of the masts, creating an image of Renaissance splendour. To increase the impact of his arrival in France, Henry ordered the sails of the ship to be painted gold.

By 1523, when England declared war on France, Henry VIII's fleet was the most powerful in English history.

Henry VIII sailed for France for the last time in 1544, three years before his death. Allied with Charles V, Holy Roman Emperor, his intention was to take Paris and subdue France. Henry took command of the English forces personally, despite objections from his council regarding his health. But the joint invasion was unsuccessful as Charles V was already involved in peace negotiations with the French king, François I. In the end, Henry VIII successfully took Boulogne but was left without an ally.

The following year, the Battle of the Solent took place on 18 July 1545. Henry VIII was at Portsmouth reviewing his ships as the French fleet approached. They were initially repelled but continued the attack off Spithead, where the *Mary Rose* was seen to keel over onto her side and quickly sink. As the wind died down, the weather turned to the advantage of the English. Lord Admiral John Dudley positioned his flagship, the *Henri Grace à Dieu*, and the rest of the English fleet to strategically block the French ships. The French galleys exchanged long-range canon fire, before departing to invade the Isle of Wight. Local forces on the island attacked and wounded the French leaders, who retreated to their ships and departed.

In the year following the Battle of the Solent, a peace treaty was signed between Henry and François. It was to be Henry's last act of European statesmanship. After years of war the monarchs died just weeks apart – Henry VIII in January 1547 and François I in March.

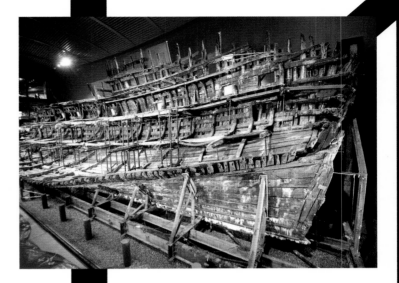

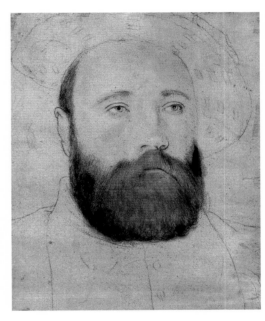

TOP: The largest surviving part of the *Mary Rose* was raised in 1982 but some remains still lie on the seabed.

ABOVE: Sir George Carew, Captain of the *Mary Rose* who perished with the vast majority of his crew when the ship sank on 19th July 1545. By Hans Holbein the Younger c1532-1543.

OPPOSITE: "The Embarkation of Henry VIII" depicts Henry's fleet departing from Dover on 31 May 1520 to meet François I of France for the event known as "The Field of Cloth of Gold". Dover Castle is depicted in the upper left-hand corner and the gun towers in the foreground fire salutes.

WIVES

From the time of Henry VIII's coronation in 1509, the peaceful continuation of the Tudor dynasty relied on the birth of a male heir. In the end, six marriages produced only one legitimate son, Edward, who ruled England from Henry's death in 1547. The quest for this legitimate male heir dominated twenty-eight years of the King's reign and helped make Henry VIII famous because of the six queens consort who became his wives.

KATHERINE OF ARAGON (1485–1536)

Katherine was born on 16 December 1485 in Spain, the daughter of Ferdinand of Aragon and Isabella of Castile. She arrived in England at fifteen years old to be married to Prince Arthur, Henry's elder brother. Their marriage took place in November 1501 at St Paul's Cathedral.

The following April, Arthur died at Ludlow Castle, Shropshire, and Katherine was left a widow, aged just sixteen. She was a princess with a high status and a large dowry and because

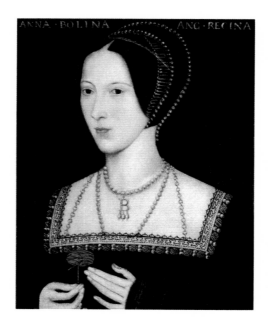

the alliance united England with Spain, she remained in England for more than seven years, while her father and her father-in-law discussed her future. After the death of Henry VII, she was married to Henry VIII on 11 June 1509.

Five of their children did not survive birth or infancy. Their one surviving daughter, Mary, was born on 18 February 1516.

In 1533, after almost twenty-four years of marriage and much debate and controversy, the couple were divorced. Katherine was informed that she would no longer be called queen and that her household would be reduced. She replied that she would live as a beggar if needs be, but that she would always be queen.

She died aged fifty on 7 January 1536, at Kimbolton Castle, Huntingdonshire, and is buried in Peterborough Cathedral.

ANNE BOLEYN
(C.1501–36)

Anne was born at Blickling Hall in Norfolk to Sir Thomas Boleyn and Elizabeth Howard, daughter of the second Duke of Norfolk. Henry first hinted at his feelings toward Anne on Shrove Tuesday 1526, when he wore a jousting costume embroidered with a flaming heart and the words: "Declare I dare not." Love letters written by Henry to Anne show how passionately he loved her. The couple were married in secret on 25 January 1533. He was forty-one years old and she was around thirty-two.

Henry and Anne were married for a little more than three years before Henry ordered her arrest on charges of adultery and high treason. She was imprisoned in the Tower of London, put on trial and sentenced to death. On 17 May 1536, the men accused of being her lovers were executed on Tower Hill. Two days later, dressed elegantly in grey damask, Anne Boleyn made her way to her execution. She did not protest her innocence.

She was beheaded with a sword on a scaffold within the Tower precincts. Her body is buried in the Chapel Royal of St Peter ad Vincula in the Tower of London. Their daughter Elizabeth (later Elizabeth I) was just two years old.

JANE SEYMOUR (C.1508–37)

Jane was the daughter of Sir Thomas Seymour and was probably born at Wulfhall, Wiltshire. She served as maid-of-honour to both Katherine of Aragon and Anne Boleyn, and Henry probably began pursuing her in the autumn of 1535. She was around twenty-seven and he was forty-four. The couple were married on 30 May 1536 at Whitehall Palace.

On 12 October 1537, a healthy son was born at Hampton Court Palace and baptised three days later in the Chapel Royal. Jane died twelve days after the birth, on 24 October 1537, most probably from an embolism. She was the only queen to give Henry the healthy son he so desperately wanted, and the only wife to be honoured with a state funeral. She is buried beside Henry in St George's Chapel, Windsor.

OPPOSITE: Contemporary descriptions of Anne Boleyn mention her dark hair and eyes and her slender neck.

RIGHT: Jane Seymour was Queen for only a short period and portraits of her are few. Most images of Jane are taken from a portrait produced by Hans Holbein the Younger, which today is in the collection of the Kunsthistorische Museum in Vienna.

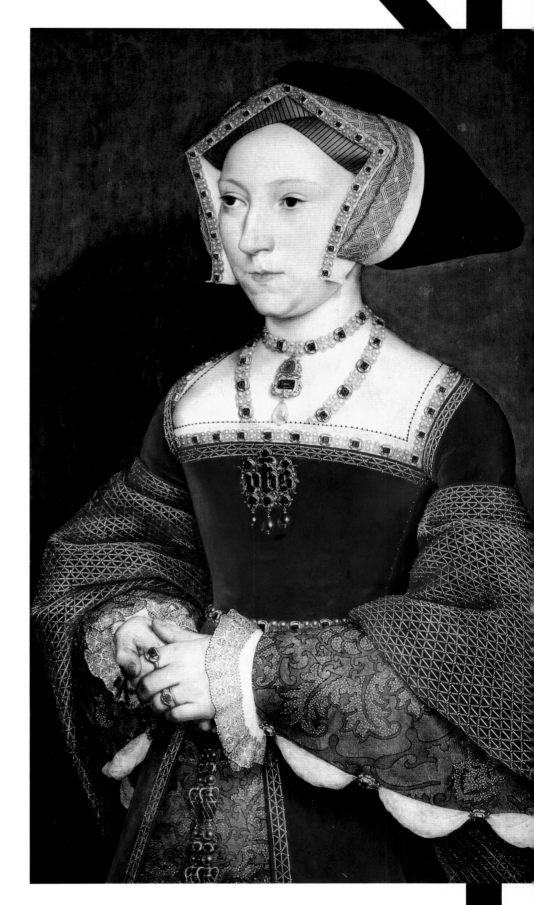

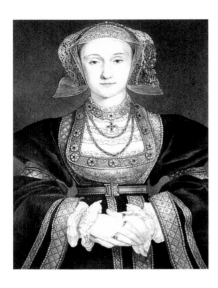

ANNE OF CLEVES (1515–57)

Anne was the daughter of John, Duke of Cleves and was born on 22 September 1515 at Dusseldorf, Germany. A political alliance, Henry and Anne met for the first time when she arrived in England for their marriage. Henry was disappointed with his bride and is said to have commented that she had "displeasant airs" about her.

The couple were married by Thomas Cranmer on 6 January 1540 at Greenwich Palace. Henry was forty-eight and Anne twenty-four. The marriage appears to have remained unconsummated. Anne was removed to Richmond Palace and a convocation of the clergy was called to investigate the validity of the union. On 12 July 1540, the marriage was declared illegal because of Anne's supposed pre-contract of marriage with the Duke of Lorraine and its non-consummation.

Anne received a generous settlement. Henry awarded her Richmond Palace, Bletchingley Manor in Surrey and Hever Castle in Kent. She stayed in England and became friends with the King, who signed himself in letters to her as "your loving brother".

Anne died on 16 July 1557 at Chelsea Old Palace, London, at the age of forty-one, possibly of cancer. She is the only one of Henry's wives to be buried in Westminster Abbey.

KATHERINE HOWARD (C.1525–42)

Katherine and Henry married on 28 July 1540 at Oatlands Palace, Surrey. Her date and place of birth is uncertain, but she was around nineteen and he was forty-nine. The couple had met at court in late 1539, when Katherine was a maid of honour to Anne of Cleves. Their relationship probably began the following year when Henry became infatuated with her.

In November 1541, evidence was laid before Cranmer that, while living with the Dowager Duchess of Norfolk at Lambeth, Katherine had had a pre-marital affair with a kinsman, Francis Dereham. Under interrogation, Dereham admitted it, and stated that they had entered into a precontract to marry.

Under canon law, this was considered as binding as a marriage, and it called the validity of Katherine's marriage to Henry VIII into question. Further evidence emerged that Katherine, with the assistance of Jane Parker, Lady Rochford, had enjoyed secret meetings with courtier Thomas Culpepper, one of the most favoured gentlemen of the King's Privy Chamber. Henry ordered an investigation and Culpepper, Dereham, Lady Rochford and Queen Katherine herself were arrested.

Henry never saw Katherine again. She was stripped of her royal titles and taken from Hampton Court Palace to Syon House. Dereham was hanged, drawn and quartered, and Culpepper was beheaded, their heads being displayed on London Bridge. There was no trial for Katherine or Lady Rochford. They were condemned under a bill of attainder to which the King assented.

Guilty of high treason, Katherine was taken by barge to the Tower of London, passing beneath the heads of Dereham and Culpepper. On 13 February 1542, she and Lady Rochford were beheaded. Her body was buried in the Chapel Royal of St Peter ad Vincula within the Tower of London.

KATHERINE PARR (C.1512–48)

Katherine Parr had been twice wedded before her marriage to Henry VIII on 12 July 1543 at Hampton Court Palace. She was thirty-one and Henry was fifty-two. Katherine was an intelligent woman who took an active interest in the King's children

When, in December 1546, Katherine left Hampton Court to celebrate Christmas at Greenwich, Henry intended travelling to London. She was never to see her husband again, as on 28 January 1547, Henry died at Whitehall Palace, at the age of fifty-five.

All Henry's wives were queens of England by right of marriage but only Katherine of Aragon and Anne Boleyn were crowned.

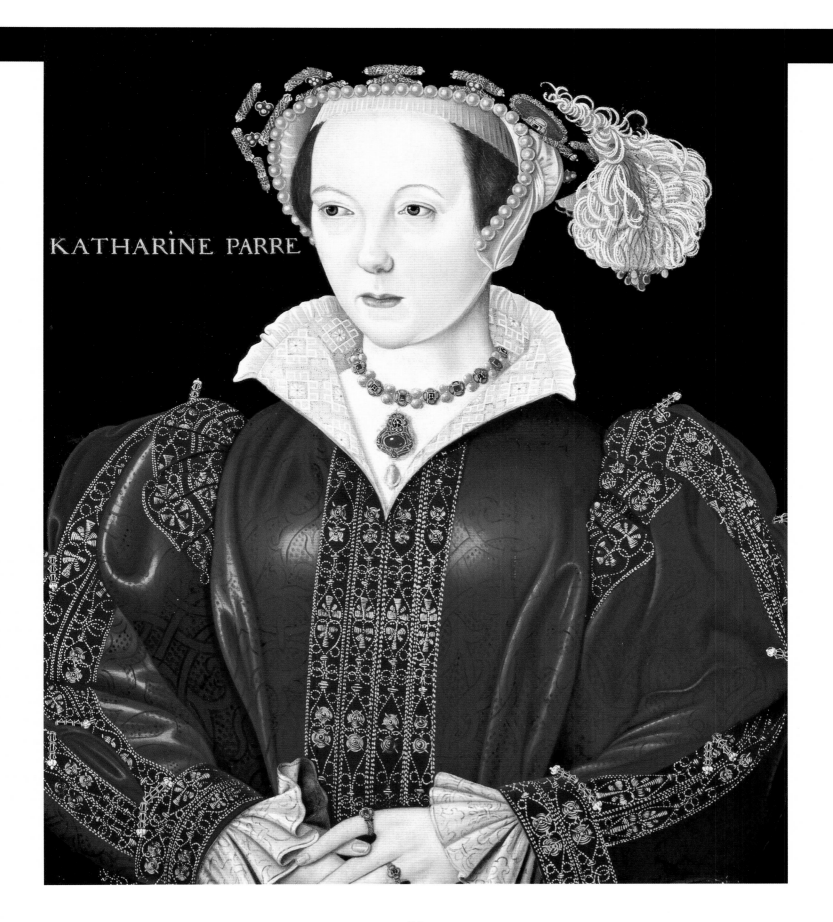

KATHARINE PARRE

DECLINING HEALTH AND DEATH

Henry VIII began his kingship in 1509 as a tall, handsome and athletic youth of seventeen. When his reign ended in 1547, he was an invalid – bloated and overweight. Henry VIII's precise medical history is either now lost or was never documented by his physicians – perhaps for fear of recrimination – but information concerning the King's health can be found in contemporary letters and state papers.

In his early years the King enjoyed good health. In 1527, he sustained an injury to his foot while playing tennis, and in the same year there is mention of an injury to his thigh, possibly a leg ulcer, which healed without incident.

By 1536, Henry, now forty-five, was already significantly overweight. Suits of close-fitting armour provide evidence of his growing obesity. In January of that year, while jousting at Greenwich, the King fell from his horse and remained unconscious for two hours. His legs were injured and he may have sustained a fracture. The wounds on his limbs initially healed but reappeared shortly afterward, and thereafter ulceration proved to be troublesome. Henry's ulcers were lanced with red-hot pokers to allow them to drain. If the wounds healed superficially, it was considered dangerous for the King's health, as it brought on sepsis and fever. The stench from the ulcers was said to be significant.

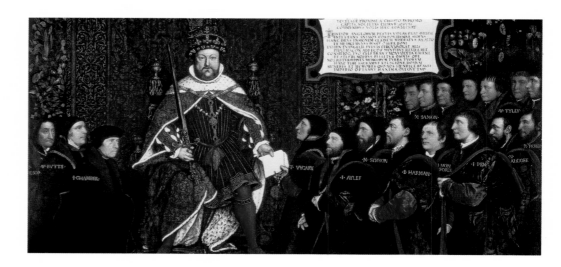

By 1544, Henry found it harder to take exercise and his weight further increased. At twenty-three years old, his armour had been produced with a 35 in (89 cm) waist and a 42 in (107 cm) chest. Twenty years later it had increased to a 51 in (130 cm) waist and a 55 in (140 cm) chest. His weight is estimated to have been about 30 st (190 kg).

After his fall in 1536, the King was plagued by headaches, which soured his mood and led him to fly into sudden rages. He became tyrannically unpredictable. By 1547, swollen legs and extreme obesity led to Henry being carried around the Palace of Whitehall in a chair, before finally he took to his bed.

The Treasons Act forbade anyone to speak of the King's death, but eventually it was Anthony Denny, a member of the Privy chamber, who broke the news to Henry that his death was imminent. The day before he died, Henry met his confessor Thomas Cranmer and took Holy Communion.

His decline was rapid and Henry VIII died at Whitehall Palace on 28 January 1547, at the age of fifty-five. Since then, the cause of his death has been much debated. Henry was still a young man when the first ulcer appeared on his thigh and this has led some scholars to consider primary syphilis as the cause of death. The "great pox", as syphilis was known in Tudor times, would have been treated with mercury pills. However, purchase accounts do not reveal the buying of any mercury. Neither is there evidence that any of his wives developed the sexually transmitted disease.

Henry may have suffered a deep vein thrombosis due to his obesity and immobility. His risk of high blood pressure and Type 2 diabetes would also have been high. Swollen legs were perhaps representative of congestive heart failure. The King most likely died from a combination of the ailments that plagued him, finally being taken by a pulmonary embolism, a blood clot in the lung.

Church bells tolled throughout the land as Henry's body was embalmed and encased in lead. It lay in state in the Presence Chamber at Whitehall. The coffin was covered with velvet and cloth-of-gold, with a wax effigy of the King placed on top.

On 14 February, he was carried by sixteen Yeoman of the Guard to Syon Abbey, and the following day to Windsor Castle. Stephen Gardiner, Bishop of Winchester, spoke the eulogy and a Requiem Mass was celebrated. King Henry VIII is buried in St George's Chapel at Windsor Castle, beside Jane Seymour, his third queen and the mother of his son, Edward.

In his youth, Henry was a handsome, intelligent and charming Renaissance prince. He was also ruthless, arrogant and cruel. He married six times, he broke with the Church of Rome and founded the Church of England. Henry VIII has been called "the father of the English Navy". His increased fortifications secured England against invasion. In 1536, the Act of Union united Wales with England and in 1541 Henry was accorded the title King of Ireland.

During his reign the power of the nobles diminished and that of Parliament increased, particularly over matters of taxation. It is reasonable to consider that Henry VIII laid the foundation for a modern Britain.

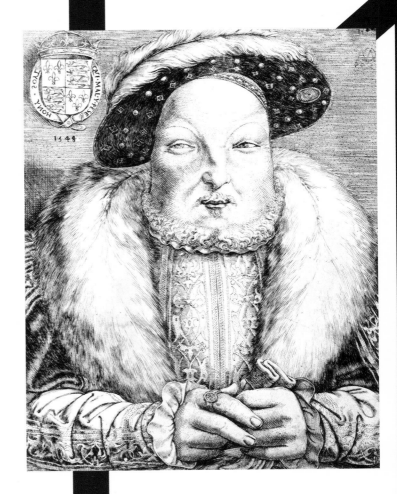

ABOVE: Henry VIII by Cornelis Metsys, line engraving c.1545.

OPPOSITE: King Henry VIII is seen here celebrating the Act of Union between the Company of Barbers and the Guild or Fellowship of Surgeons in 1540.

EDWARD VI & LADY JANE GREY

PROTESTANTISM AND SUCCESSION

The dominant figure of the Tudor period is held to be
Henry VIII, but the short reign of his long-awaited son,
Edward VI, is also important. Trained for greatness,
Edward was King of England for only six years, but
his rule was marked by the full-scale introduction of
Protestantism. It ended with a succession crisis and the
tragedy of Lady Jane Grey.

EDWARD VI:
THE BOY KING

E ven today the two dominant figures of the Tudor period are held to be Henry VIII and Elizabeth I, yet the short reign of Edward VI is equally important. Edward was King of England for only six years, but his rule was marked by the full-scale introduction of Protestantism. It ended with a succession crisis.

As heir to the throne, "His Majesty's most noble jewel" was brought up with every precaution to ensure his good health. Recent research reveals him as a normally strong and healthy boy fond of hunting and hawking.

During Edward's reign the Church of England became more explicitly Protestant: the *Book of Common Prayer* was introduced in 1549; aspects of Roman Catholic practices, including statues and stained glass, were eradicated; and the marriage of clergy was allowed. Such was the boy King's devotion to the Protestant religion that he excluded his sisters from the succession, in favour of Lady Jane Grey, and set in place a tragic series of events that would lead his young cousin Jane to the scaffold.

THE LONG-AWAITED SON

By 1537, Henry VIII had waited twenty-eight frustrating years for God to give him a healthy, living son. In October that year his third wife, Jane Seymour, was expecting a baby. The birth of the child was long and difficult, taking two days and three nights. Finally, at 2am on Friday 12 October, the eve of St Edward's Day, Jane gave birth to a healthy boy. Master Secretary Thomas Cromwell wrote that the announcement "hath more rejoiced this realm and all true hearts ... than anything hath done this 40 years".

Jane Seymour was born at Wulfhall in Wiltshire around 1508, one of ten children. By 1536 Henry VIII was courting her, promoting her brothers and sending her expensive gifts. They were betrothed on 20 May, the day after Anne Boleyn's execution, and they married at the Palace of Whitehall on 30 May.

Jane was about twenty-eight years old when she married the King – rather late for a Tudor bride, but her family were known for their fertility. The Imperial Ambassador, Eustace Chapuys, described her as "of middle stature and no great beauty, so fair that one would call her rather pale than otherwise". Henry would in years to come remember her as "the fairest, the most discreet, and the most meritorious" of all his wives. She died twelve days after the birth of their son.

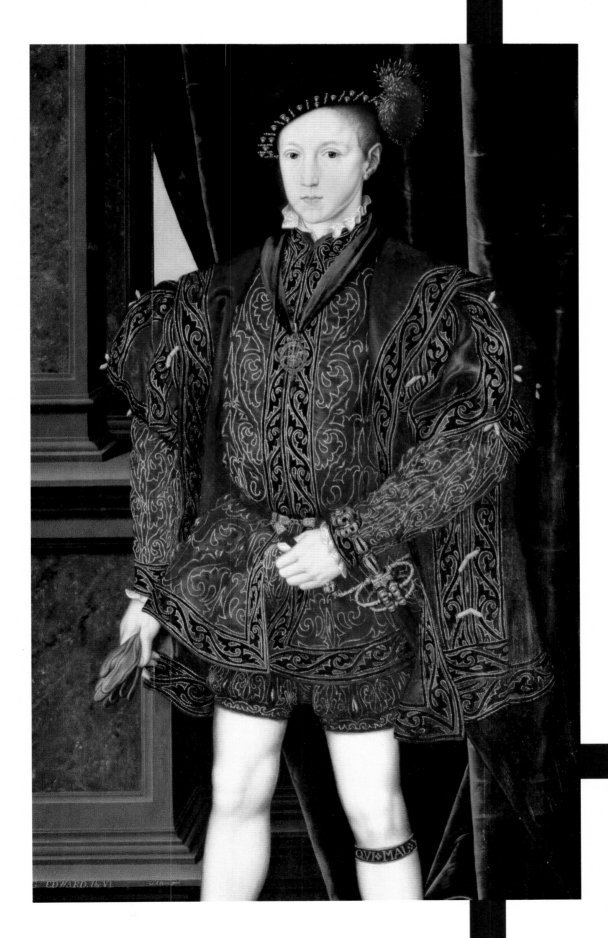

LEFT: King Edward VI, aged thirteen by William Scrots c.1550. As court painter, Scrots was responsible for the design of the most important official portrait of Edward as King.

Edward was placed in the care of Margaret Bryan, Lady Governess of the Prince's Household, who controlled his nursery. He was a healthy baby who suckled strongly from his wet nurse, Mother Jack. Brought up, as he put it later in his chronicle, "among the women", he also had a dry nurse, Sybil Penn, to whom he became very attached. Even if Jane had lived, she would not have taken care of her son.

A PRINCELY NURSERY

It was customary for royal babies to be established in their own household straight away and Edward had a presence chamber at Hampton Court, which contained a great cradle instead of a throne. Henry commanded that every room and hall in the nursery be swept and washed, ready for the prince. He also demanded high standards of security for "this whole realm's most precious jewel". When Edward was moved to any other palace – and he had nurseries in several – his servants had to check back doors into gardens and courtyards.

Edward's health was carefully monitored by doctors, and precautions were ordered to protect him from disease. A detailed record was kept of every servant and no one was allowed to touch the prince unless they had permission to do so. Even those bringing in wood for fires had to be clean, and servant boys were forbidden in his presence since they "without any respect go to and fro and be not wary of infection and do oftimes resort to suspect places".

Henry's desire for magnificence was reflected in his baby son's lifestyle and Edward grew up surrounded by splendour. His rooms were hung with valuable Flemish tapestries and all his possessions reflected his high status. Later he would eat with a cutlery set with precious stones and on fine plate.

His tiny clothes were of rich fabrics and cloth of gold, embroidered with pearls. Even his buttons were made from solid gold and his caps studded with diamonds and sapphires. Furthermore the baby was lavishly provided with toys and comforts, including his own troupe of minstrels. No wonder visitors described the prince as a contented child. Contemporaries also seem to have been struck by Edward's beauty. On finally being granted an interview, the Spanish envoy called him "the prettiest child we ever saw".

On New Year's Day 1540, Hans Holbein the Younger presented Henry VIII with a superb portrait of the two-year-old Prince Edward wearing a wide-brimmed bonnet and clutching a gold rattle. The portrait bears the inscription:

Little one, emulate thy father and be the heir of his virtue; the world contains nothing greater ... Heaven and earth could scarcely produce a son whose glory would surpass that of such a father. Do thou but equal the deeds of thy parent and men can ask no more. Shouldst thou surpass him, thou hast outstript all, nor shall any surpass thee in ages to come.

As the child grew up this would be impressed upon him continuously, and his short life would be driven by the desire to emulate his father.

TOP: The exterior of Edward's nursery at Hampton Court Palace can still be seen today. The baby had his own household and Privy Chamber.

OPPOSITE: "Edward VI as a Child" by Hans Holbein the Younger, 1539. This important infant is the future head of the Church of England and raises a tiny hand as if in a blessing.

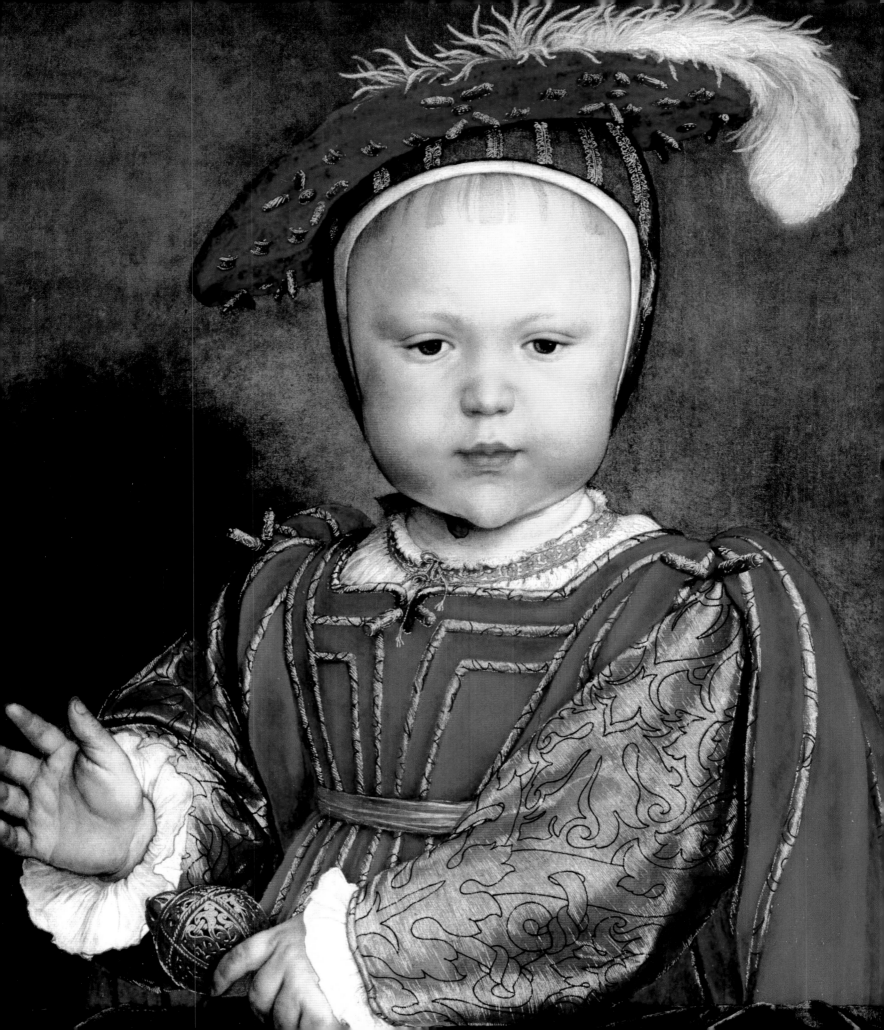

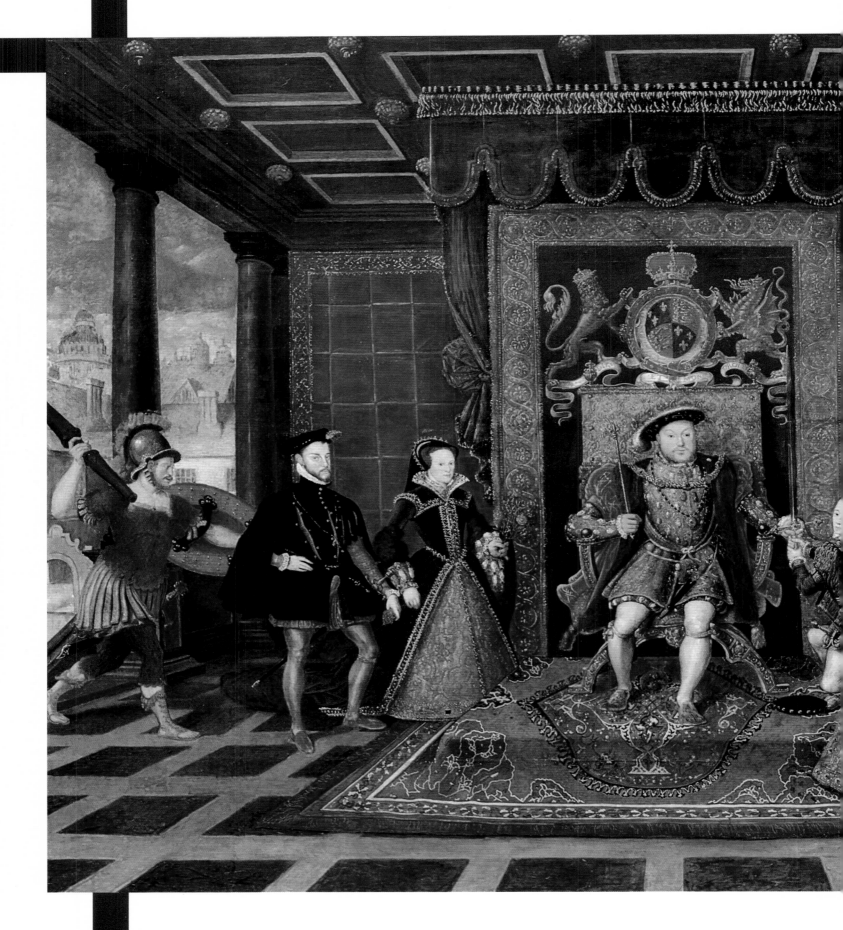

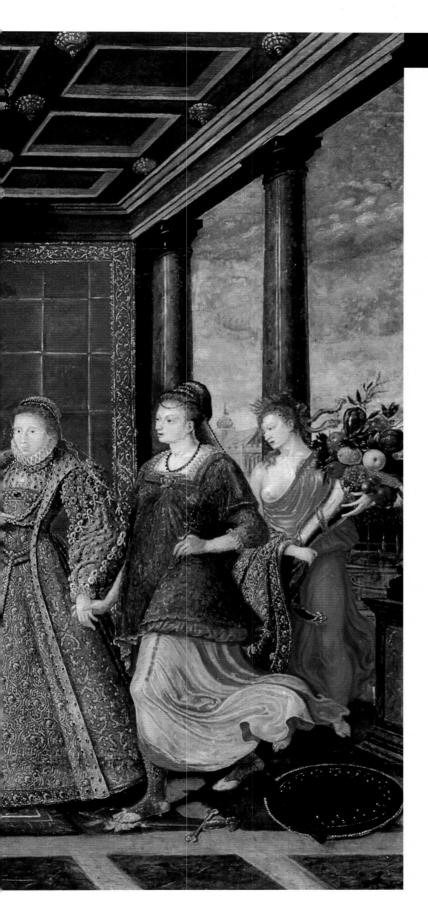

ROYAL RELATIONSHIPS

The Lady Mary, always fond of small children, was keen to visit her new brother. When living at Hampton Court, she would take a barge journey to see him at Richmond Palace, and her accounts show expensive presents for the baby such as a coat of crimson satin, with sleeves of tinsel.

Records show that both of Edward's sisters were attentive to him, and Elizabeth sent him a shirt "of her own working", but, according to Lady Margaret Bryan, Edward "took special content" in Mary's company. He looked like his sister Elizabeth and they were alike in their love of books, but it could be argued that his mind was more like Mary's. They shared a fanatical belief that salvation could be found only in one form of Christian worship, where Elizabeth would later take a middle stance.

In July 1543, Henry married Katherine Parr. She would prove to be a loving step-mother and it was probably with her encouragement that Henry invited all his children to spend Christmas with him that year.

From the time of his birth Prince Edward was surrounded by servants and had never wanted for anything material. The King professed to love the child he had so longed for but, surprisingly, his visits to his son were infrequent. Henry's ill health and disability may be the cause and few visits are recorded, although in May 1538 he spent the day with Edward "dallying with him in his arms a long space and holding him in a window to the sight and great comfort of the people". Henry certainly showered the prince with gifts. On one occasion Edward thanks him, writing, "... in which things and gifts is conspicuous your fatherly affection towards me, for, if you did not love me, you would not give me these fine gifts ..."

Edward did not inherit his father's robust build, but the tradition that he was always a sickly child is incorrect. He was small, slender and slightly short-sighted but he was a lively and good-looking boy of normal physical health.

LEFT: "The Family of Henry VIII: An Allegory of the Tudor Succession" attributed to Lukas de Heere, c.1572. Edward receives the sword of justice from his father. His sister Mary is on the left, with her husband Philip of Spain and the figure of "war". Elizabeth stands to the right, holding the hand of "Peace".

ABOVE: Charles Brandon by
Hans Holbein the Younger,
1541. One of Edward's childhood
friends.

SCHOOLDAYS AND PLAYMATES

From the age of six Edward began his formal education, under eminent scholars Richard Cox and John Cheke, concentrating on the "learning of tongues, of the scripture, of philosophy, and all liberal sciences". He also received tuition in French, Spanish and Italian, studied geometry and learned to play the lute and the virginals.

Henry VIII intended that his son be trained for greatness by the best minds of the day. He was educated with the sons of nobles, "appointed to attend upon him" within his household. Edward was naturally academic and seems to have outshone his classmates, always motivated to work hard and please his father.

School friends included Charles Brandon and his brother Henry, whose doodles can be found on Edward's school work. The brothers went on to Cambridge University, where they died in 1551, still in their teens, of the sweating sickness. Barnaby Fitzpatrick, the son of an Irish lord, became a close and lasting friend, and he and Robert Dudley (later to be Queen Elizabeth's favourite) went on to be appointed two of the six gentlemen of King Edward's privy chamber.

From infancy the Prince was taught not to show his feelings, which meant he could be cold in manner, and he was certainly prim in outlook. But it's clear his friends were important to Edward; later, as King, he would write to them often, sending them money and paying off debts. Among his surviving letters to Barnaby is one advising his teenage friend to remember his prayers and avoid ladies and too much dancing.

In 1546 Henry decided that Edward should perform his first official duty, receiving a French admiral on a state visit to Hampton Court Palace. Riding out from the palace gates with his entourage, the small prince dismounted on the riverside and made his first public speech of welcome in Latin. He was eight years old.

DEATH OF HENRY VIII

Henry VIII died at Whitehall Palace in January 1547 and Edward Seymour, uncle to the new King Edward, rode to collect his nephew from Hertford and bring him to Enfield, where Lady Elizabeth was living. Here they were told of the death of their father, resulting in both children bursting into uncontrollable sobs.

Henry VIII was buried at Windsor on 16 February 1547, in the same tomb as Jane Seymour, as he had wished. Edward VI's coronation took place later the same month, at Westminster Abbey. The day before, he had progressed on horseback from the Tower of London to Westminster, through thronging crowds and pageants, stopping his coronation procession outside St Paul's Cathedral to watch a Spanish tightrope walker who "tumbled and played many pretty toys".

The address of Archbishop Cranmer to the youthful monarch included a repudiation of the Roman Catholic Church and a call for Edward to emulate the godly King Josiah of Judah in banishing idolatry from the land.

REGENTS AND PROTECTORS

During Edward's reign the realm was governed by a Regency Council, initially led by his uncle, Edward Seymour, 1st Duke of Somerset, as Lord Protector. For two and a half years Somerset acted as king in all but name. He secured letters patent from his nephew, granting him the right to appoint members to the Privy Council and to consult them only when he wished. He proceeded, therefore, to rule by proclamation, calling on the Council only to sanction his decisions.

Discontented nobles soon became frustrated by Somerset's overbearing attitude and there was opposition to many of his policies. Ultimately, his chief rival for power would be John Dudley, Earl of Warwick, but the first serious opposition came from his own brother.

Thomas Seymour, being also an uncle of the King, expected a greater share of power and envied his older brother's position and influence. A contemporary described the younger Seymour as "fierce in courage, courtly in fashion, in personage stately and in voice magnificent" but "somewhat empty in matter".

Somerset tried to placate his brother with a barony and appointment to the Lord Admiralship, but Thomas still worked to unseat and replace him as Lord Protector. He began smuggling pocket money to Edward, telling him that Somerset held the purse strings too tight, making him a "beggarly king". He also urged him to throw off the Protector within two years and "bear rule as other kings do".

In May 1547, using Edward's support to override Somerset's opposition, Thomas Seymour married Henry VIII's widow Katherine Parr, whose Protestant household included the thirteen-year-old Lady Elizabeth. His flirtatious behaviour toward the latter would seriously compromise her reputation and play a part in his downfall, when details eventually came to light.

On a cold night in January 1549, for reasons unclear (but probably to take the young King into his own custody), Thomas Seymour broke into the Privy Apartments at Hampton Court. Armed with a pistol, he reached Edward's bedroom but was unexpectedly attacked by the King's dog. Panicking, he shot the dog, woke the guards and was arrested.

ABOVE: Edward Seymour, Duke of Somerset, who became Lord Protector to his nephew and took control of government.

BELOW: Drawing of Hampton Court Palace by Antonis Van Der Wyngaerde, 1558.

On 18 January the Privy Council sent agents to question everyone associated with Thomas, including Elizabeth, and in February they officially accused him of treason. He was condemned to death and executed on 20 March at Tower Hill. His estranged brother and his nephew did nothing to save him.

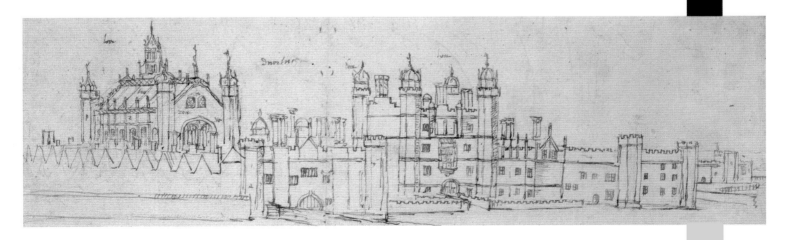

WAR AND UNREST

From the first, Somerset's main interest as Protector was the war against Scotland, begun in 1543 with Henry VIII's "rough wooing" of the baby Mary, Queen of Scots. Following his break with Rome, Henry had attacked Scotland partly to destroy her "Auld Alliance" with France and prevent Scotland being used as a springboard for French invasion, and partly to force Scotland into a marriage between its child-queen Mary and his son Edward.

Somerset fought and won the Battle of Pinkie Cleugh, near Musselburgh, in September 1547, crushing the Scots and gaining control of the whole of southern Scotland. It was one of the last pitched battles to be fought between English and Scottish armies. After this great victory Somerset built a network of garrisons in Scotland.

Despite these successes, his aim of uniting the realms through conquest became increasingly problematic. The Scots remained allied with France, which continued to send support, while Mary, Queen of Scots was betrothed to the dauphin. The cost of maintaining the Protector's massive armies and his permanent garrisons in Scotland also placed an unsustainable burden on the royal finances.

Meanwhile, at home, England was subject to social unrest. In 1549 a series of armed revolts broke out, fuelled by religious and land grievances. The two most serious rebellions were in Devon and Norfolk. The first, sometimes called the Prayer Book Rebellion, arose in protest at the new church services in English. The second was led by a tradesman called Robert Kett, who was later executed, and came about due to the encroachment of landlords on common grazing ground.

The popular view of Somerset as sympathetic to the poor lies partly here, as he had forbidden enclosures – that is, the taking of arable common land by the gentry to use as pasturage. The landlords resisted and the disturbances were made complex because the rebels believed they were acting with Somerset's approval.

For more than three months the government struggled, as England experienced the most widespread rebellions of the sixteenth century, with Exeter under siege and Norwich in the hands of rebels. Order was finally restored after a major deployment of forces, by which time the Privy Council had lost all confidence in Somerset's ability to govern England.

After proclaiming mismanagement and gathering forces against him, the Council finally arrested Somerset in October 1549. Edward summarized the charges against his uncle in his chronicle: "[A]mbition, vainglory, entering into rash wars in mine youth, ... enriching himself of my treasure, following his own opinion, and doing all by his own authority etc."

In February 1550 John Dudley, Earl of Warwick emerged as leader of the Council and was raised to the dukedom of Northumberland in October 1551. Somerset was released from the Tower and supposedly reconciled with his enemies on the Council. It was highly unusual in Tudor politics for a fallen statesman to be given a second chance and it did not last long. He was executed for felony in January 1552, after plotting against the new regime.

Edward coldly noted his uncle's death in his chronicle: "The duke of Somerset had his head cut off upon Tower Hill between eight and nine o'clock in the morning." Now both the brothers of Jane Seymour, brought to prominence through her spectacular marriage, had been executed.

The new Lord President of the Council, Northumberland, sought both to introduce the adolescent monarch into the business of government and to win his personal esteem. The King now began to enjoy more freedom in pastimes and entertainment, particularly in the physical sports his father had enjoyed. The Venetian ambassador noted that Edward was "beginning to exercise himself in the use of arms and enjoys it heartily".

Northumberland proved an able administrator, tackling finances and ending the costly wars with France and Scotland. His religious policy was decidedly Protestant, continuing the Reformation and promoting radicals to high Church positions. Northumberland married his son Lord Guilford Dudley to Lady Jane Grey, one of Henry VIII's great-nieces and a claimant to the throne – a match that would have tragic consequences.

OPPOSITE: John Dudley, Earl of Warwick and Duke of Northumberland became the new Lord President of the young King's Council.

THE ENDVR
WORDE ETH
OF THE FOR
LORD EVER

SVPERSTICION

IDOLATRY

POPE

ALL FLESHE
IS GRASSE.

FEYNED
HOLINE

REFORMATION

Edward was the third monarch of the Tudor dynasty and England's first monarch raised as a Protestant. It is hardly surprising that he found himself at the extreme end of the new religion, as he imbibed harsh views regarding Catholicism from his Protestant teachers.

An important influence was his godfather Thomas Cranmer, the Archbishop of Canterbury, who was responsible for establishing the first doctrinal and liturgical structures of the reformed Church of England. He had helped build the case for the annulment of Henry's marriage to Katherine of Aragon, which was one of the causes of the separation of the English Church, and he supported the principle of Royal Supremacy.

LEFT: "King Edward VI and the Pope" by an unknown artist, c.1575. Henry VIII, on his deathbed, points toward his successor Edward VI. The Pope is crushed by "the worde of the Lord" – written in English. The blank white spaces may have been intended for further anti-Catholic inscriptions.

BELOW: Thomas Cranmer by Gerlach Flicke, c.1545, Archbishop of Canterbury and architect of Edward's Protestant Reformation.

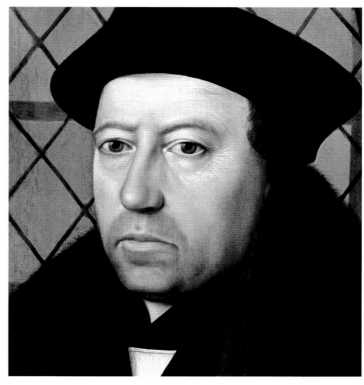

My deuise for the Succession.

317

1 For lakke of issu of my body. To the L Fraunceses heires masles, and her heires masles, to the L Jane and her heires masles, To the L Katerins heires masles, To the L Maries heires masles, To the heires masles of the daughters which she shal haue hereafter. Then to the L Margets heires masles. For lakke of such issu, To theires masles of the L Janes daughters To theires masles. of the L Katerins daughters and so furth til you come to the L margets daughters heires masles.

2 If after my death theire masle be entred into 18 yere old, then he to haue the hole rule and gouernance therof.

3. But if he be under 18, then his mother to be gouuernres til he entre 18 yere old. But to dee nothing w'out thaduice and agrement of 6 parcel of a counsel to be pointed by my last will to the nombre of 20.

4 If the mother die befor theire entre into 18 the realme to be gouerned by the counsel Prouided that after he be 14 yere al great matters of importaunce be opened to him.

5. If i died w'out issu, and ther were none heire masle, then the L Frauncess to be gouuernres for lakke of her the her eldest daughters and for lakke of them the L margets to be

Under Henry's rule Cranmer could not make radical changes, due to power struggles between religious conservatives and reformers, but when Edward came to the throne, he was able to promote major reforms.

The Archbishop wrote and compiled the *Book of Common Prayer*, a complete liturgy for the English Church and now the only legal form of worship. He changed doctrine in areas such as clerical celibacy, and in 1549 the first Act of Uniformity removed aspects of Catholicism such as the role of images in churches and the veneration of saints.

By the same year Edward had written a treatise on the Pope as an antichrist, and was making notes when he listened to sermons from priests such as Hugh Latimer, who was court preacher until 1550. Later, in the reign of Queen Mary, both Cranmer and Latimer were tried for their beliefs and burned at the stake outside Balliol College, Oxford.

DEVISE FOR THE SUCCESSION

In 1552 Edward was preparing to emerge as King in his own right and, apart from a bout of measles, his health was good. But early in 1553 he fell ill again, with a fever and cough. The Imperial Ambassador, Jean Scheyfve, reported that "he suffers a good deal when the fever is upon him, especially from a difficulty in drawing his breath ... the matter he ejects from his mouth is sometimes coloured a greenish yellow and black, sometimes pink, like the colour of blood".

Edward's doctors believed he was suffering from a tumour of the lung and finally admitted that his life was beyond recovery. Soon his legs became so swollen that he had to lie on his back, and he lost the strength to resist the disease. To his tutor John Cheke he whispered, "I am glad to die."

The young King's suffering ended at Greenwich Palace on 6 July 1553, about three months before his sixteenth birthday. The surgeon who opened his chest after death found that "the disease whereof his majesty died was the disease of the lungs". The Venetian ambassador reported that Edward had died of consumption – in other words tuberculosis; a diagnosis accepted by most historians.

Edward VI was a clever boy who coped well with the enormous pressures forced on him from a very young age by his father, and showed signs of becoming a strong ruler himself; his last journals show a growing maturity and interest in state affairs. Edward's reign was one of dramatic change and tumult, yet many of the changes from this period – certainly in terms of religious reformation – have endured the more than four centuries since his death.

King Edward regarded his half-sisters Mary and Elizabeth as illegitimate and excluded them from the succession. As his death approached, he changed his will so that his Protestant cousin Jane Grey could inherit the Crown.

The traditional view is that it was Northumberland's plot to maintain his power by placing his family on the throne, after the King's death, but many historians now see the project as being Edward's. Certainly the Duke knew that Mary's accession would eclipse his power and might even lead to his death. The "Devise for the Succession" was a gamble he was therefore willing to take and one which might just succeed.

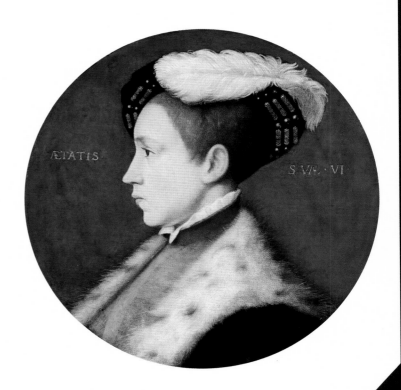

THE TRAGEDY OF JANE GREY

ROYAL BLOOD

Jane Grey inherited her royal blood from her mother, Frances Brandon, the elder daughter of King Henry VIII's younger sister Mary Tudor, former Queen of France. The sex of their first child would have been a disappointment to Frances and her husband Henry Grey, Duke of Suffolk. However, the little girl was to be given the same excellent education as a boy, studying Latin, Greek and Hebrew. Through the influence of her father and her tutors she became a committed Protestant and was deeply religious to the end of her short life. Her upbringing was strict and typical of the time, but it's clear that Jane regarded it as harsh.

To the visiting scholar Roger Ascham, who found her reading Plato, Jane is said to have complained,

For when I am in the presence either of father or mother, whether I speak, keep silence, sit, stand or go, eat, drink, be merry or sad, be sewing, playing, dancing, or doing anything else, I must do it as it were in such weight, measure and number, even so perfectly as God made the world; or else I am so sharply taunted, so cruelly threatened, yea presently sometimes with pinches, nips and bobs and other ways (which I will not name for the honour I bear them) ... that I think myself in hell.

In May 1553, at the wish of her family, Jane married Lord Guildford Dudley, youngest son of John Dudley, Duke of Northumberland, the most powerful man in the country. If Jane ever came to the throne, it was assumed her husband or father-in-law would take control, since female authority was perceived to be unnatural.

A RELUCTANT QUEEN

On the death of Edward VI, Jane was informed that she was now Queen and accepted the crown with reluctance. On 10 July, four days after Edward's death, she was officially proclaimed and took up residence in the Tower of London, where English monarchs always resided from the time of accession until coronation. The populace of London did not respond to this with joy. Jane was also not as compliant as Northumberland had expected, saying she would make her husband Guildford Dudley a duke but not a king.

OPPOSITE: Nineteenth-century hand-coloured engraving of Roger Ascham calling on Lady Jane Grey at Bradgate Park, 1550.

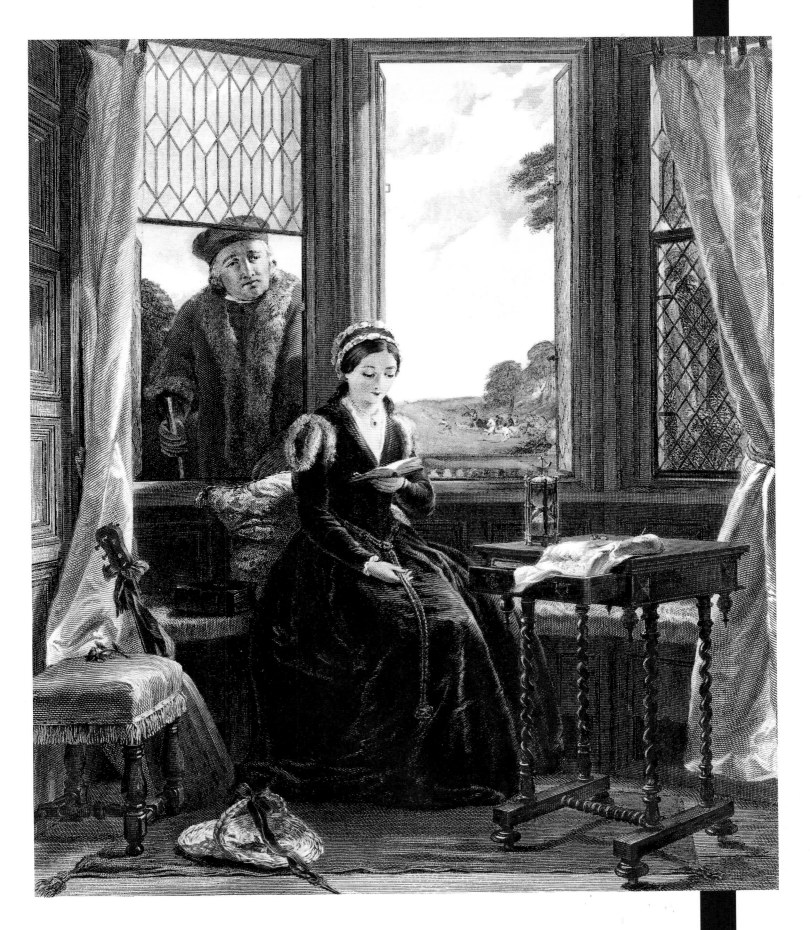

> "If my faults deserve punishment, my youth at least, and my imprudence, were worthy of excuse. God and posterity will show me more favour."
>
> (Jane Grey)

RIGHT: Original letter of Lady Jane Grey, signed by her as "Quene".

OPPOSITE: "Lady Jane Grey's Reluctance to Accept the Crown" by W. H. S. Aubrey, 1890.

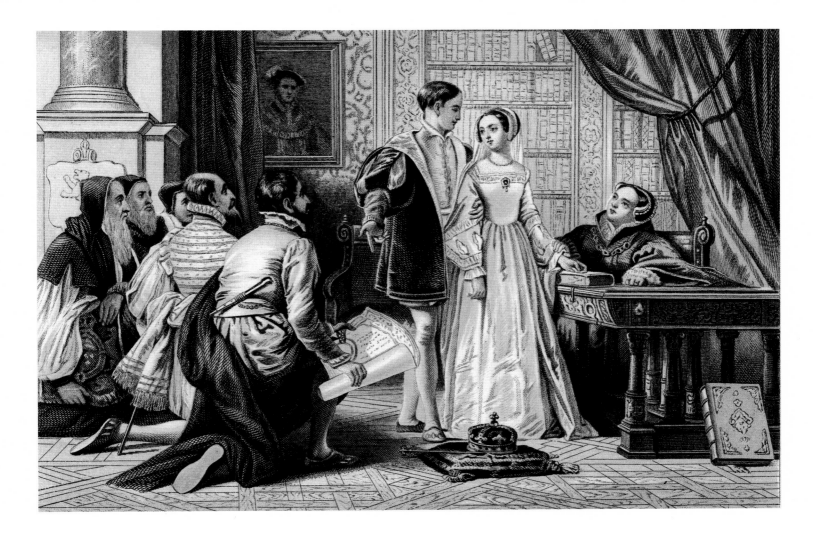

Northumberland needed to consolidate the new regime and, most importantly, he had to capture Mary Tudor to prevent her from gathering support. In this he failed, for as soon as Mary knew of her brother's death, she set out to East Anglia, where she began to rally her supporters, raising her standard at Framlingham Castle in Suffolk. Northumberland left London to meet her opposition and his power base unravelled very quickly.

By 19 July, the Privy Council switched their allegiance and in London proclaimed Mary queen. The historical consensus for this assumes it was in recognition of overwhelming support of the population for Mary, as the eldest daughter of King Henry VIII.

On 19 July 1553, Jane was moved from the royal apartments and imprisoned in the Tower's Gentleman Gaoler's lodgings. Guildford Dudley was held in the Beauchamp Tower with his brothers. The Duke of Northumberland was executed the following month, and Parliament declared Mary the rightful queen, then denounced Jane as a usurper. Referred to as Jane Dudley, wife of Guildford, Jane was charged with high treason, as was her husband.

Their trial took place on 13 November 1553 at Guildhall in the City of London. As was to be expected, the defendants were found guilty and sentenced to death. Jane's guilt of having treacherously assumed the title and the power of the monarch was evidenced by a number of documents she had signed as "Jane the Quene". Her sentence was to "be burned alive on Tower Hill or beheaded as the Queen pleases".

However, the Imperial Ambassador, Simon Renard, reported to Charles V, Holy Roman Emperor, that her life was to be spared. Queen Mary had no desire to execute her young cousin and also hoped to "save her soul", despite Jane's still fierce condemnation of the Catholic Mass and steadfast refusal to convert, even in her perilous situation.

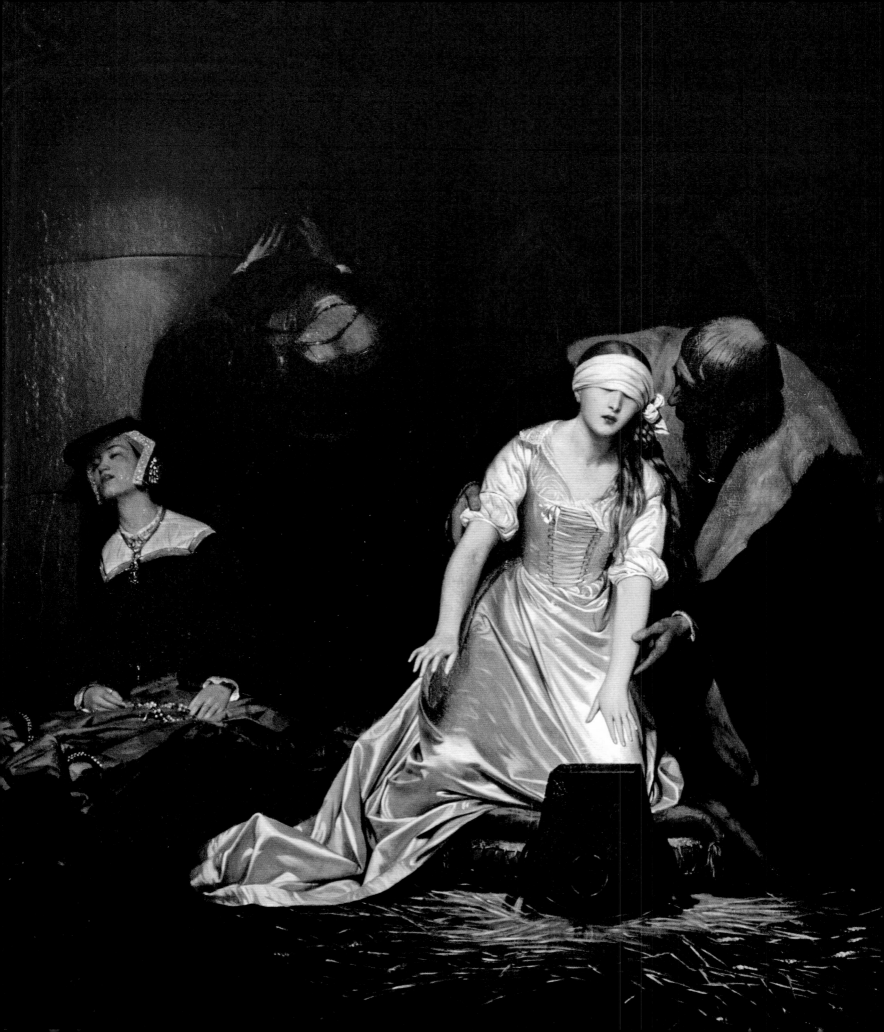

It was the rebellion of Thomas Wyatt the Younger in January 1554, against Mary's marriage plans with Philip of Spain, that sealed Jane's fate. Her father Henry Grey joined the rebellion, and so the government decided to go through with the verdict against Jane and Guildford.

DEATH AND POSTERITY

On the morning of 12 February 1554 the authorities took a weeping Lord Guildford Dudley from his rooms in the Beauchamp Tower to the public execution place at Tower Hill, where he was beheaded. Tradition has it that Jane saw his body when a horse and cart brought his severed remains back to the Tower, past the windows of her prison.

Later the same day she was taken out to Tower Green, within the Tower grounds, to be beheaded. Dressed in black, Jane mounted the scaffold and made a short speech to the watching crowd. The executioner asked her forgiveness, which she granted him, pleading, "I pray you dispatch me quickly." She then blindfolded herself but failed to find the block with her hands and cried, "What shall I do? Where is it?" It may have been Sir Thomas Brydges, the Deputy Lieutenant of the Tower, who helped her find her way. With her head on the block, Jane spoke her last words: "Lord, into thy hands I commend my spirit!"

Jane's father, the Duke of Suffolk, was executed soon after and her mother Frances Brandon married her own Master of the Horse, Adrian Stokes, the following year. The Duchess was fully pardoned by Queen Mary and allowed to live at court.

Jane Grey was around seventeen years old at the time of her execution. She has long been viewed as a victim in the power game of Tudor politics, but behind the legend was an opinionated adolescent, strong and steadfast in her religious beliefs. As a Protestant icon, she featured in the *Book of Martyrs* by John Foxe and the tale of the tragic "nine-day queen" grew in popular culture, producing numerous romantic biographies, novels, plays and paintings.

However, Jane Grey is the only English monarch in the past five hundred years of whom no proven contemporary portrait survives – though whether her short reign was legitimate is disputed.

LEFT: "The Execution of Lady Jane Grey in 1554" by the French artist Paul Delaroche, 1833. Despite its popularity the painting is not an accurate portrayal of her execution.

MARY TUDOR

ENGLAND'S FIRST QUEEN

The short reign of England's first Queen, Mary Tudor,
has traditionally been viewed as unsuccessful, and the
burning of Protestants earned her the sobriquet of
"Bloody Mary" in the seventeenth century. However,
she came to the throne amid popular acclaim and paved
the way for her sister, Elizabeth, to be accepted as a
female sovereign. Her courage, in the face of almost a
lifetime of adversity, has never been in doubt.

A KING'S DAUGHTER

Mary Tudor was the only child of Henry VIII and Katherine of Aragon. She was born at Greenwich Palace on 18 February 1516 and she was baptized the following Wednesday, Cardinal Wolsey standing as her godfather. In the course of seven pregnancies Katherine of Aragon had given birth to three sons, who died either at birth or within weeks. Mary was to be the only one of her children to survive and, as such, the little girl with beautiful red hair was much cherished. If just one of Mary's brothers had lived to be a future king, her life would have been very different – less exalted but probably much happier.

Princess Mary seems to have been a precocious child and is reported in July 1520, when four years old, as entertaining important visitors by a performance on the virginals. Her education was supervised by her mother and she was taught by Humanist tutors to be a competent Latin scholar. When she was nine years old, she was addressed in a Latin oration by commissioners sent over from Flanders, and replied to them in the same language "with as much assurance and facility as if she had been twelve years old".

While still an infant, she was proposed in marriage to the dauphin, son of King Francis I of France. In 1522, when the French alliance was broken off, she was betrothed to her cousin, the Holy Roman Emperor Charles V, by the Treaty of Windsor. However, within a few years Charles released himself from this engagement and made a more convenient match.

Before her tenth birthday Mary was given an establishment of her own on the borders of Wales, at Ludlow, where she represented her father, with a household of three hundred persons. For some years she kept her court here while new arrangements were made for the disposal of her hand; but the great match expected for such an important princess would never happen.

[N]ot only is she brave and valiant ... but so courageous and resolute that neither in adversity nor peril did she ever even display or commit any act of cowardice ...

(Giovanni Michieli,
Venetian ambassador to Mary I)

OPPOSITE: "Queen Mary I" by
Hans Eworth, c.1555–58.

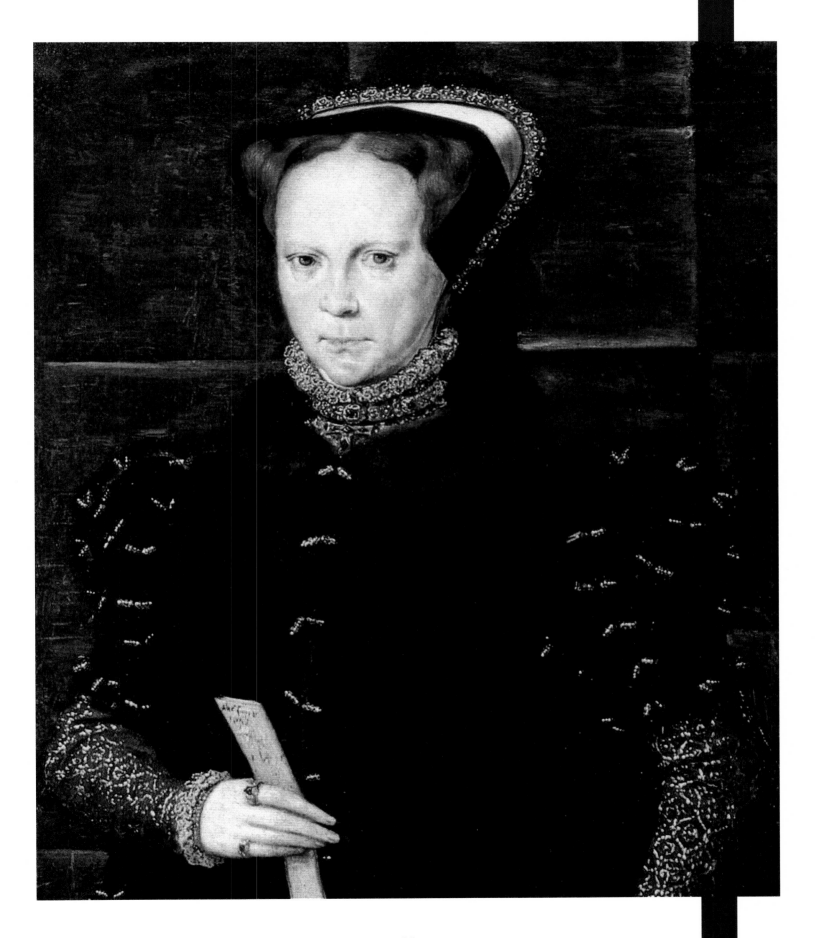

A BANISHED PRINCESS

By 1527 Henry VIII was determined to put Queen Katherine aside and marry Anne Boleyn. He needed a son and he was passionately in love with Anne, so the two desires combined into an obsession. Mary's happy childhood came to an end at the time of her parents' separation in 1531. The subsequent years would be painful, while Henry VIII sought an annulment of his marriage and kept mother and daughter apart.

In 1533 the Archbishop of Canterbury, Thomas Cranmer, formally dissolved the King's union with Katherine, and Henry proceeded to marry Anne Boleyn. Removed from court and treated as a bastard, Mary was, on the birth of Anne's daughter Elizabeth, sent to Hatfield to act as lady-in-waiting to her own infant half-sister. She was to no longer be called "Princess", but rather the "Lady Mary".

Her new stepmother Queen Anne argued that her own daughter should be christened "Mary", as she was born on the eve of the Virgin Mary's nativity. Henry, sensibly, refused this, but the Lady Mary lost much-loved attendants and now came under the authority of the Queen's aunt, Lady Shelton. At Hatfield, Mary was made to feel her inferiority to Elizabeth and, on one occasion, Anne ordered Lady Shelton to box her ears "as the cursed bastard she was".

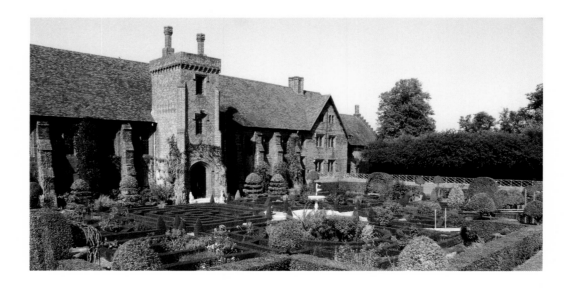

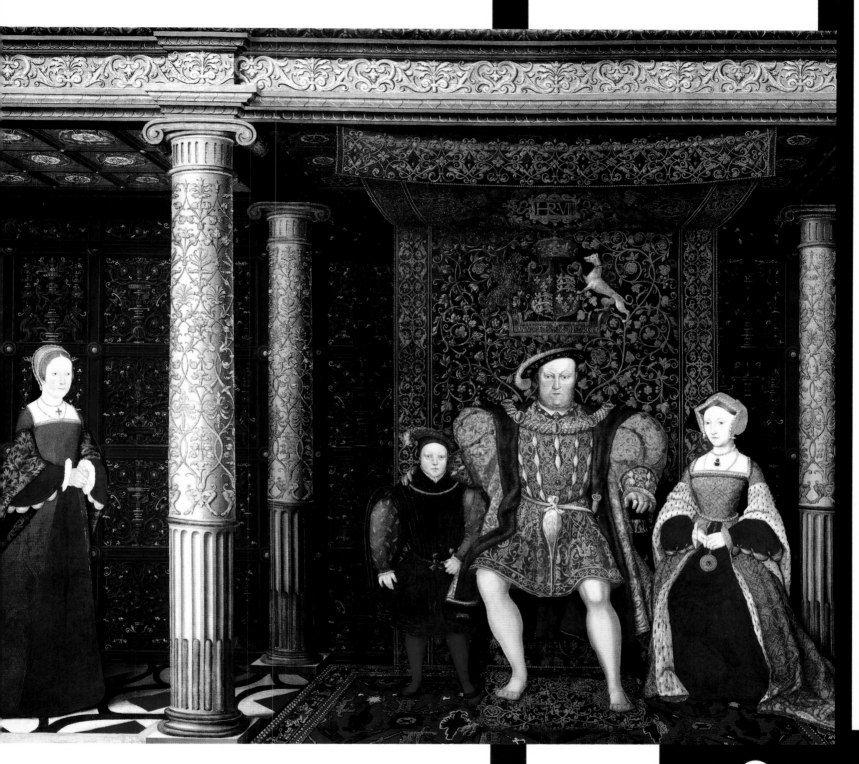

ABOVE: Detail from "The Family of Henry VIII". Lady Mary stands to the left. The large column separating her from her brother denotes her illegitimate status.

OPPOSITE: Hatfield Palace, where Mary joined the household of the infant Princess Elizabeth.

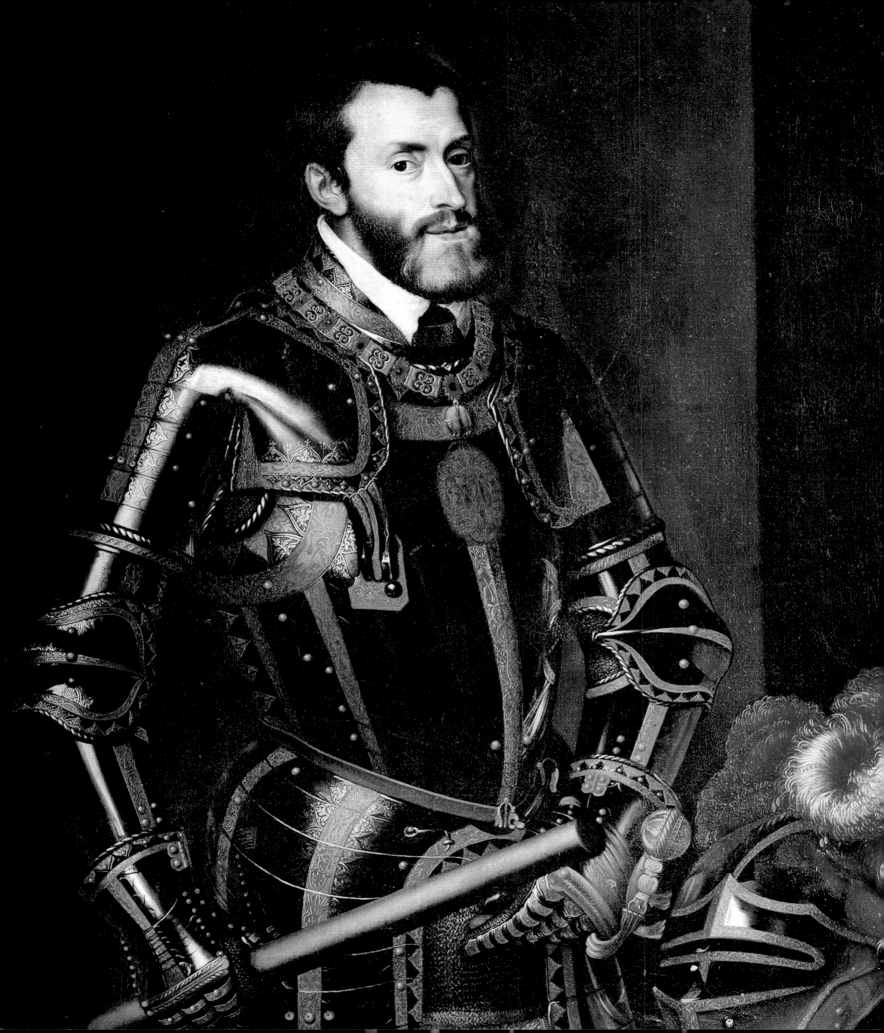

When harsh treatment failed to subdue the girl, Anne offered to have her restored to favour, if only she would recognize her as the true Queen of England. Mary replied boldly that she knew of no other queen save her lady mother, but would appreciate it if the King's mistress would recommend her to her father.

In spite of this outward defiance, deep unhappiness began to take its toll on the seventeen-year-old Mary. She suffered from illnesses that may have been stress-related, such as headaches and infrequent menstruation. Even when she was ill, Henry would not let her mother visit her, and one of his cruellest acts was to forbid Mary to see her dying mother in January 1536. In May of the same year Anne Boleyn fell under the King's displeasure and was put to death.

Mary was then urged to make a humble submission to her father and, after a good deal of correspondence with the King's secretary, Thomas Cromwell, she actually did so. We know it took a great deal of persuasion because Cromwell described her that year as "the most obstinate woman that ever was". Her final capitulation meant repudiating the Pope's authority, and confessing that the marriage between her father and mother "was by God's law and man's law incestuous".

All Europe still looked on Mary as the only lawful child of her father, but the psychological pressure brought to bear on her had been intense. Due to the illegitimate status, bestowed on her by the King, the chance of a good marriage seemed remote, and she told the French ambassador that she thought she would always remain "only Lady Mary, the unhappiest lady in Christendom".

Her life, however, was about to improve in the last years of Henry VIII's reign as, now reconciled with her father, Mary was given her own household again. Her privy purse accounts show that Beaulieu in Essex and Hunsdon in Hertfordshire were her principal homes, and that she received money for clothes on the King's warrants.

A portrait from 1544, when she is in favour with the King, shows the 28-year-old Mary wearing a striking cloth-of-gold gown with a pomegranate design. The artist, Master John, used silver and gold leaf and a rich red glaze to recreate the sumptuous and expensive materials she was wearing, showing that this was a young woman of extremely high status.

Although she was still considered illegitimate, Henry VIII, having obtained from Parliament the extraordinary power to dispose of the Crown by his will, restored her to her place in the succession with the Third Succession Act in 1543.

However, under the reign of her brother Edward VI, Mary was again subjected to attacks on her religion. The new regime was set on overtly Protestant beliefs, which put Mary completely at odds with the younger brother she loved. Edward was as firmly

Protestant as Mary was Catholic and, as the new head of the Church of England, he took his duty very seriously. He lectured his older sister not only on her religion but her pastimes, saying that she should "attend no longer to foreign dances and merriments which do not become a most Christian princess".

In 1550 she seriously thought of taking flight and escaping abroad to her cousin, the Emperor Charles V. He and his ambassador, Eustace Chapuys, had always advised and protected the young woman through her years of adversity. It was a great advantage for Mary to have such an immensely powerful relative, who intervened on her behalf and negotiated with Edward's Privy Council.

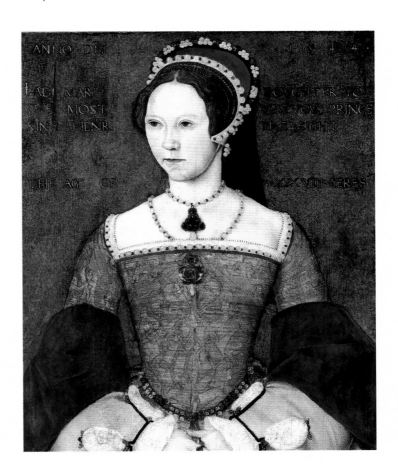

ABOVE: The Lady Mary, aged twenty-eight, by the English artist, Master John.

OPPOSITE: "Emperor Charles V" by Juan Pantoja de la Cruz, After Titian, 1550. He was Mary's cousin and greatest protector.

A WARRIOR QUEEN

King Edward died early in July 1553 and within days Mary called for support, then raised her standard at Framlingham Castle in Suffolk. The move was a courageous gamble. The Duke of Northumberland had already installed her cousin Jane Grey as Queen, and all of the Privy Council at first stood with Jane. However, the rest of the country was devoted to Mary's cause; her right in law was unquestionable, she was King Henry's daughter, and so her army and support grew quickly.

No one had expected this from Mary and doubt began to spread among the Privy Council. They had remained in London when Northumberland marched off to meet Mary's forces, and one by one they now changed sides. Finally, aware that his cause was lost, Northumberland surrendered without any bloodshed.

Mary Tudor, at the age of thirty-seven, was proclaimed Queen on 19 July 1553 in London and, accompanied by her sister Elizabeth, she entered the city soon after to widespread joy. Her clemency toward those who had taken up arms against her was altogether remarkable. She released from prison Lady Jane's father, the Duke of Suffolk, and fully intended to spare Jane herself.

For counsel the new Queen looked to Stephen Gardiner, Bishop of Winchester, who became her Lord Chancellor, and she continued to rely on the advice of her cousin, the Emperor Charles V. Mary also retained her brother's Lord High Treasurer, William Paulet, 1st Marquess of Winchester, assigning him to oversee the revenue collection system and plan currency reform, English coinage having been debased under both Henry VIII and Edward VI.

From the start, she was a hard-working queen, attending endless council meetings and seldom retiring before midnight. The Venetian ambassador recorded that she rose "at daybreak when, after saying her prayers and hearing mass in private", she would "transact business incessantly".

Her first Act of Parliament was the validation of her mother's marriage to Henry VIII, which meant Mary was once

again legitimate, followed by the Act for Regal Power, which enshrined in law that a queen regnant held power as "fully, wholly and absolutely" as any king. And Mary's coronation saw her crowned with the full regalia of a male monarch.

The new Queen fervently wished to restore the Catholic Church in England and to provide England with a Catholic heir. She therefore needed a husband as soon as possible.

OPPOSITE: Engraving of Mary I based on an original painting by Antonis Mor.

BELOW: "Entry of Queen Mary I with Princess Elizabeth into London in 1553" by John Byam Liston Shaw, 1910. Mary is depicted releasing the Duke of Norfolk and Bishop Stephen Gardiner (who were both Catholics) from the Tower of London.

SPANISH MARRIAGE

Marriage to Emperor Charles V's son, Philip of Spain, made perfect sense to Mary. No one at the time believed a female sovereign could rule alone; Philip was Catholic and Spain was a long-time ally of England. However, her subjects feared this marriage would put England under the dominion of Spain, and seditious pamphlets inflamed the people with hatred against Spaniards. Parliament petitioned the Queen against the marriage, but Mary was determined.

News of her intentions provoked insurrections in different parts of the country; the Duke of Suffolk, whose first rebellion against Mary had been pardoned, proclaimed his daughter Jane queen again. The most serious rebellion was led by the Kentish gentleman Sir Thomas Wyatt. Mary called out her troops and, refusing to flee in the face of a rebel army heading into London, rode to Guildhall and made an impassioned speech defending her rights.

The rebellion soon failed but it had serious consequences. Princess Elizabeth, heir to the throne, was implicated in the Wyatt plot and sent to the Tower of London in March 1554. Known to be Protestant and viewed as a threat, Elizabeth spent two months in fear of her life before being released.

Jane Grey was not so fortunate and went to the block within weeks of her father's uprising. In the midst of the danger Mary had shown herself calm and steadfast once more; the rebellion was crushed and her plans were going ahead.

Winchester Cathedral, on a rainy day in 1554, was the setting for the marriage of the Queen of England and Philip of Spain. Mary appeared gorgeously attired, recorded in one contemporary report as wearing a dress of "rich tissue with a border and wide sleeves,

ABOVE: Sir Thomas Wyatt the Younger, c.1550, was the son of Thomas Wyatt, the celebrated poet from the court of Henry VIII.

OPPOSITE: "Philip II, King of Spain". Copy of an original portrait painted by Titian which was sent to Mary Tudor in England in 1553.

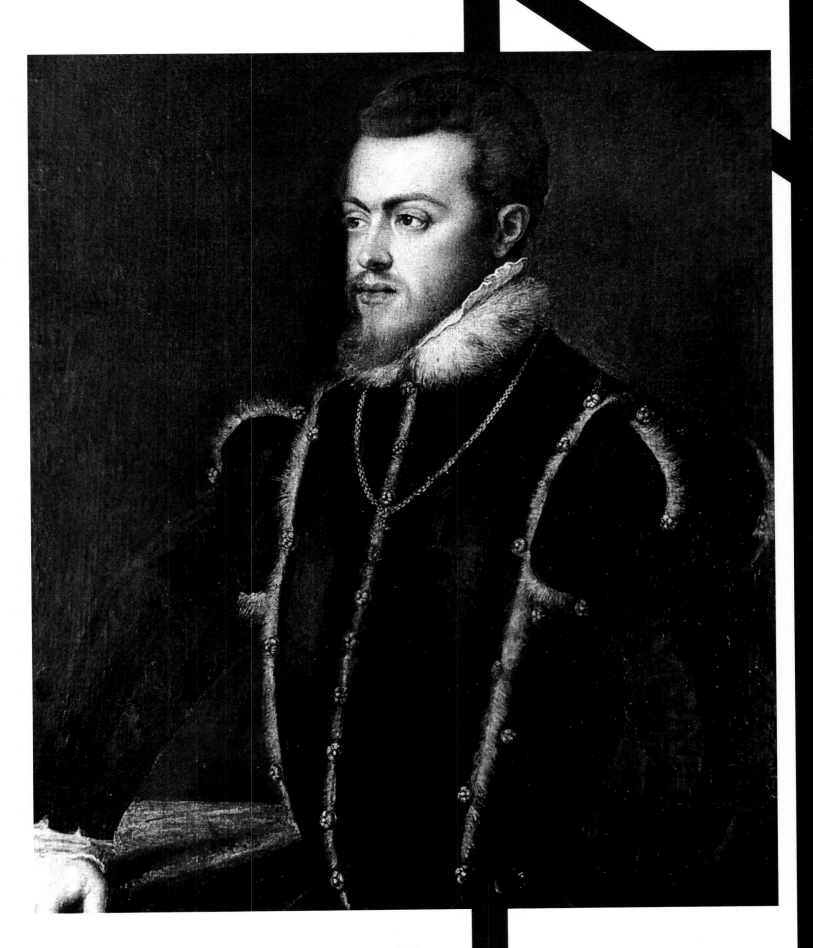

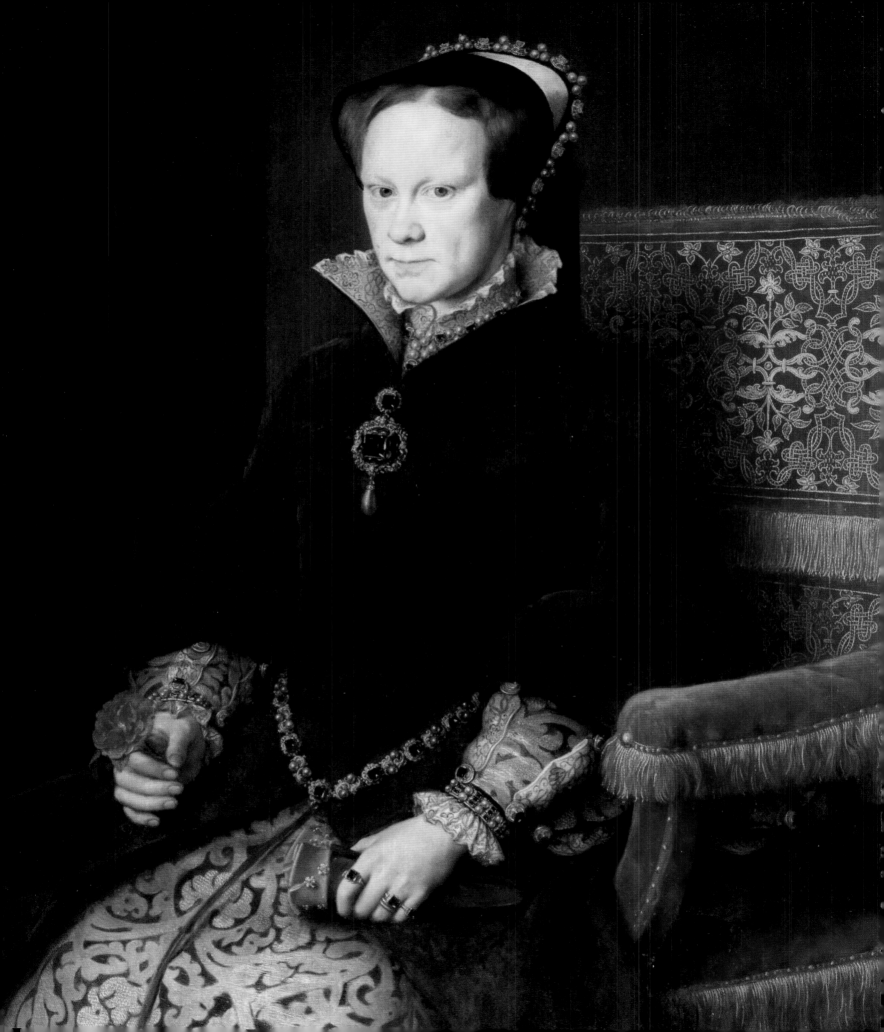

embroidered upon purple satin, set with pearls of our store, lined with purple taffeta".

But her new husband was eleven years younger than Mary, who was thirty-eight, and he did not find her attractive. A vivid description left to us by the Venetian ambassador said, "she is of low rather than of middling stature, ... of spare and delicate frame", and that she had "wrinkles, caused more by anxieties than by age, which makes her appear some years older".

The realistic 1554 portrait of Mary by the artist Antonis Mor confirms this description and shows how adversity had prematurely aged her. For Philip the marriage was purely political, but the Queen fell in love for the first time in her life.

Philip and Mary appeared on coins together, with a single crown suspended between them as a symbol of joint reign. However, as the marriage treaty stipulated, he did not hold equal power in ruling England. An Act of Parliament gave him the title of king but, significantly, stated that he "shall aid her Highness ... in the happy administration of her Grace's realms and dominions".

FALSE PREGNANCY

Mary was subject to frequent illness all her adult life, and feelings of "a very deep melancholy, ... so that the remedy of tears and weeping, to which from childhood she has been accustomed, and still often used by her, is not sufficient; she requires to be blooded". Her false pregnancy is one of the saddest aspects of her medical history and twice during her reign she believed that she was with child. It is possible that she so convinced herself that her body responded as if she were pregnant.

A few months after her marriage she was experiencing morning sickness and her belly was growing. She wanted a child as desperately as her father had once wanted a son, to ensure the Catholic religion that she was determined to restore. Mary was overcome with joy when, in November 1554, she thought the child moved, and thanksgiving services were ordered. She wrote to her cousin and father-in-law, "As for that which I carry in my belly, I declare it to be alive and with great humility thank God for His great goodness shown to me."

Around Easter, Mary withdrew for her lying-in at Hampton Court Palace but, as the due date came and went, no baby arrived. Finally, the Queen had to accept, with sorrow and humiliation, that her pregnancy was false. She would suffer another imagined pregnancy in 1557 and she may have had an ovarian cyst that could have contributed to her early death.

TOP: Silver Shilling showing facing busts of Philip and Mary with crown, 1554.

ABOVE: (Reverse) Garnished shield with arms of Spain and England.

OPPOSITE: "Mary Tudor, Queen of England" by Antonis Mor, 1554. This accomplished work depicts a realistic image of Mary, aged thirty-eight.

COUNTER-REFORMATION

Though Henry VIII had broken from Rome, he was conservative in his religious beliefs and fully prepared to burn for heresy anyone he perceived to be radical. The English Reformation took place in the reign of his son, Edward VI, but Protestantism was still a minority religion, supported by the educated of London and urban areas.

Queen Mary's return to the old Catholic faith would not have unsettled the majority of her subjects, and Parliament, reassured that monastery lands need not be returned, now bowed again to the supremacy of Rome. White-washed churches were once more filled with colour as altars, statues and painted windows were replaced, and processions and ceremonies restored.

Reginald Pole, Mary's cousin, arrived as papal legate in November 1554, and together they planned a reformed Catholic Church in England. The old heresy laws were revived by Act of Parliament and the process of counter-Reformation naturally included the persecution of heretics.

The first to die was John Rogers, a Bible translator and Protestant preacher, sentenced to death for "heretically denying the Christian character of the Church of Rome". Shortly before his execution, Rogers was offered a pardon if he were to recant, but he refused and was burned at Smithfield in February 1555.

John Hooper, Bishop of Gloucester, suffered the same fate and the burnings continued for nearly four years, with victims including Bishops Ridley and Latimer. Whether, as the flames were kindled, Latimer really said, "We shall this day light such a candle by God's grace in England as shall never be put out" is uncertain, but nothing has given the Marian restoration – and Mary herself – a worse reputation than the fires of Smithfield. Nearly three hundred victims are known to have perished at the stake.

The Queen wanted to make an example of high-profile opponents and none more so than Thomas Cranmer, Archbishop of Canterbury – the highest ranking of all. Twenty years earlier Cranmer had pronounced Mary's parents' marriage invalid; he was the chief architect of the Protestant Reformation, under her brother; and he had also taken part in the plot to make Jane Grey queen.

OPPOSITE: Cardinal Reginald Pole, the last Catholic Archbishop of Canterbury and architect of Mary's counter-Reformation.

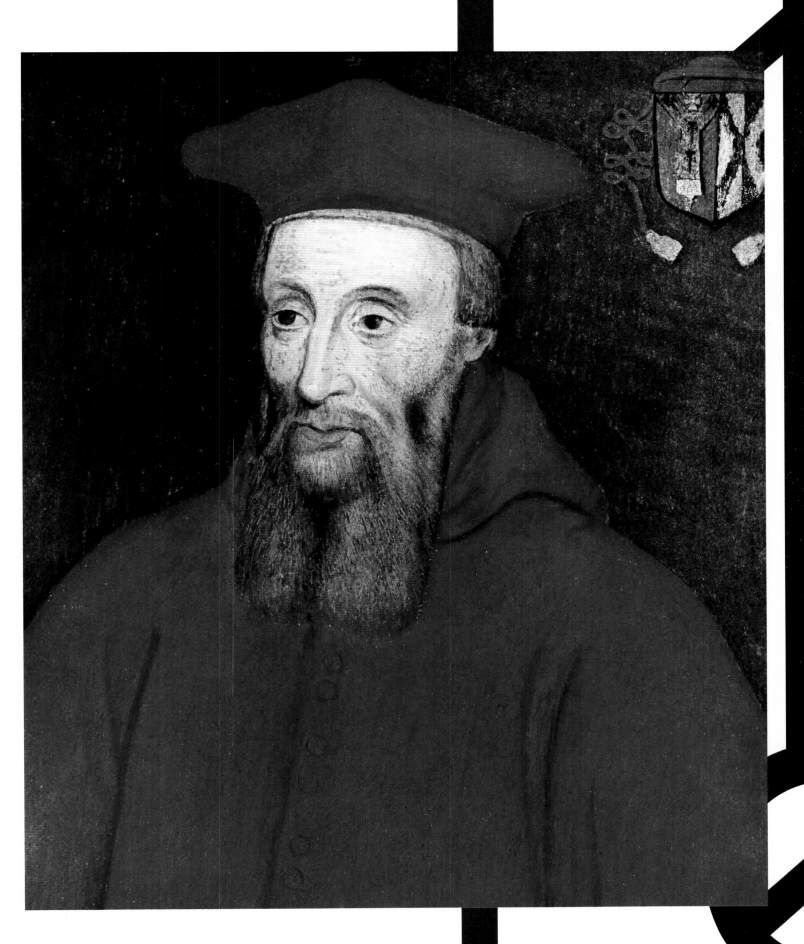

The Marian authorities gave religious prisoners a chance to save themselves from the flames, in return for a recantation of their beliefs, but there was to be no reprieve for Thomas Cranmer. The Queen was set on personal revenge. Terrified of the flames, the old man at first recanted and accepted papal supremacy. Later, when he realized that this would not save him, he renounced his recantations publicly at Oxford, saying, "And as for the Pope, I refuse him, as Christ's enemy." He was pulled from the pulpit and taken to be burnt where Latimer and Ridley had died six months before.

Mary had not intended to make martyrs of the Protestant bishops – and the hundreds of humble men and women who opposed her – but their deaths were recorded by John Foxe in his *Acts and Monuments*, commonly known as *Foxe's Book of Martyrs*. Emphasizing the sufferings of English Protestants in the reign of Mary I, the book was illustrated with violent woodcuts of torture and executions. It was widely owned and read after Mary's death, and hugely influential in shaping English popular opinion against the Catholic Church.

RIGHT: The death of Archbishop Thomas Cranmer, burned at the stake for heresy in 1556. Woodcut from *Foxe's Book of Martyrs*.

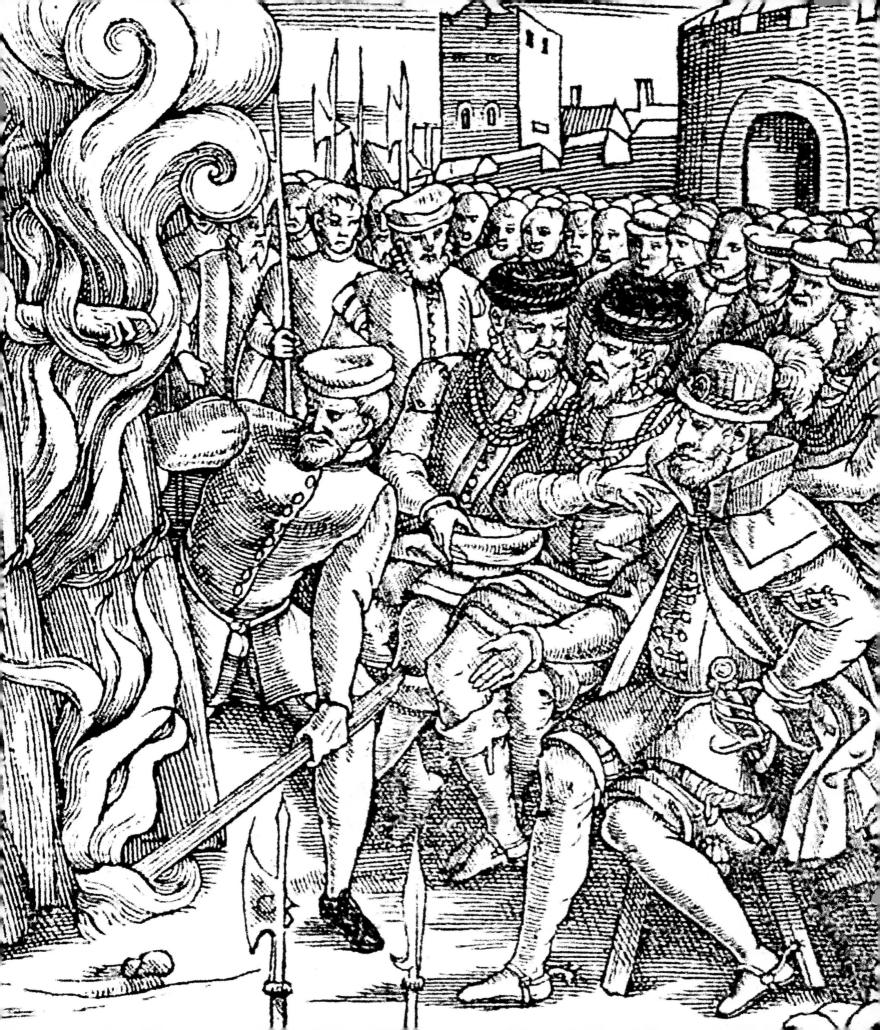

LEGACY

The traditional narrative of Mary's five-year reign is one of cruel persecutions and disasters. Her regime had to confront difficult economic circumstances and the years of her reign were consistently wet, leading to flooding, bad harvests and famine.

Philip left for Brussels just a year after their marriage, to Mary's deep distress. He received from his father the kingdom of Spain and did not return to England until March 1557. The Queen was overjoyed to see him again, but this last visit was with the aim of involving England in the war against France, after which he left for good.

The war was regarded as a failure because, in January 1558, England lost Calais – the last French possession, held since the fourteenth century. Although Calais actually cost more to maintain than it was worth, this was regarded as a national dishonour. Mary certainly felt the humiliation, although there is no contemporary evidence for her having said that when she died, Calais would be found engraved on her heart.

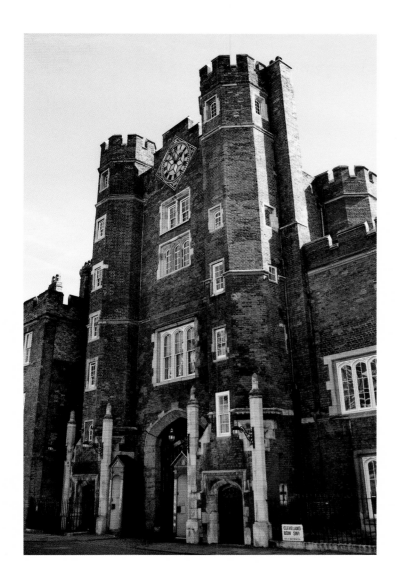

OPPOSITE: Gold medal minted in 1555. The Latin legend translates as "Mary I Queen of England, France and Ireland, defender of the faith".

LEFT: St James's Palace, where Mary I died in November 1558.

Mary was ill and in pain from May 1558, possibly from ovarian cysts or uterine cancer. On 17 November she died at the age of forty-two, at St James's Palace, during an influenza epidemic. Several Protestant heretics were saved from the Smithfield stake, moments before the kindling beneath them was lit, after a royal messenger announced the Queen's death. Her cousin Reginald Pole – the last Catholic Archbishop of Canterbury – died later the same day. The counter-Reformation was at an end.

However, Mary did make lasting advances during her reign and, far from being dark and gloomy, her court was filled with music, colourful pageants and masques. She had a penchant for betting on cards and dice and she loved rich clothing and jewels as much as her sister Elizabeth, using dress as a vehicle for magnificence. This is at odds with the picture of a joyless bigot so often painted by Protestant writers.

Mary maintained the building programme of the Tudor navy, and during her reign English shipwrights were able to examine and adapt modern Spanish galleon design to the needs of the English Navy. She laid the foundations for reform of the coinage, increased the authority of local government and endowed five new hospitals.

Although England gave Philip the title of king, the country did not benefit from Spain's lucrative New World trade. In an attempt to increase trade and rescue the English economy, Mary's government looked for new commercial opportunities, and in 1555 Mary granted a royal charter to the Muscovy Company. One of its founders, the English explorer Richard Chancellor, not only found and opened up a sea-trading route to Russia – and the court of Ivan the Terrible – but also brought back the first Russian ambassador to England.

Mary Tudor was the first woman to successfully claim the throne of England and if she had not fought for her right to rule in 1553, her sister Elizabeth might also have been excluded forever. Mary was steadfast and certainly brave, and she made it possible for women to rule on the same terms as men, setting the stage for Elizabeth to become possibly England's greatest monarch.

ELIZABETH I

GLORIANA AND
HER GOLDEN AGE

Elizabeth I was highly intelligent and a shrewd survivor
in the shifting sands of Tudor politics. We usually think
of her as a triumphant "Gloriana", who defeated the
Spanish Armada, but her early life was full of danger.
Her long reign helped forge a sense of English national
identity, shaped the Church of England, and proved
to be a "golden age" in exploration, drama, music
and literature.

CHILDHOOD AND EDUCATION

The last Tudor monarch was born at Greenwich Palace on 7 September 1533, the daughter of Henry VIII and his ill-fated second wife Anne Boleyn. Her birth caused disappointment to her parents because she was intended to be a boy. The letters prepared to announce the birth of the "Prince" show the word hastily changed into "Princess" by the addition of a scribbled letter "s".

Her mother Anne Boleyn was executed on 19 May 1536, when Elizabeth was just two years and eight months old. The charges against Anne included adultery with five men, and the death warrant was signed by Elizabeth's father Henry VIII. Somehow Elizabeth reconciled her feelings for her parents, growing up devoted to her father but acknowledging her mother, too. In time she would adopt Anne's falcon badge and she wore a ring which bore both her own and her mother's portrait.

Anne had entrusted her daughter to the care of Margaret Bryan, her Lady Governess, who thought her "as toward a child and as gentle of conditions as ever I knew any in my life". In August 1536, Lady Bryan wrote to Secretary Cromwell of the disorder in the Princess's household

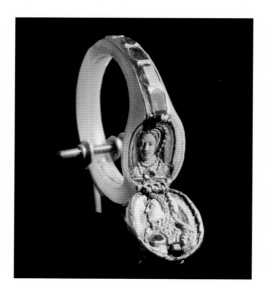

following her mother's fall. She reported that Elizabeth "has neither gown nor kirtle nor petticoat nor linen for smock", as the child was out-growing her clothes.

Elizabeth lost Lady Bryan to Prince Edward's service in October 1537, but her care was taken over by two surrogate mothers who would influence her life for decades. The first was Blanche Parry, Elizabeth's former cradle-rocker, and the second was Kat Ashley, who joined the household as governess. Both would advise and protect Elizabeth through her dangerous formative years and well into her reign. Kat remained Elizabeth's friend until the former's death in 1565; Blanche was by her side even longer, pre-eminent at the Elizabethan court until her death in 1590, at the age of eighty-two.

Elizabeth received a rigorous Humanist education under a series of distinguished tutors, of whom the best known is the Cambridge scholar Roger Ascham. Her studies centred on classical languages, history, rhetoric and moral philosophy. "Her mind has no womanly weakness," Ascham wrote, "her perseverance is equal to that of a man, and her memory long keeps what it quickly picks up." The child was an academic student, with a natural love of learning and fascination with languages. In addition to Greek and Latin, she became fluent in French and Italian, attainments of which she was very proud. Importantly, she also studied theology and learned the principles of her father's new Church of England – an education that would ultimately shape the future course of her country.

By the summer of 1543 Henry VIII had married his sixth wife, Katherine Parr, and Elizabeth found comfort in the new Queen's attention. Her earliest surviving letter, written in Italian, was addressed to Katherine Parr in 1544, a year after she and her sister Mary were restored to the succession. The following year, on New Year's Day, eleven-year-old Elizabeth gave her stepmother her own translation of the French devotional treatise *The Mirror of the Sinful Soul*. Elizabeth's translation was enclosed in a beautifully embroidered cover, with the initials "KP" incorporated, and worked in the princess's own hand.

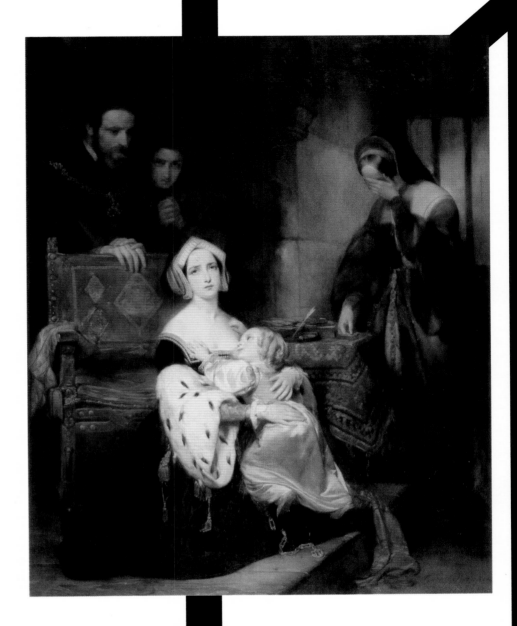

OPPOSITE: An extraordinary ring containing the portraits of Elizabeth and her mother, Anne Boleyn, made in 1575.

ABOVE RIGHT: "Anne Boleyn Says a Final Goodbye to her Daughter, Princess Elizabeth" by Gustaf Wappers, 1838.

RIGHT: Elizabeth's translation of *The Mirror of the Sinful Soul*.

I may not be a lion, but I am a lion's cub and I have a lion's heart.

(Elizabeth I)

A PRINCESS
IN DANGER

On the death of Henry VIII Katherine Parr married Thomas Seymour, and the couple took Elizabeth into their household. Her new step-father was handsome and Elizabeth was flattered by his attentions. Seymour paid morning visits to Elizabeth, in her bedchamber, before she was dressed, where romping and tickling took place. It is unclear how far this "playfulness" went but her reputation was being compromised. Finally, after Katherine Parr discovered the pair in an embrace, she ended the flirtation by sending Elizabeth away.

Katherine Parr died in childbirth in September 1548, and Seymour renewed his attentions toward Elizabeth, hoping to marry her, while also plotting to overthrow his brother, the Lord Protector. Seymour's suit to Elizabeth was rejected by the Privy Council and, when he was arrested for treason, details of his behaviour toward her emerged. Elizabeth was now implicated in a scandal so serious that her servants, Kat Ashley and Thomas Parry, were arrested and questioned in the Tower

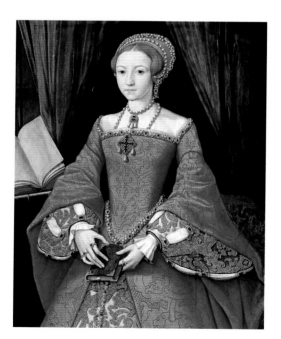

of London. There were even rumours that Elizabeth was pregnant by Thomas Seymour, and the Privy Council sent Sir Robert Tyrwhitt to Hatfield Palace to examine her. Elizabeth withstood all interrogation with such confidence that he reported, "She hath a very good wit and nothing is gotten of her but by great policy."

Elizabeth survived the crisis and the scandal taught her a valuable lesson. Given the lurid charges against her mother, she

Much suspected by me,
Nothing proved can be.

(The Lady Elizabeth)

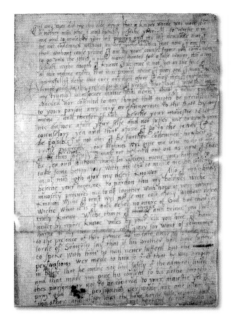

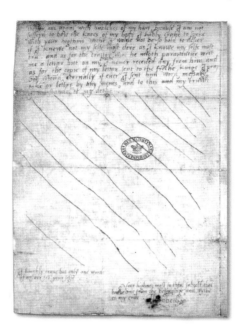

may have felt vulnerable to any slur on her virtue and she began to dress in a sombre fashion. Thomas Seymour was found guilty of high treason and executed in March 1549. Elizabeth wrote, "This day died a man with much wit and very little judgment."

By far the most dangerous episode of Elizabeth's life occurred in 1554, when she became one of the most famous inmates at the Tower of London and came close to execution.

Her brother Edward VI died the year before, leaving a will that excluded both Mary and Elizabeth from the succession, and instead declared as his heir Lady Jane Grey. Jane was deposed after nine days and, on 3 August 1553, Mary rode triumphantly into London with Elizabeth at her side. However, the solidarity of the sisters did not last long. Mary, a devout Catholic, was determined to crush the Protestant faith in which Elizabeth had been educated and when she ordered that everyone attend Catholic Mass, Elizabeth had to outwardly conform.

Mary's initial popularity ebbed away in 1554 when she announced plans to marry Philip of Spain. Discontent spread and many looked to Elizabeth as a focus for their opposition to Queen Mary's religious policies. In January 1554 the Wyatt rebellion broke out, a popular uprising named after its main leader. The Queen's overthrow was implied in the rebellion and her Protestant sister was implicated. Elizabeth fervently protested her innocence; it is unlikely that she had plotted with the rebels, but some of them were known to have approached her.

Elizabeth was interrogated at Whitehall Palace, then told she would be imprisoned in the Tower of London. On hearing this, she sat down and compiled one of the most famous letters of her life, in a desperate attempt to secure an audience with her sister, pleading, "Remember your last promise and my last demand that I be not condemned without answer and due proof."

Fearing that her enemies might alter the text, she struck lines across the blank space above her signature. It is known as the "Tide Letter" because Elizabeth wrote it so slowly that the low tide that enabled boats to pass under the narrow arches of London Bridge had turned, sparing her from the Tower for an extra day.

Elizabeth arrived at the Tower on 17 March 1554. She did not enter through Traitors' Gate but walked over a drawbridge to the Byward Tower. In the fifteenth and sixteenth centuries it was usual for kings and queens to use the Byward Tower gate, the private entrance to the Tower of London, and this is the route her mother Queen Anne had taken eighteen years earlier.

The yeoman of the guard, which had assembled to escort her, looked sympathetic to the young prisoner. Legend has it that she fell to her knees at the entrance, afraid to enter the fortress and declared: "Oh Lord, I never thought to have come in here as a prisoner, and I pray you all bear me witness that I come in as no traitor but as true a woman to the Queen's Majesty as any as is now living."

Held in her mother's former apartments, Elizabeth was comfortable but under severe psychological strain, and at times she felt convinced she was going to die. Her childhood friend, Robert Dudley, was held in the Beauchamp Tower, condemned for his part in the Jane Grey plot. In years to come, this shared experience formed a bond between them.

Elizabeth's interrogation continued, during which she vehemently proclaimed her innocence and defended herself against every accusation. Mary's closest confidant, Charles V's ambassador Simon Renard, argued that her throne would never be safe while Elizabeth lived; and the Chancellor, Stephen Gardiner, worked to have Elizabeth put on trial. However, Wyatt had refused to implicate Elizabeth in the rebellion and he asserted this again in his speech from the scaffold. Eventually lack of evidence meant Elizabeth was released into house arrest on 19 May, the anniversary of her mother Anne Boleyn's execution.

ACCESSION

Elizabeth became Queen on 17 November 1558 – a day that would be celebrated in England as Accession Day for decades afterward. Her sister Queen Mary had died early that morning. According to legend, Princess Elizabeth was sitting under an old oak tree in the grounds of Hatfield, reading a book, when Lords of the Council arrived to give her the news and present her with Mary's ring. Overcome with emotion, she sank to her knees and said in Latin, "This is the Lord's doing: it is marvellous in our eyes."

Although only twenty-five years old, Elizabeth had been made politically astute by the adversity and dangers of her youth. But good counsel was essential, too, and within hours of her accession Elizabeth appointed trusted servants who would become the mainstay of her regime: Sir Thomas Parry and Sir William Cecil.

Parry had been Princess Elizabeth's financial manager in the late 1540s and now became Controller of the Queen's Household. William Cecil had been a principal secretary of Edward VI, a role he reassumed immediately for Elizabeth. Prudent, shrewd and industrious, for almost the next forty years Cecil would be at Elizabeth's side as her chief minister and trusted counsellor.

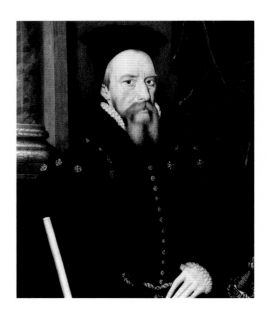

The week after her accession Elizabeth made a triumphal state entry into the City of London, where she was welcomed wholeheartedly, and on 15 January 1559 England's new sovereign was crowned queen. It was the last occasion on which the Latin service was used, as Elizabeth I in her coronation robes, patterned with Tudor roses and trimmed with ermine, was crowned with full Catholic ritual.

However, Elizabeth was not committing herself to the maintenance of her sister's Catholicism, and the pageants and speeches which Londoners prepared for her coronation progress left no doubt of the role they had cast for her. She was to be their Protestant saviour.

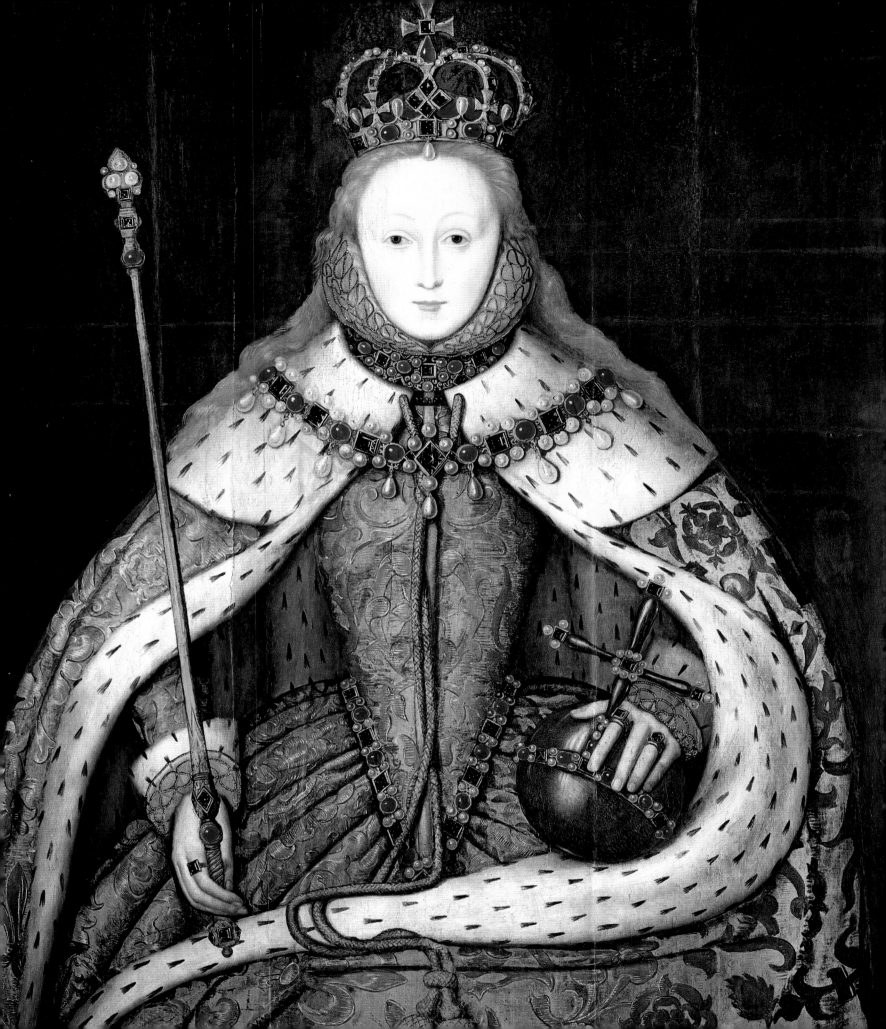

RELIGIOUS SETTLEMENT

I t was widely believed that the new Queen would restore the Protestant faith in England, and when she summoned her first Parliament, the most pressing issue was religion. There had been many changes since Henry VIII had become the Supreme Head of the Church, and the people of England had lived through a quarter-century of Reformation and counter-Reformation.

Although Elizabeth had outwardly conformed to Catholicism during Mary's reign, inwardly she was a committed Protestant, albeit a moderate one. Her religious settlement would be an attempt to unite the country, and she had already decided it would be Protestant with elements of Catholic rituals.

The settlement itself was written out in two Acts of Parliament in 1559: the Act of Supremacy and the Act of Uniformity. The Act of Supremacy made Elizabeth the Supreme Governor of the Church of England and ensured that the Roman Catholic Church had no authority over the Church of England. The Act of Uniformity re-introduced the *Book of Common Prayer* and established a set form of Anglican worship in English churches.

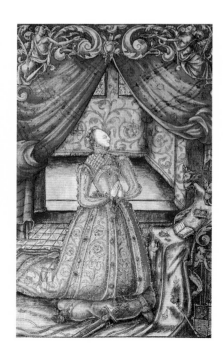

Elizabeth hoped that Catholicism would die out naturally as her people turned to the moderate religion she had established. In this she was largely successful – by the end of her reign most of her subjects had accepted the compromise as the basis of their faith. The Church of England's character today is largely the result of the Elizabethan Settlement – a middle way between Roman Catholicism and Protestantism.

The Queen's preference was for Protestant liturgy with Catholic traditions, particularly in church music, and her religious views were remarkably tolerant for the Tudor age. "There is only one Christ, Jesus, one faith," she said later in her reign, "all else is a dispute over trifles." She also declared that she had "no desire to make windows into men's souls".

Her chapels were conservative – the crucifix was displayed, and she also liked candles and colourful images. However, the reformed religion largely rejected the Catholic veneration of saints and the Virgin Mary. The position of a virgin deity in England was one Elizabeth intended to fill herself. No longer would the Catholic Virgin Mary reign in England; the Protestant Virgin Queen would be venerated in her place.

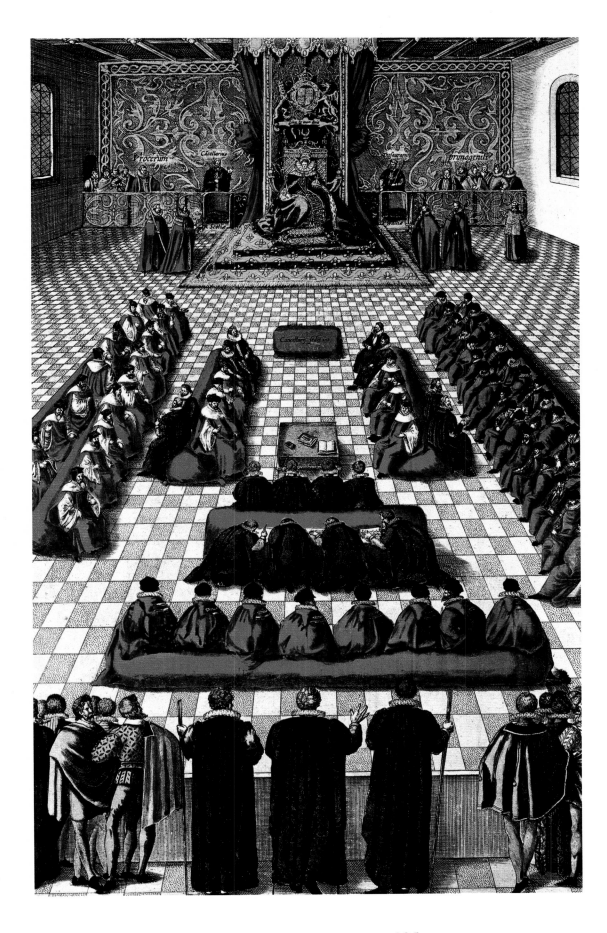

OPPOSITE: The frontispiece
of Queen Elizabeth's prayer
book, showing her kneeling in
reverence to God.

VIRGIN QUEEN

For many years it was expected that the Queen of England would make a favourable match and provide an heir to succeed her, but Elizabeth I chose never to marry. A match with a European prince might draw England into foreign wars, so her council was usually divided on the matter. Marrying an Englishman was equally problematic and likely to cause jealousy and infighting.

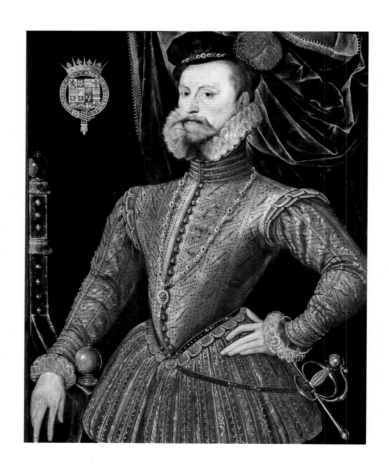

... this shall be for me sufficient, that a marble stone shall declare that a Queen, having reigned such a time, lived and died a virgin.

(Elizabeth I)

Instead Elizabeth used her marriage prospects as a political tool and promoted the cult of virginity that was to form the substance of her legend. The "Virgin Queen" was presented as a selfless woman who sacrificed personal happiness for the good of the nation. Elizabeth wore a pelican jewel in several state portraits to remind the English of this selfless love for her subjects for, according to legend, the pelican pecked its own breast to feed its children with the blood.

There was no shortage of eminent suitors for the Queen's hand, including Philip II of Spain, Erik XIV of Sweden, the Archduke Charles of Austria and the Duke of Anjou. Elizabeth made a deliberate policy of keeping these princes in hope, thereby ensuring their friendship. Throughout her reign, while fruitless foreign marriage negotiations continued, she revelled in the flattery of a succession of young courtiers like Christopher Hatton and Walter Raleigh, and later Robert Devereux, Earl of Essex.

But Robert Dudley, Earl of Leicester, remained the Queen's first and probably only love. Within days of her accession Elizabeth appointed him Master of the Horse – a position ensuring they spent many hours together. Their mutual attraction and flirtatious behaviour sparked endless gossip and they would remain on intimate terms for more than thirty years. Despite his endeavours to make Elizabeth his wife, she would never marry her "Sweet Robin".

It would be unsurprising if Elizabeth feared childbirth. Two of her step-mothers and her grandmother had died in childbed – the greatest danger a woman could face. Traumatic events from her childhood may also have put her off marriage. Her father Henry VIII had had her mother Anne Boleyn executed for treason and adultery, and her step-mother Katherine Howard later suffered the same fate.

But the real reason for her remaining single was probably that in the sixteenth century a husband was deemed to have authority over his wife, and Elizabeth feared that marriage would bring some erosion of her power.

The Scottish ambassador in 1564, Sir James Melville, summed it up perfectly when he told Elizabeth, "You will never marry ... the Queen of England is too proud to suffer a commander ... you think if you were married, you would only be Queen of England, and now you are king and queen both."

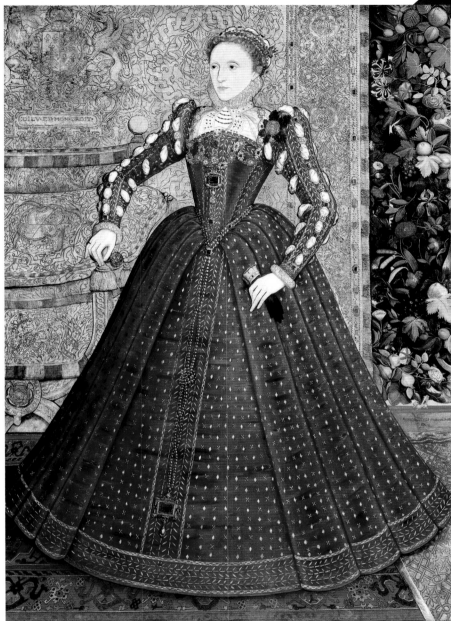

OPPOSITE: Robert Dudley, 1st Earl of Leicester was one of Elizabeth's leading statesmen and, for many years, aspired to become her husband.

ABOVE: A young Queen Elizabeth in "The Hampden Portrait" by Steven Van Der Meulen, 1563. The fruit and flowers on the right-hand side suggest her youth and fertility.

WAR AND EXPLORATION

E lizabeth's foreign policy was always very defensive, but her long reign saw several wars, beginning with a failed offensive in Scotland in 1559 to support Protestants and combat French presence in the Scottish kingdom. She also sent troops to Ireland to quell the Desmond rebellions of the 1560s, 70s and 80s, and the Tyrone rebellion which lasted from 1594 to 1603. And her principal conflict was the English war against the Spanish, which was fought on both land and sea.

The Desmond rebellions in Ireland were ignited by competition between Gerald Fitzgerald, 15th Earl of Desmond and Thomas Butler, 10th Earl of Ormond, who was brought up a Protestant at the English court and allied with Queen Elizabeth. The rebels were responding to the threat of extended English rule over the Irish province of Munster. In addition, it was a religious war of Catholic against Protestant. Fitzgerald was decapitated by a rival clan member, who had been paid by the Earl of Ormond on behalf of the Queen, and his head was sent to Elizabeth. The Desmond

family had ruled much of southern Ireland for more than three hundred years but, following four years of war with the English, thousands had died and the area was left devastated. The poet Spenser wrote, "A most populous and plentiful country was suddenly left void of man and beast."

In 1585 Elizabeth sent an English army, led by the Earl of Leicester, to aid Protestant Dutch rebels against Philip II of Spain. From the start, the Queen was reluctant and nervous about the cost and unpredictability of war. Her strategy was to appear to support the Dutch while negotiating with Spain, and Leicester was given insufficient money for wages, supplies and equipment. A notable battle, and scene of English defeat, was that of Zutphen, where the celebrated poet Philip Sidney was mortally wounded. The Queen's doubts about the war contributed much toward its outcome, and

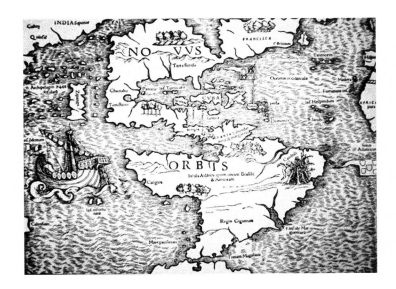

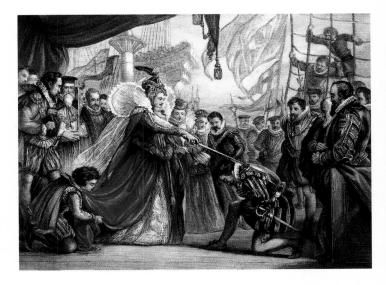

nothing was really gained. England's interference only contributed to her ongoing hostile relationship with Spain.

The Tyrone rebellion of 1595 took place around Ulster in the north of Ireland, and was led by Hugh O'Neill, 3rd Earl of Tyrone, who aimed to expel English rule and govern Ulster himself. Elizabeth proclaimed Tyrone a traitor and seventeen thousand English troops were sent to Ireland under the command of Robert Devereux, 2nd Earl of Essex. The Earl was ordered to subdue the uprising, but his troops were not effectively deployed and his expensive mission failed. He returned to England in 1599 and was replaced by Charles Blount, 8th Baron Mountjoy, who finally defeated Tyrone, at Kinsale in 1603.

While the Queen's military ventures tended to meet with indifferent success, her explorers achieved spectacular feats, and commerce provided them with a tempting incentive to explore the globe. Since medieval times, exotic spices as well as gems, perfumes, pigments and dyes had been brought by sea and in the sixteenth century advancements in navigation and cartography allowed explorers to open up trade routes with countries around the world. No longer did ships have to stay close to the shore but could advance across oceans. By 1494 the New World of the Americas was divided between Spain and Portugal, seafaring nations who proved to be aggressive competitors.

English explorers were determined to share the opportunities offered up by the discovery of the New World, and Elizabeth was willing to sponsor expeditions on condition that it was financially advantageous to the Crown. Whereas pirates kept the treasure they stole, privateers gave a proportion of their spoils to the Queen.

One such state-sponsored pirate was Francis Drake, who attacked and robbed Spanish galleons. In 1577–80 he became the second person to circumnavigate the globe (after Magellan of Portugal). Of the five ships that began the voyage, only one – the *Golden Hind* – returned. Drake had sailed the world in a ship only 70ft (21.3m) long and 19ft (5.8m) wide. Returning to England, he was knighted on deck by the Queen. However, Drake had his detractors both at home and abroad. A Spanish nobleman would later suggest in a letter to King Philip II, "The people of quality dislike him for having risen so high from such a lowly family; the rest say he is the main cause of wars."

Another of Elizabeth's explorers, Walter Raleigh, was a soldier, poet, courtier and favourite. In 1584 he established an English settlement at Roanoke Island, off the coast of North Carolina. About a hundred settlers began building homes, but on returning the following year it was found to be abandoned. In 1587, 117 further colonists arrived, among them Eleanor Dare, who on 18 August gave birth to the first English child to be born on American soil. The colony was named "Virginia", after the Queen, and the child was called Virginia Dare.

ABOVE LEFT: Map of the American continent by Sebastian Münsterin,

ABOVE RIGHT: Queen Elizabeth knighting Sir Francis Drake on board the *Golden Hind* after his round-the-world voyage.

LEFT: Miniature of Sir Walter Raleigh by Nicholas Hilliard, c.1584.

OPPOSITE: "The Death of Sir Philip Sidney" after John Francis Rigaud.

CATHOLIC PLOTS

Elizabeth's attitude to her Catholic subjects was initially a moderate one; she wanted peace in England and her emphasis was on outward conformity. However, as her reign progressed, various events began to challenge the Queen's policy of toleration, resulting in her government taking a much harsher stance.

In 1570 Pope Pius V issued *Regnans in Excelsis*, a public decree denouncing Elizabeth as a heretic and releasing her subjects from their allegiance. Now English Catholics faced the dilemma of choosing loyalty to their Queen or obedience to papal authority. A number of Catholic plots threatened the security of English Protestants and all aimed at replacing Elizabeth with her cousin and rival, Mary, Queen of Scots.

In 1568 Mary, who was implicated in the assassination of her husband, was driven from Scotland by her subjects and fled to England, where she sought protection. Elizabeth wished to preserve her cousin's life but, perceiving her as a threat, had her confined – an imprisonment that would last almost nineteen years.

As the great-granddaughter of Henry VII, Mary's claim to the English throne was strong, and unlike Elizabeth she had never been declared illegitimate. Many English Catholics supported Mary's claim, especially in northern England, where several powerful nobles were still Catholic. These Catholic lords of the north rose up on Mary's behalf in 1569, although

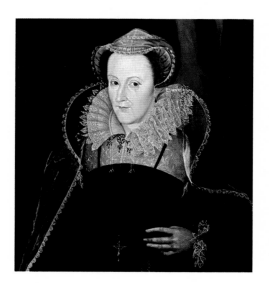

LEFT: "Mary, Queen of Scots in captivity" after Nicholas Hilliard and painted when she was held at Sheffield House in 1578.

OPPOSITE ABOVE: "St Bartholomew's Day Massacre" by François Dubois, c.1572–84.

OPPOSITE BELOW: Sir Francis Walsingham by John De Critz the Elder, c.1585. He gathered intelligence, disrupted a range of plots against Elizabeth and secured the execution of Mary, Queen of Scots.

their rebellion was quickly suppressed.

Within two years Roberto Ridolfi, an Italian banker, began to plot Mary's escape and marriage to the Catholic Duke of Norfolk. The Ridolfi Plot called for Spain to intervene with troops to support the marriage and put Mary on the throne. Its discovery by Elizabeth's agents brought the Duke to the block. Then, on St Bartholomew's Day in August 1572, French Protestants were massacred by French Catholics in Paris, causing revulsion in England and fears of a Catholic invasion.

In 1583 Francis Throckmorton, a Catholic acting as a go-between for Mary and Bernardino de Mendoza, the Spanish ambassador, was betrayed and arrested. Under torture Throckmorton confessed to a conspiracy to murder Elizabeth and make Mary Queen of England. Londoners knelt in the streets to give thanks for the Queen's delivery, and Parliament passed the Bond of Association in 1584, calling on all Englishmen to take an oath to seek out and kill anyone plotting to murder the Queen.

Recusancy Laws had already been introduced which meant that people who failed to attend Church of England services committed a statutory offence and could be fined as "recusants" (from the Latin word *recusare*, meaning "to refuse"). By 1585 all Catholic priests ordained abroad and returning to England were declared guilty of high treason, and could be hanged, drawn and quartered. During Elizabeth's reign hundreds of young men came back as missionaries, using false papers, aliases and disguises. The English government viewed them as potential assassins and hunted them down. Sir Francis Walsingham, Elizabeth's Principal Secretary and spymaster, was especially active in attempting to control these Catholic threats.

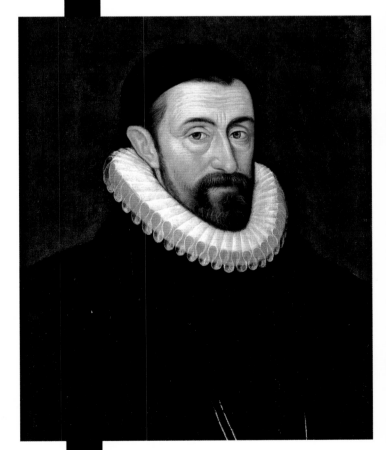

In 1586 Anthony Babington, a former page to the Scottish Queen, was drawn into a plan to kill Elizabeth and free Mary. However, his coded letters were intercepted by a double agent working for Walsingham. When enough evidence was amassed, the plotters were executed and Mary, Queen of Scots was put on trial. Elizabeth's councillors used this conspiracy to persuade her that she would never be safe as long as Mary lived. "You have planned in divers ways and manners to take my life and to ruin my kingdom," she wrote to Mary, and, after great hesitation, signed her death warrant in 1587.

The execution of Mary, Queen of Scots is generally believed to be the final reason Philip II needed to launch his planned offensive against England and her "heretic" Queen. The Spanish Armada would finally achieve what no amount of legislation had been able to do, uniting English people in opposition to a great Catholic crusade.

THE SPANISH ARMADA

On 11 May 1588, after two years of planning, the Spanish Armada set sail from Lisbon under the command of Alonso Pérez de Guzman, Duke of Medina Sidonia. One hundred and thirty ships and thirty thousand men were blessed by priests as they sailed down the river on their journey to conquer England. Philip II of Spain intended to overthrow Elizabeth I and return England to the Catholic fold.

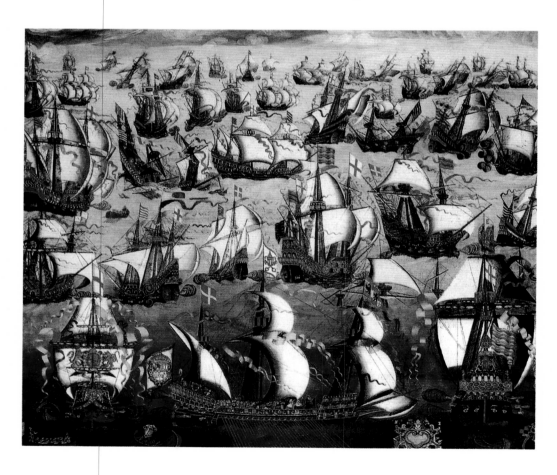

His plan was to sail the great fleet along the English Channel, join the army of the Netherlands and invade Protestant England. Before reaching open water, however, the wind changed direction and the Armada was forced to take shelter; the fleet was then delayed by further storms. Food stores became inedible and it was to be a month before fresh supplies were obtained and the Armada resumed its journey.

Meanwhile, England had extended her defences in expectation of an attack from Spain, and armed militia were organized. In an address intended to motivate her troops for battle, Elizabeth I gave a famous speech at Tilbury: "I know I have but the body of a weak and feeble woman but I have the heart and stomach of a King, and of a King of England too."

On 29 July the Spanish fleet was sighted off the coast of Cornwall. Francis Drake was playing bowls on Plymouth Hoe when he was given the news of the Armada's approach. An experienced sailor, he knew that it was low tide and the fleet could not leave harbour for eight hours, which led to his celebrated comment that "there is plenty of time to finish the game and beat the Spaniards".

Finally, the small ships of the English fleet set sail in driving rain to repel the great Armada. The Battle of Gravelines followed, with Drake leading the attack. The English were able to send fireships at the closely packed Armada, which caused panic, and most of the Armada's ships broke formation. Three Spanish ships were sunk and twelve more damaged. About six hundred Spaniards were killed and as many as eight hundred more wounded. The English lost barely a hundred men.

As the wind drove the Spanish ships toward the sandbanks, the English prepared to take their victory, but no attack followed as they were virtually out of ammunition. Then a change of wind released the Spanish from the shoals. The Armada sailed north pursued by the English, rounded Scotland and, battered by more storms, finally limped home. Of the one hundred and thirty ships that had left Lisbon, eight had been destroyed and more than half required substantial repair. Hearing of the defeat, Philip II is said to have replied, "I sent them to fight against men, not storms."

The English had won a remarkable victory, Spain was humiliated and England now gained prominence on the European stage. At St Paul's Cathedral, in December 1588, Queen Elizabeth gave thanks to God for the conquest, declaring, "He made the winds and waters rise to scatter all mine enemies."

She is only a woman, only mistress of half an island, and yet she makes herself feared by Spain, by France, by the Empire, by all.

(Pope Sixtus V)

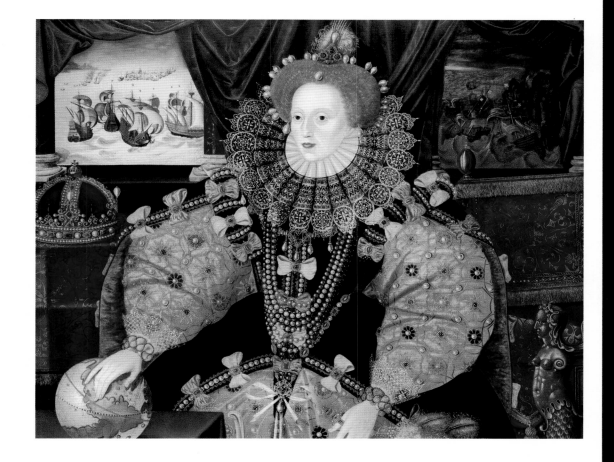

RIGHT: "The Armada Portrait", c.1590, shows a triumphant Elizabeth, along with the hopes and aspirations of England as an imperial power.

OPPOSITE: English ships and the Spanish Armada in August 1588.

DRAMA, LITERATURE AND MUSIC

In Elizabeth's England, theatre was revolutionized, literature thrived and sacred music was enriched by the addition of secular compositions.

Popular plays in Elizabeth's reign were no longer the "miracle" or "mystery" plays of the previous century, nor the short, secular and often political farces known as "interludes". Elizabethan drama was breaking away from the restraints of the Church and turning toward stage presentations based on Humanist ideals. Performances became more diverse and morally complex. Tragedy and comedy developed from the Renaissance interest in classical drama and the term "tragicomedy" was first coined in the Elizabethan era.

Christopher Marlowe's writing focused on the dilemma of the human condition. *Tamburlaine the Great* was the first publicly performed play to be written in blank verse, which later became a standard for future writing. William Shakespeare gave more range to Marlowe's achievements, writing thirty-six plays, both comedy and tragedy. Generally regarded as the greatest writer in the English language and the world's greatest dramatist, his plays are still widely studied and performed today.

In the 1570s purpose-built playhouses such as The Rose and The Globe were constructed in London. Plays were usually performed in the afternoon, yet they were incredibly popular with the labouring classes, and by the end of the century a third of Londoners were attending the theatres every week. There was little in the way of props and lighting so, to distinguish between different scenes – and even night and day – the play depended on the power of words. Music also played a large part in the theatre, where it was used to express mood to the audience. In his plays Shakespeare makes more than four hundred references to music.

Elizabethan music flourished under the Queen's patronage, and composers like Thomas Tallis and William Byrd came

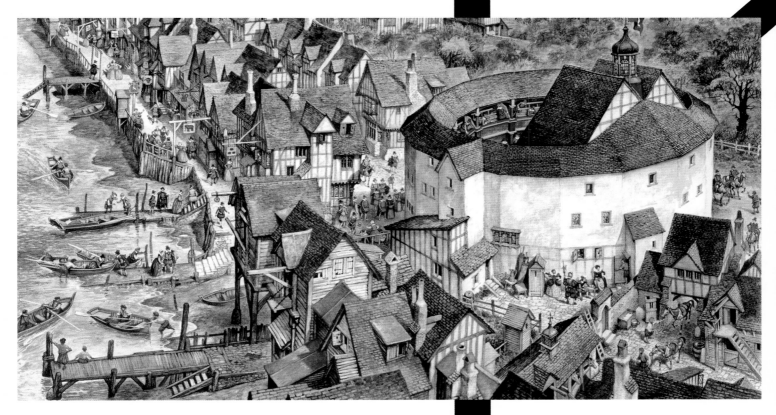

to exemplify the era with their beautiful arrangements. Both musicians were Catholic and subject to shifts of religious worship from one monarch to the next. Their key works include Catholic sacred music in Latin, with pioneering English-language works for the new Church of England.

Tallis was a Gentleman of the Chapel Royal and had composed masses for Henry VIII, English-language music for Edward VI, Latin hymns for Queen Mary and under Elizabeth I set music to words in both English and Latin. Byrd was his pupil and in 1575 Queen Elizabeth granted both men exclusive rights to print and publish music. Taking advantage of this, the musicians published a collection of *Cantiones sacrae* (vocal sacred music) dedicated to the Queen.

The Elizabethan era has been called the most splendid age in the history of English literature, with gifted writers including Sir Philip Sidney, John Donne and Ben Johnson. Although remembered principally as a playwright, Shakespeare's poetry and sonnets are viewed as some of the most beautiful in English literature. In 1590 Edmund Spenser began writing his epic poem *The Faerie Queen*. He invented a new verse form in this poem, the nine-line stanza, that is now known as the Spenserian stanza. *The Faerie Queen* is a story of medieval knights in which Spenser created a form of chivalric Humanism. It is essentially an allegorical work praising the qualities of Queen Elizabeth I.

The arts in Elizabeth's reign were influenced by Renaissance ideas but mostly given an English interpretation. The major inspiration for the arts of this period was Elizabeth herself – the "Gloriana" of her people.

OPPOSITE: William Shakespeare, England's greatest writer and dramatist.

TOP: The Rose theatre, Southwark, was associated with the plays of Christopher Marlowe.

ABOVE: "Queen Elizabeth I playing the Lute", c.1576. A miniature by Nicholas Hilliard.

THE CULT OF GLORIANA

Queen Elizabeth I needed a very particular image to hold her divided country together and overcome the fact that she was a woman. The female role in the sixteenth century was essentially passive, and most people believed that it was contrary to nature for a woman to exercise authority over men. At a time when an ordinary woman could not rule a household, Elizabeth sought to rule a whole country.

In order to do this, the Queen and her council manufactured a deliberate myth to portray her as unlike other women. Using her single status and virginity, they cultivated an image of

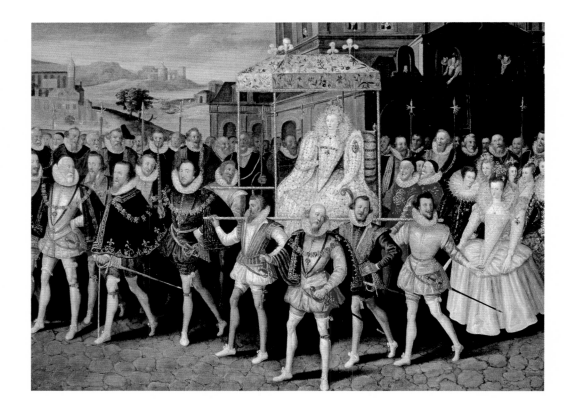

> *And though you have had, and may have,*
> *many mightier and wiser princes sitting in this*
> *seat, yet you never had, nor shall have,*
> *any that will love you better.*
>
> (Elizabeth I)

the Queen as a goddess, who loved her people above everything, and promoted this idea through the use of spectacle, drama and pageantry. The Cult of Gloriana was a movement in which authors, playwrights and artists revered the Queen in their works, depicting her as a virgin, a goddess or both.

Printed accounts were circulated, too, spreading the idea of Elizabeth as a much-loved ruler, and her portraits were widely owned and distributed. These paintings show the growing stylization of images of the Queen. With a mask-like face, she is presented as a young woman even when in her sixties. As Elizabeth's own personal attractiveness faded with age, her clothes became increasing spectacular – the pearls and jewels creating an illusion of beauty. Her wardrobe was full of gowns of rich fabrics adorned with jewels and she used clothing as an effective vehicle for royal magnificence.

The Tudors believed that outward beauty was a sign of inner goodness and Elizabeth needed to remain looking young and beautiful. She had survived smallpox in 1562, which may have left her face scarred and become one of the reasons for her use of make-up. Her legendary alabaster face was created with ceruse, a concoction of finely ground white lead powder mixed with vinegar. It created a perfect white, capable of smoothing away pockmarks and wrinkles, but it was also a poison which corroded the skin. As the Queen's auburn hair became sparse and grey, she favoured wigs, and her teeth were badly decayed by old age, yet courtiers still eulogized her "dazzling beauty".

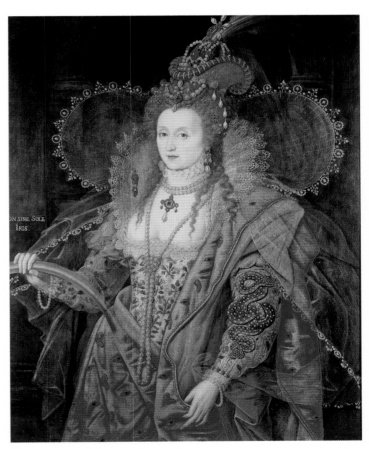

TOP: "Queen Elizabeth riding the chariot of Fame" by Sir William Teshe, 1570.

ABOVE: "The Rainbow Portrait" by Isaac Oliver, 1600. Elizabeth was in her late sixties but for iconographic purposes is portrayed as young and beautiful.

OPPOSITE: "Queen Elizabeth's Procession to Blackfriars" by Robert Peake the Elder, c.1600.

FINAL YEARS

I n Elizabeth's England a tiny social elite had enjoyed a period of brilliance at court, in exploration and in literature and music. However, life had become increasingly hard for the vast majority outside court, most of whom still lived and worked on the land. While there were increased opportunities and social mobility for merchants and yeomen, the poor suffered badly from inflation, unemployment, population increase and bad harvests.

Elizabeth's final years were blighted by these economic problems and mounting criticism from a younger generation at court. Her last favourite, Robert Devereux, Earl of Essex, tried to raise a rebellion against her in February 1601, which was quickly suppressed.

The following year, a series of deaths among her close friends plunged the Queen into deep depression, as her 44-year reign came to its close. The seventy-year-old Elizabeth fell sick in March 1603 and died at Richmond Palace, bringing the Tudor dynasty to an end.

Many factors contributed to the success of Elizabeth Tudor and explain why, even today, she is often viewed as the greatest English monarch. These include her own considerable intelligence and political judgement; her ability to choose good ministers and listen to wise council; and her formidable grasp of public relations. Elizabeth's long reign had provided peace and stability in England, allowing the arts to flourish; her moderate stance had shaped the Church of England; and the defeat of the Spanish Armada is regarded as one of the most significant military victories in English history.

Elizabeth's coffin was taken to Westminster Abbey, on a hearse drawn by four horses and hung with black velvet. She still lies there today, in a tomb decorated with the falcon badge of her mother, the executed Anne Boleyn.

OPPOSITE: "Queen Elizabeth I in Old Age", English School, c.1610. Allegorical Portrait of Elizabeth with Old Father Time at her right and Death looking over her shoulder.

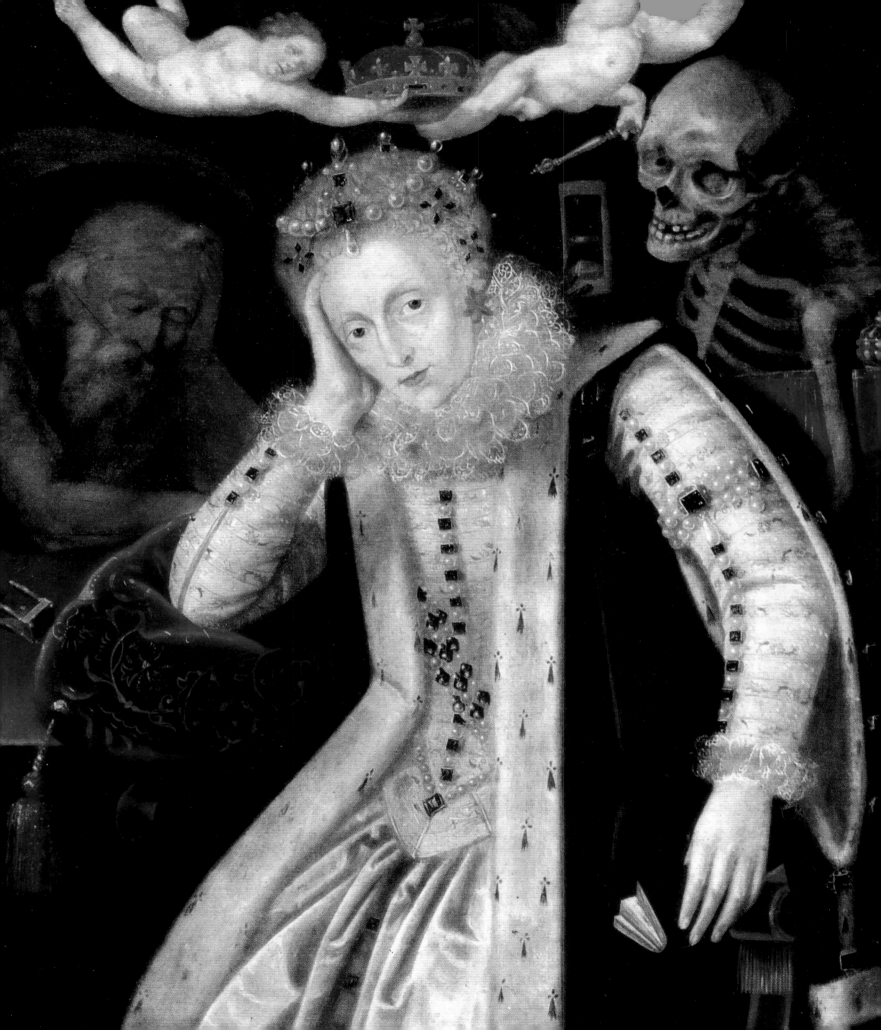

THE END OF THE TUDORS

THE UNION OF THE CROWNS

The death of Elizabeth I, in 1603, signalled the end of
the Tudors and the beginning of a new dynasty: the
Stuarts. This family descended from her old rival,
Mary, Queen of Scots, and became the first monarchs of
the United Kingdom. By uniting the crowns of Scotland
and England, they ended centuries of hostility between
the two countries.

THE
STUART CLAIM

Queen Elizabeth I refused to name her successor and she gave a reason. She did not want discontented elements to turn to the next in line, as they had turned to Elizabeth herself, in Mary Tudor's reign. But, as a childless monarch, a successor was needed. The most likely claimant was James VI, King of Scots, a direct descendant of Henry VII, the first Tudor king. The Scottish claim originated from the marriage, in 1502, of Margaret Tudor, eldest daughter of Henry VII, to James IV of Scotland. Their union produced James V, who died in 1542 leaving one legitimate child, Mary, Queen of Scots, and she, in turn, left one surviving child, James VI.

BELOW: The Tudor rose and Scottish thistle with the royal crown became a personal heraldic badge of James I, after 1603.

OPPOSITE: Margaret Tudor, the English princess who became Queen of Scots and the source of the Stuart claim to the English crown.

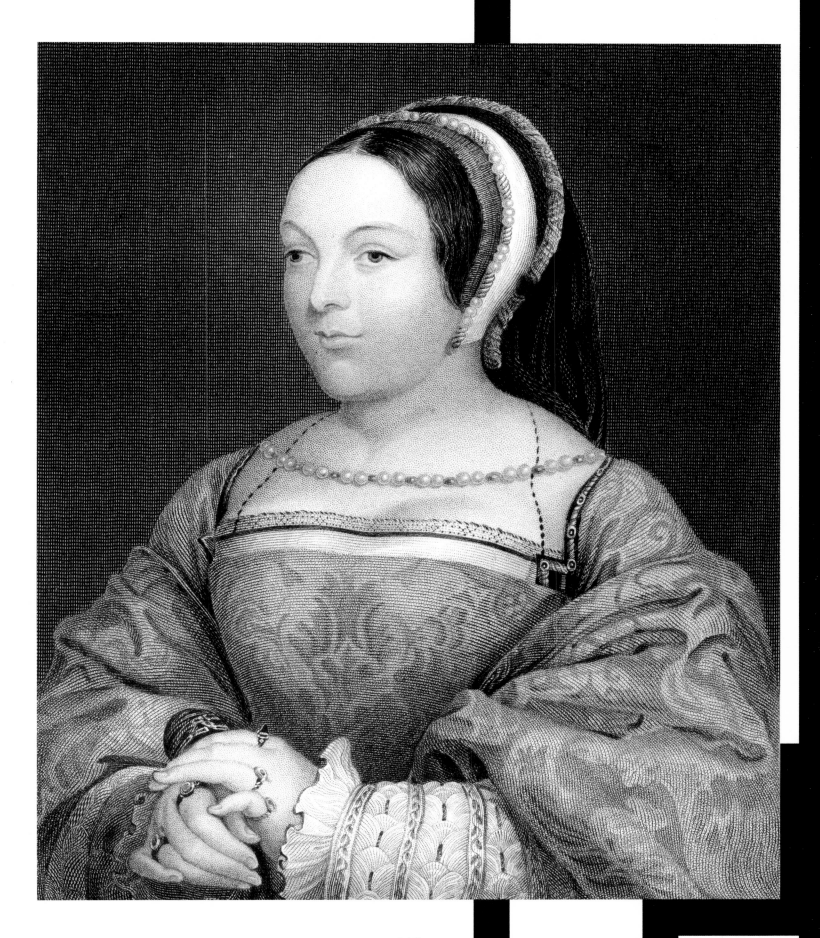

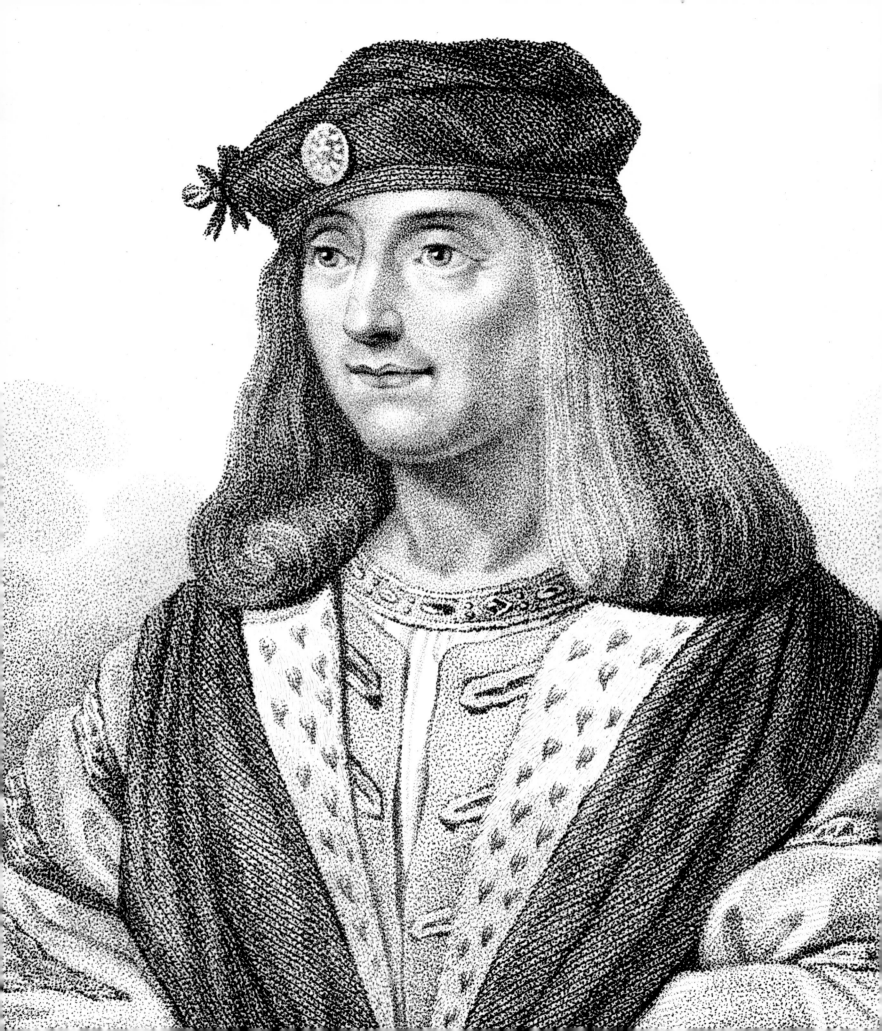

OPPOSITE: An influential and popular Scottish king, James IV invaded England in 1513 and was killed at Flodden Field. His marriage to Margaret Tudor in 1502 led to his great-grandson inheriting the English throne one hundred years later.

RIGHT: King James I of England (and VI of Scotland) with his wife, Anne of Denmark.

The prospect of a Scottish succession had been foreseen back in 1502, before the signing of Margaret Tudor's marriage agreement. Henry VII knew that a Scots king might one day inherit England, but he believed (rightly) that England, so much larger, richer and more populous, would always be the dominant partner in a united realm.

Through his descent, from the eldest sister of Henry VIII, James VI had the strongest claim to the English crown, but there were some impediments. Under English law foreigners could not inherit lands in England, and Henry VIII had excluded his Scottish relatives from the throne in his will of 1547. Furthermore, a statute of 1585 stated that if any claimants should conspire against Elizabeth, all their legal rights were forfeited. Mary, Queen of Scots had been executed in 1587 for her involvement in a Catholic assassination plot against Elizabeth, and if her rights were void, so too, it could be argued, were the rights of her son.

But James had considerable points in his favour. After fifty years of female rule a male monarch offered a welcome return to the "natural order". He was also the right religion; raised by Protestant nobles in the reformed faith. James was married to Anne of Denmark and they already had two boys, so his family promised dynastic stability. Furthermore, since emerging from his minority, James had around twenty years' experience of kingship in Scotland. And he had proved himself an astute monarch, gaining control over the fractious Scottish nobility that had destroyed Mary, Queen of Scots.

THE KING
OF SCOTS

J ames VI was born at Edinburgh Castle in 1566 and succeeded to the Scottish throne at the age of thirteen months, after his mother was forced to abdicate. It is not clear whether it was Henry IV of France or his chief minister, the Duc de Sully, who described James as "the wisest fool in Christendom", or what exactly was intended by the epithet. It may mean that James was wise in that he was very learned, yet he was also, according to some reports, clumsy, uncouth, awkward and blustering.

A French envoy's description of James, as a young King of Scots, suggests he did not have the aura of majesty so cultivated by Elizabeth:

> He is learned in many tongues, sciences and affairs of state ... His manners, as a result of the failure to instruct him properly, are very uncivil, both in speaking, eating, clothes, games, and conversation in the company of women. ... his carriage is ungainly, his steps erratic.

He may have been ungainly but James was an enthusiastic scholar and writer. He published works on a variety of subjects, from witchcraft to statecraft, including *Daemonologie* (1597), *The True Law of Free Monarchies* (1598) and *Basilikon Doron* (1599). James had also succeeded in Scotland where his mother had failed. He now saw himself as a wise scholar-king, who would lead a united and peaceful British nation.

PEACEFUL SUCCESSION

Over the last decade of Elizabeth's reign, the candidature of the Scottish king became increasingly secure. The man who facilitated this was Sir Robert Cecil, the Queen's Principal Secretary and son of her trusted councillor and old friend, William Cecil.

Robert Cecil knew that the succession must be settled before Elizabeth's death. He began a secret correspondence with James, in letters that were partly encoded, since Elizabeth still refused to acknowledge an heir. The combined forces of the strongest candidate and the most influential English politician avoided what might have been a major succession crisis. In the early hours of 24 March 1603 Elizabeth I died at Richmond Palace, and James VI of Scotland was smoothly proclaimed the new King of England.

OPPOSITE: James VI in 1595 by the Scottish court painter, Adrian Vanson.

SERO, SED SERIO

OPPOSITE: Allegorical painting of the crown passing from Elizabeth I to James I, by Paul Delaroche, 1828.

LEFT: Robert Cecil, 1st Earl of Salisbury by John De Critz the Elder, 1602. Robert followed in his father's footsteps, becoming Principal Secretary of State for Elizabeth. He ensured the peaceful succession of James I and was rewarded for his efforts by the new King.

On 5 April 1603 James left Edinburgh, travelled across the border for the first time and progressed down through England. He travelled very slowly toward London, stopping along the way, in order to arrive in the capital after Elizabeth's funeral. The ride south comprised feasting, indulging his passion for hunting, and meeting his new subjects. Public response in England was one of relief at the peaceful succession, mixed with intense curiosity to see this foreign monarch.

THE UNION OF TWO ANCIENT KINGDOMS

James's proudest achievement was to unite the realms of Scotland and England, but it was largely symbolic until the middle of the following century. The Act of Union was not passed until 1707,

in the reign of his great-granddaughter, Queen Anne, despite the King's ardent desire for political union in 1603.

The great blessing that God has with my person sent unto you, is peace, and that in a double form. First, by my descent, of Henry VII, is reunited and confirmed in me the union of Lancaster and York, whereof that King of happy memory was the first uniter, ... But the union of these two princely houses is nothing comparable to the union of two ancient and famous kingdoms, which is annexed to my person ...

Just as Henry VIII had become the personification of the peace between Lancaster and York, King James now represented an even greater peace. Scotland and England would never be at war

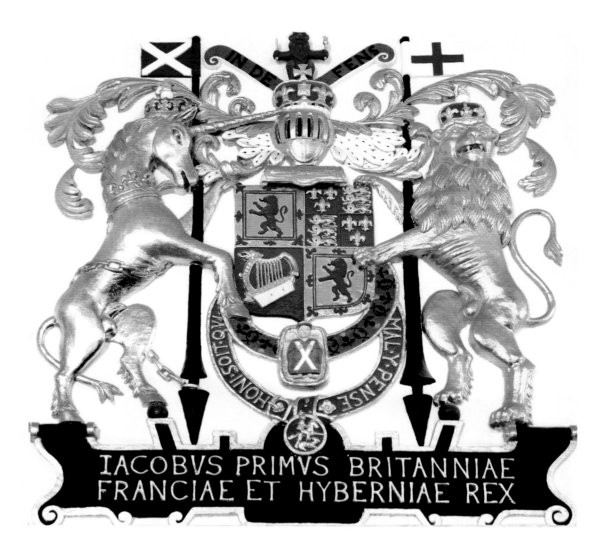

IACOBVS PRIMVS BRITANNIAE
FRANCIAE ET HYBERNIAE REX

ABOVE: The new coat of arms
for King James, supported
by the Scottish unicorn with
the flag of St Andrew and the
English lion with the flag of
St George.

OPPOSITE: Image of James as
King of Great Britain in 1603.

again, nor support different allies, although they kept their own
distinctive parliaments, legal systems, cultures and economies.

The King's ideas about Britain met with little enthusiasm at
Westminster. Some Members of Parliament thought that James
might become a more absolute ruler in a united Great Britain than
he was in separate kingdoms. Some of the English opposition was
based on commercial jealousy and prejudice against the poorer
Scots, who were perceived as having much more to gain from
the union; the ancient name and realm of England had to be
protected. In the end, his successes were limited to a new title and
the devising of the union flag. James styled himself "King of Great
Britain" and he gave orders for a British flag to be created that bore
the combined crosses of St George and St Andrew.

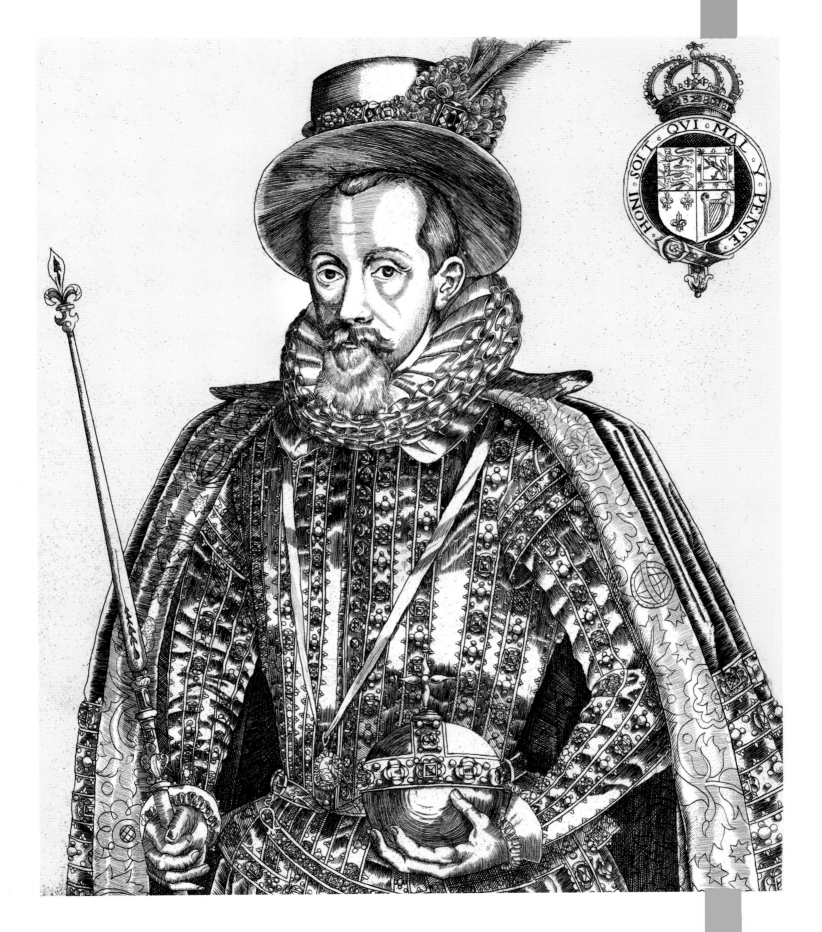

JAMES I

The golden age of Elizabethan literature and drama continued to flourish in the new reign, and the King James Bible was published in 1611. Under James, the Plantation of Ulster by English and Scots Protestants began and the English colonisation of North America continued with the foundation of Jamestown, Virginia in 1607.

Religious differences were still problematic. In 1605 dissident Catholics planned the King's assassination by trying to blow up both him and the Westminster Parliament. The sensational Gunpowder Plot, as it became known, was disastrous for the cause of Catholic emancipation. Meanwhile, Puritanism was on the rise and the 1620 voyage of the *Mayflower* marked the start of the Puritans' departure from English shores to seek religious freedom in America.

James's foreign policy was dominated by a wish for peace with Spain and the Treaty of London, signed in 1604, concluded the long Anglo-Spanish War. James also refused to sanction the privateering of Elizabeth's seafaring heroes. Sir Walter Raleigh was executed in 1618 and it was widely believed that this was done to appease the Spanish, whose colonies and ships had been attacked. Raleigh then became a popular hero, as the incarnation of Elizabethan hostility to Spain.

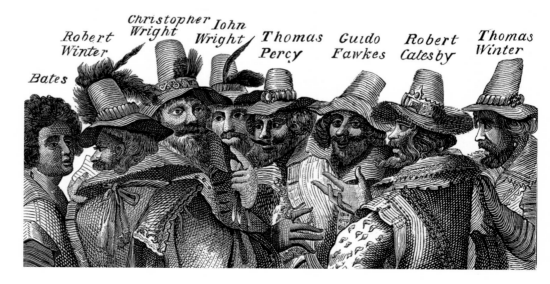

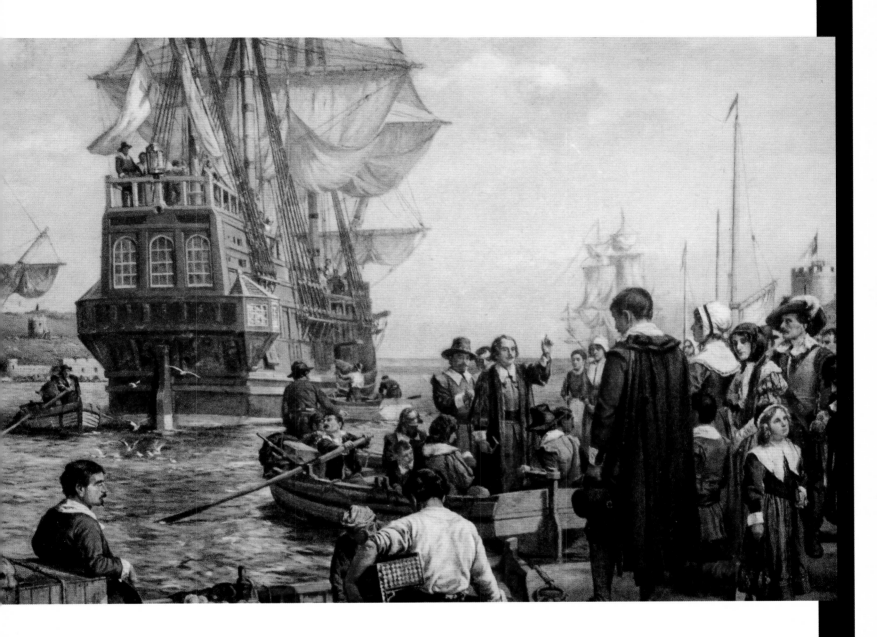

King James I continued to reign until his death in 1625 – a period known as the Jacobean era. He was often criticized for neglecting the business of government in favour of hunting, for his lavish spending and for his attachment to unpopular favourites. The scandal-ridden Jacobean court fell short of the esteemed image of monarchy so carefully constructed by Elizabeth. James also had a taste for political absolutism – he instructed his son, Charles, in the divine right of kings – combined with a disdain for Parliament. These beliefs would prove fatal by the middle of the seventeenth century, culminating in the English Civil War and the execution of King Charles I.

... for kings are not only God's lieutenants upon earth, and sit upon God's throne, but even by God himself they are called gods.

(James VI, King of Scots)

OPPOSITE: Contemporary sketch of the conspirators who planned to blow up Parliament, 5 November 1605.

ABOVE: The Departure of the Pilgrim Fathers in 1620. The *Mayflower* became a cultirual icon in the history of the USA.

LAYING THE
QUEENS TO REST

The young King of Scots showed no curiosity about his mother in 1584, when Mary was still alive and confined in an English prison. Her envoy, De Fontenay, wrote, "At one thing only, I am astonished ... he has never inquired anything of the Queen, his mother, of her health, or her treatment, her living, her servants or her recreation ..."

James's tutors had instilled in his mind the idea that Mary was a murderess who conspired to kill his father Lord Darnley. In 1587 James did make a formal protest to stop her execution, but he was careful not to jeopardize his first concern: succession to the English crown. There are conflicting stories about James's real feelings toward his mother's violent death; some report that he retired without eating, and others that he remained totally impassive.

*Who hopes still constantly
with patience shall obtain
victory in their claim.*

(Inscription on the Scottish "Lennox Jewel")

LEFT: The elaborate, canopied tomb of Mary, Queen of Scots in the Lady Chapel of Westminster Abbey, London.

OPPOSITE: Mary, Queen of Scots by François Clouet, 1560–61. Mary is dressed in white (*en deuil blanc*), traditional mourning wear of the French royal family.

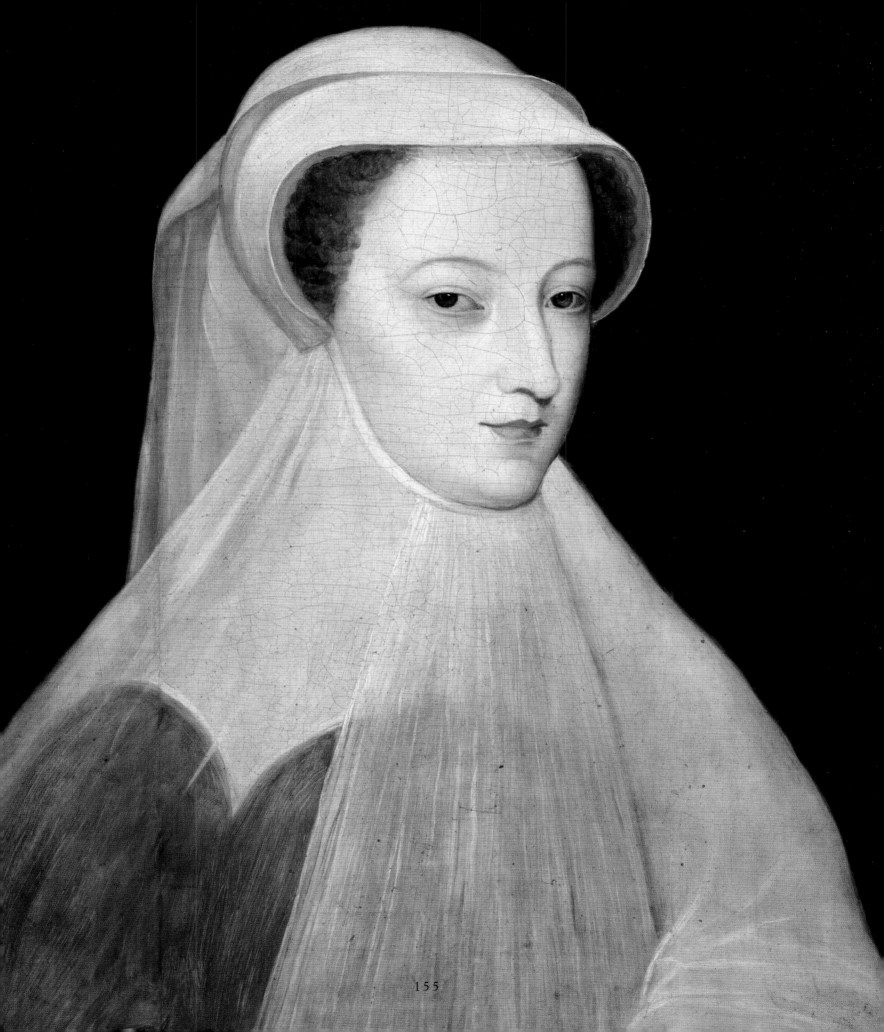

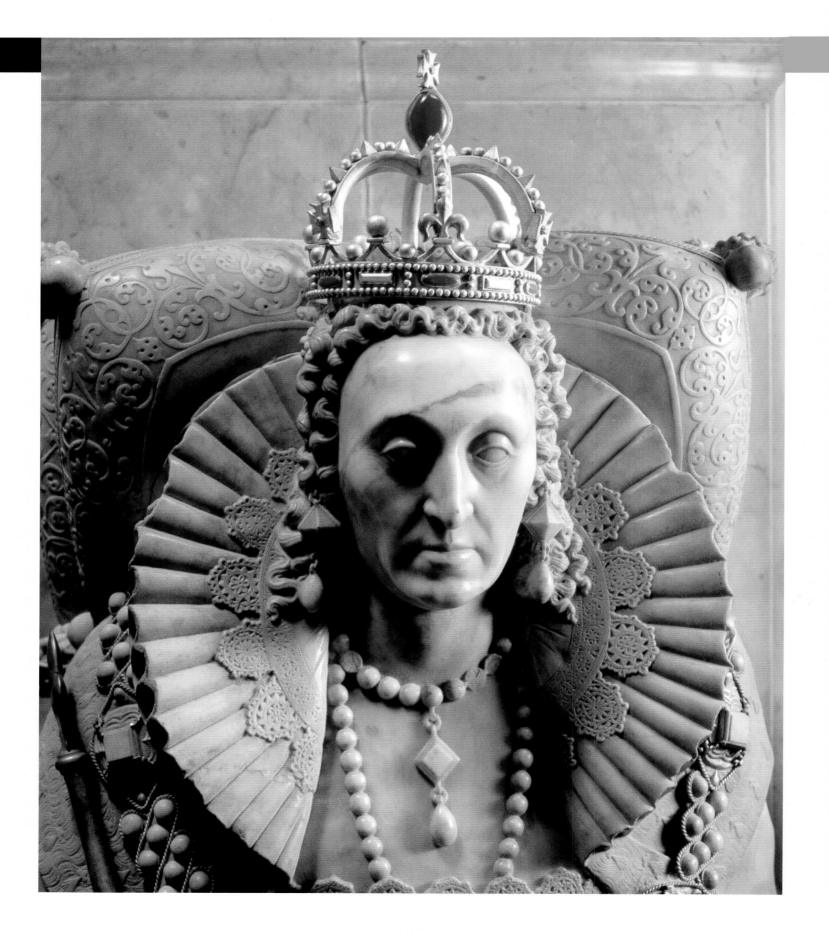

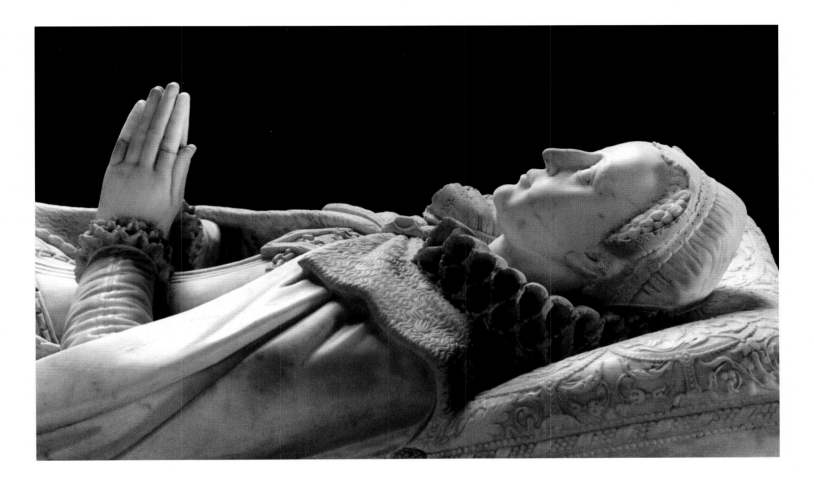

However, once James was safely enthroned as King of England, he started to rehabilitate Mary's memory, sending a velvet pall to cover her grave in Peterborough Cathedral. In 1612 he ordered that her remains be moved to Westminster Abbey, to a magnificent tomb with a fine, white marble effigy and a crowned Scottish lion at her feet. The Scottish queen who sought the English crown would likely have been satisfied with her final burial, among the kings and queens of England, and with the victory of her claim.

In 1867 the tomb of Mary, Queen of Scots was opened, and it was discovered that she shared her resting place with two of her grandchildren and numerous tiny coffins of Stuart children who had died in infancy. Although she never achieved her ambition to rule both Scotland and England, every sovereign of Britain since her death has been directly descended from her.

King James also erected a large monument for Elizabeth I in the north aisle of Westminster Abbey's Henry VII Chapel (less tall than the monument erected for his mother). In 1606 the Queen's coffin was transferred to a vault below the new monument and placed on top of the coffin of her half-sister, Mary I. Together, in one grave, lie the childless daughters of Henry VIII – Mary and Elizabeth Tudor.

Tudor rule ended in 1603 but it would not be long into the Stuart age before Englishmen looked back with nostalgia to the days of "Good Queen Bess". For the Tudors were masters of propaganda, using great artists and writers to convey their version of historical events. The Wars of the Roses were presented as a dark time, and the Tudor period as a golden age of peace, law, order and prosperity. The Tudors came to symbolize the national character, the beginnings of the English church, the navy and the empire. They may have lacked the prodigy of the Stuarts, but no other royal family has occupied such a central place in the nation's memory.

ABOVE: The white marble effigy on the tomb of Mary, Queen of Scots shows Mary in peaceful repose.

OPPOSITE: Tomb effigy of Elizabeth I. Although the effigy is now plain marble, it was originally brightly painted by Jan de Critz.

INDEX

Page numbers in italics refer to illustrations. Nobility are indexed by their titles, e.g. "Bedford, Jasper Tudor, Duke of".

Abraham tapestries 59, *59*
Agincourt, Battle of (1413) 12
America, first settlements in 129, *129*, 152
Anne of Cleves, Queen 70, *70*
Anne of Denmark, Queen 145, *145*
Arthur Tudor, Prince of Wales *34*, 35, 46, 49, 54, 68
Ascham, Roger 90, *91*, 119
Ashley, Kat 118, 120
Aske, Robert 65
attainder, acts of 43, 46, 70
Audley, Lord 41

Babington, Anthony 131
Barnet, Battle of (1471) 19, *20*, 21
Beaufort, Margaret 12
Bedford, Jasper Tudor, Duke of 46
Belknap, Edward 49
Bergavenny, George Neville, Lord 43, *43*
Bible (English translation) 62, 63
Blanche of Lancaster 11, 12
Blore Heath, Battle of (1459) 16
Boleyn, Anne, Queen 60, 61, *68*, 69, 100, 118, *118*, *119*
Bolingbroke Castle, Lincolnshire 11, *11*
bonds 43, 44
Book of Common Prayer 76, 89, 124
Bosworth, Battle of (1485) 10, 24–25, *25*, 43
Brandon, Charles 82, *82*
Brandon, Frances 90, 95
Brandon, Sir William 25
Breton Crisis 39
Bryan, Lady Margaret 78, 81, 118
Byrd, William 134–135

Calais, France 16, 57, 114
Campeggio, Cardinal Lorenzo 60–61
Carew, Sir George 67
Catholicism 55, 76, 87, 89, 124, 128, 130–131, 152
 break from Rome 61, 62–63, 64–65
 return to, under Mary I 103, 105, 109, 110–112, 115
Cecil, Robert, Earl of Salisbury 146, *149*
Cecil, Sir William 122, *122*, 146

Chamber, Robert 39
Chancellor, Richard 115
Chapuys, Eustace 76, 103
Charles I 153
Charles V, Holy Roman Emperor 60, 67, 93, 98, *102*, 103, 104, 106
Charles VIII, King of France 39, *48*, 49
Cheke, John 82, 89
Cheyney, Sir John 25
Church of England 61, 63, 73, 76, 87–89
 under Elizabeth I 119, 124, 131, 135
Clarence, George, Duke of 19, 21, 38
Clement VII, Pope 60, *60*, 61
Conisburgh Castle, Doncaster *15*
Cornish rebellion 41
Coverdale, Miles 63
Cranmer, Thomas, Archbishop of Canterbury 70, 73, 82, 87–89, *87*
 Henry VIII's divorce 61, 100, 110–112, *112–113*
Cromwell, Thomas 62, *62*, 63, 64, 76, 103, 118
Culpepper, Thomas 70

Darnley, Henry Stuart, Lord 154
Daubeney, Giles Daubeney, Baron 41
"Defender of the Faith" title 55
Denny, Anthony 73
Derby, Thomas Stanley, Earl of 25, 29, *29*
Dereham, Francis 70
Desmond rebellions 128
Dissolution of the Monasteries 62–63, 65
Donne, John 135
Dorset, Thomas, Marquess of 56
Drake, Sir Francis 129, *129*, 133
drama 134, 152
Dudley, Lord Guilford 84, 90, 93, 95
Dudley, Lady Jane *see* Grey, Lady Jane
Dudley, John, Lord Admiral 67

East Stoke, Battle of (1487) 38
Edgecote, Battle of (1469) 19
Edmund of Langley 10, 15
Edward III 10, *10*, 11, 15
Edward IV 15, 17, *17*, 19, 21, 22, 33, 43
Edward V 19, 21
Edward VI 76–78, *77*, *79*, 80–81, 81, 82, *86–87*, *89*, *101*
 continues Reformation 87–89, 103, 110

governance under 83, 84
succession of *88*, 89, 121
Edward of Westminster, Prince (son of Henry VI) 12, 16, 21
Egremont, Sir John 39
Elizabeth I *80–81*, *118*, *127*, *135*, *136*, *137*, *156*, 157
 accession and governance of 122, 123
 Catholic plots against 130–131
 childhood 61, 69, 81, 82, 100, 104, *105*, 106, 118–121, *120*, *121*
 death and succession of 138, *139*, 142, 145, 146, *148*
 governance of *125*, 128–129, *129*, 132–133, *133*, 135
 religious reform 124, *124*
 as "Virgin Queen" and "Gloriana" 126–127, 136–137
Elizabeth of York, Queen 22, 28, 32–33, *33*, 35, 38, 49
Erasmus, Desiderius 54, 55, 59
Essex, Robert Devereux, Earl of 127, 129, 138
Etaples, Treaty of (1492) 39, 49
exploration 129

Ferdinand of Aragon 49, 56, 68
"Field of the Cloth of Gold, The" 58–59, 66, 67
Fish, Simon 62
Flamank, Thomas 41
Flodden, Battle of (1513) 57
Foxe, John 95, 112
Foxes Book of Martyrs 61, 95, 112, *112–113*
France 39, 49, 58–59, 84, 131
 wars against 56–57, 59, 67, 114
François I, King of France 55, 58, 67, 98

Gardiner, Stephen, Bishop of Westminster 73, 104, *105*, 121
Geoffrey, Count of Anjou 10
Globe, The (theatre) 134
Gloriana, the Cult of 136–137
Gloucester, Richard, Duke of *see* Richard III
Golden Hind 129, *129*
Gordon, Lady Catherine 39
Gravelines, Battle of (1588) 133
Great Britain 150
Grey, Lady Jane 84, 90, *91*, *92*, *93*
 declared successor to Edward VI 76, 89, 90–93, 104
 death *94–95*, 95, 106
Gunpowder Plot 152, *152*

Hampton Court Palace, Surrey *50–51*, 55, 59, 78, *78*, 81, 82, 83, *83*
Hatfield Palace, Hertfordshire 100, *100*
Henri Grace à Dieu 66, 67
Henry IV, Bolingbroke 11, *11*, 12, *12*
Henry V 12, *13*
Henry VI 12, 16–19, *16*, 21
Henry VII 12, *23*, 32–35, *37*, 47, 145
 at Battle of Bosworth 22, 24–29
 governance of 36–41, 42–44, 46–49, 66
Henry VIII *58*, *61*, *72*, *73*, *80–81*, *101*
 childhood 35, 54–55, *54*, *55*
 governance of 58–59, 66–67
 health and death 72–73, 82, *86–87*
 marriages and succession of 60–61, 68–70, 76, 81, 100
 military success of 56–57, 66–6
 Reformation 62–65, 110
Hexham, Battle of (1464) 19
Holbein the Younger, Hans *6*, *43*, *58*, 61, *62*, *67*, *69*, *70*, *78*, *82*, *89*
Holy Roman Empire *see* Charles V, Holy Roman Emperor
Howard, Sir Edward, Lord High Admiral 67
Howard, Katherine, Queen 70

Innocent VIII, Pope 32, 36
Ireland 39, 73, 128–129, 152
Isabella of Castile 15, 49, 68

James I 146, *147*, *151*, 152–153, 154–157
 succession as King of England 142, 145, *145*, 146–150, *148*, *150*
James IV, King of Scotland 39, 49, 57, 142, 144
James VI, King of Scotland *see* James I
John of Gaunt, Duke of Lancaster 10, 11, 12
Johnson, Ben 135
Joseph, Michael 41
Julius II, Pope 56

Katherine of Aragon, Queen 49, 54, 57, *60*, 68, 69, 98
 separation and divorce 60–61, 68, 100
Katherine of Valois, Queen 12
Ketts Rebellion 84
King James Bible (1611) 152
Kratzer, Nicholas 55

Lancaster, John of Gaunt, Duke of
10, 11, 12
Lancaster, House of 10, 11–12, 15,
16, 19, 32, 33
Latimer, Bishop Hugh 89, 110, 112
Leicester, Robert Dudley, Earl of
82, 121, *126*, 127, 128
Leo X, Pope 55, 57
Lincoln, John de la Pole, Earl of 38
Lionel of Antwerp 10, 15
literature 55, 135, 152
Louis XI, King of France 21
Louis XII, King of France 49, 56
Lovell, Francis, Lord 36, 38
Ludford Bridge, Battle of (1459) 17
Luther, Martin 55

March, Edward, Earl of *see* Edward IV
Margaret, Duchess of Burgundy 36,
38, *38*, 39
Margaret, Queen of Scots 49
Margaret of Anjou, Queen 12, 16,
17, 19, 21
Margaret (daughter of Henry VII)
35, 142, *143*, 145
Marlowe, Christopher 135
Mary I *80–81*, 93–95, *99*, *104*, 106–
109, *108*, *109*, 114–115, *114*, 157
Catholicism 103, 104–105, *105*,
110–112
childhood 68, 81, 98, 100–103,
101, *103*
Mary, Queen of France 35, 49, 90
Mary, Queen of Scots *130*, 142,
154–157, *154*, *155*, *157*
plot against Elizabeth I 84, 130–
131, 145
Mary Rose 67, *67*
Maximillian I, Holy Roman Emperor
39, 56
Mayflower 152, *153*
Medina Sidonia, Alonso Pérez de
Guzman, Duke of 132
Melton, Nicholas 64–65
Melville, Sir James 127
Mirror of the Sinful Soul, The 119, *119*
More, Sir Thomas 55, *55*, 61
Mortimer's Cross, Battle of (1461)
17, 19
Mountjoy, Charles Blount, Baron
129
Mountjoy, William Blount, Baron 54
music 55, 134–135

Norfolk, John Howard, Duke of 25
Norfolk, Thomas Howard, Duke of
(and Earl of Surrey) 39, 43, *43*,

57, 64, 65
Norfolk, Thomas Mowbray, Duke
of 11
Northampton, Battle of (1460) 17
Northumberland, Henry Percy, Earl
of 25, 39
Northumberland, John Dudley,
Duke of (formerly Earl of
Warwick) 83, 84, *85*, 89, 90, 93,
104

Ormond, Thomas Butler, Earl of 128
Oxford, John de Vere, Earl of 24,
24, 38

Parr, Katherine, Queen 70, *71*, 81,
83, 119, 120
Parry, Blanche 118
Parry, Sir Thomas 120, 122
Philip II, King of Spain *80–81*, 95,
127, 128, 129, 131, 132–133
as Mary I's husband 106–109,
107, *109*, 114–115
Philippa of Hainault, Queen 10
Pilgrimage of Grace, The 64–65
Pinkie Cleugh, Battle of (1547) 84
Pius V, Pope 130
Plantagenet, House of 10, 29
Pole, Cardinal Reginald 110, *111*,
115
Poor Law Acts 63
Prayer Book Rebellion 84
"Princes in the Tower, The" 21, *21*
see also Edward V; Richard, Duke
of York (son of Edward IV)
Privy Council 83, 84, 93, 103, 104,
120
Protestantism 63, 76, 87, 103, 121,
124, 128, 130
see also Church of England;
Reformation
punishment under Mary I 110–
112, 115

Raleigh, Sir Walter 127, 129, *129*,
152
Redemore, Battle of *see* Bosworth,
Battle of (1485)
Reformation 64, 84, 87–89, 110–
112, 124
see also Dissolution of the
Monasteries
Regency Council 83
Renaissance era 54, 55
Renard, Simon 93, 121
Richard, Duke of York (son of
Edward IV) 19, 21, 38, 39
Richard, Duke of York (son of

Richard of Conisbrough) 16, 17
Richard II 11, 12
Richard III 10, 15, 21, 22, 24–25, *28*,
29, 36
Richmond, Edmund Tudor, Earl
of 12
Richmond Palace, Surrey 45, 49,
70, 81
Ridolfi, Roberto 131
Rochford, Jane Parker, Lady 70
Rogers, John 110
Rose theatre, The 134, *135*
Royal Collection 55
Royal Navy 66–67, 115

Salisbury, Robert Cecil, Earl of
146, *149*
Scheyfve, Jean 89
Scotland 39, 57, 62, 84, 128,
149–150
see also James I; Mary, Queen of
Scots
Seymour, Edward *see* Somerset,
Edward Seymour, Duke of, Lord
Protector
Seymour, Jane, Queen 69, *69*, 73,
76, 82, 84
Seymour, Sir Thomas 83, 120–121
Shakespeare, William 134, *134*
Shrewsbury, George Talbot, Earl
of 65
Sidney, Sir Philip 128, *128*, 135
Simmonds, Richard 38
Simnel, Lambert 38, *39*, 43
Skelton, John 35, *35*
Solent, Battle of the (1545) 67
Somerset, Edward Seymour, Duke
of, Lord Protector 82, 83, *83*, 84,
120
Spain 115, 128–129, 131, 132–133,
152
see also Philip II, King of Spain
Spanish Armada 132–133, *132*, *133*
Spenser, Edmund 128, 135
Spurs, Battle of the (1513) 57, *57*
Stafford Rebellion 36
St Albans, Battle of (1455) 16
St Albans, Battle of (1461) 19
Stanley, Sir William 25, 29
St James's Palace, London 115,
115
Suffolk, Charles Brandon, Duke of
64–65, *64*
Suffolk, Frances Brandon, Duchess
of 90, 95
Suffolk, Henry Grey, Duke of 90, 95,
104, 106

Suppression, Act of (1536) 63
Supremacy Acts 61, 124
Surrey, Henry Howard, Earl of 55
Surrey, Thomas Howard, Earl of
(and Duke of Norfolk) 39, 43, *43*,
57, 64, 65

Tallis, Thomas 134–135
tapestries 59, 78
taxation 39, 41, 46, 49, 57, 64, 67, 73
Tewkesbury, Battle of (1471) 21
theatre 134, 152
Throckmorton, Francis 131
Titulus Regius 22, 32
Tower of London 21, *22*, 49, 90, 121
Towton, Battle of (1461) *18*, 19
Tudor, Henry *see* Henry VII
Tudor rose emblem 33, *33*
Tyburn, London 65, *65*
Tyrone rebellion 128, 129

Uniformity Acts 89, 124
Union, Act of (1707) 149

Valor Ecclesiasticus 62–63
Vergil, Polydore 42, *42*

Wakefield, Battle of (1460) 17
Walsingham, Sir Francis 131, *131*
Waltham Abbey, Essex 63, *63*
Warbeck, Perkin 39, *40*, 41, 49
Wars of the Roses 10, 16–22,
24–29, *25*, 43
Warwick, Edward Plantagenet, Earl
of 38
Warwick, John Dudley, Earl of (later
Duke of Northumberland) 83, 84,
85, 89, 90, 93, 104
Warwick, Richard Neville, Earl of,
"the Kingmaker" 17, 19, *20*, 21
Winchester, William Paulet,
Marquess of 104
Wolsey, Cardinal Thomas 49,
56–57, *56*, 59, 61, *61*, 98
Wyatt, Sir Thomas 55
Wyatt the younger, Sir Thomas 95,
106, 121
Wydeville, Elizabeth, Queen 19, *19*

York, Cecily Neville, Duchess of,
"Rose of Raby" 15, 32, 33
York, House of 10, 15, 16, 17, 19,
21, 33
Yorkshire Rebellion 39

Zutphen, Battle of (1586) 128

CREDITS